D1544080

革命在继续

LIU WEI
PURPLE AIR III NO.2, 2006
oil on canvas,
310 x 380cm (122 x 149 1/2 in)

WANG GUANGYI
AESTHETICS OF WAR - BLUE NO.3, 2006
oil on canvas,
200 x 300cm (78 3/4 x 118in)

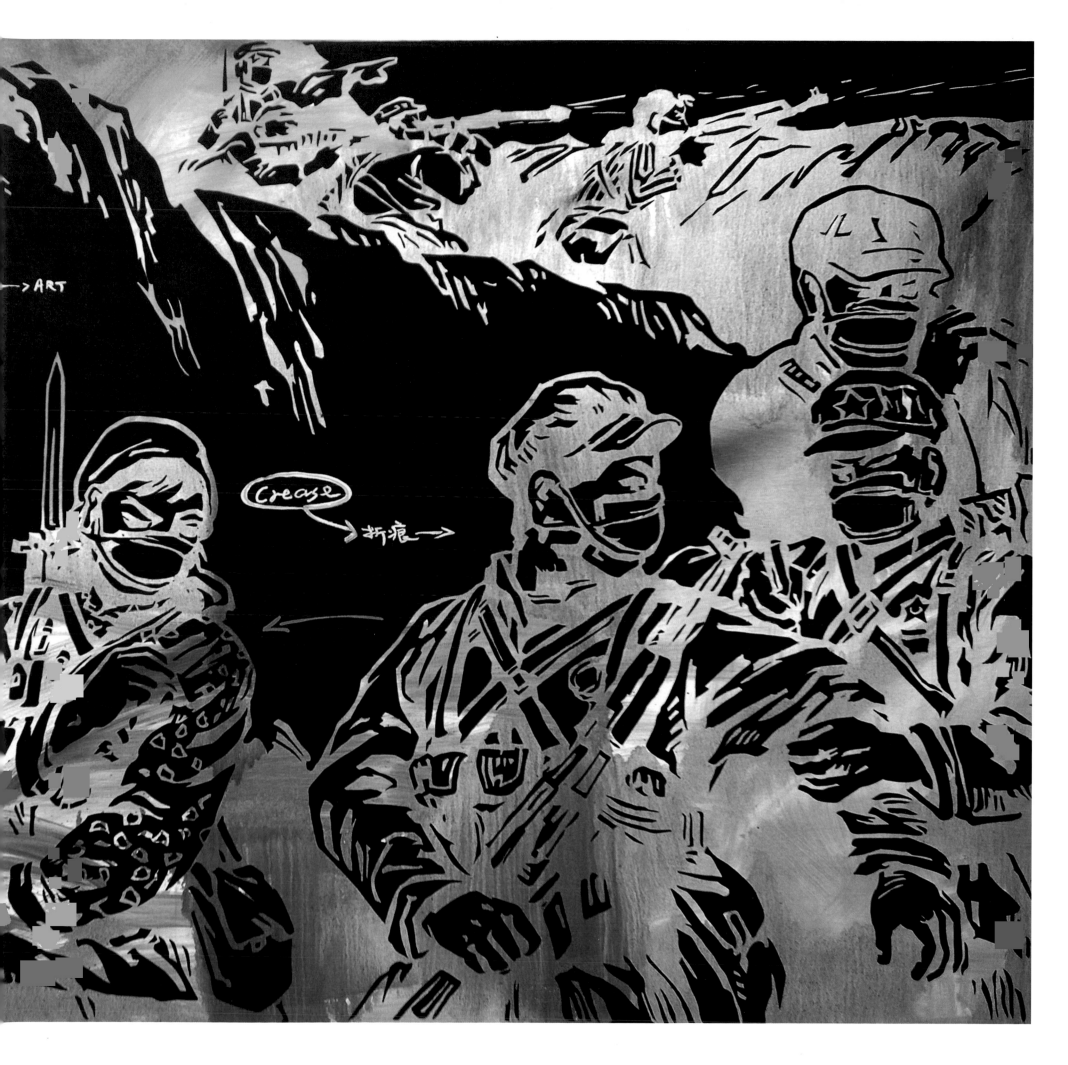

WANG GUANGYI
PORSCHE, 2005
oil on canvas,
200 x 200cm (78 3/4 x 78 3/4 in)

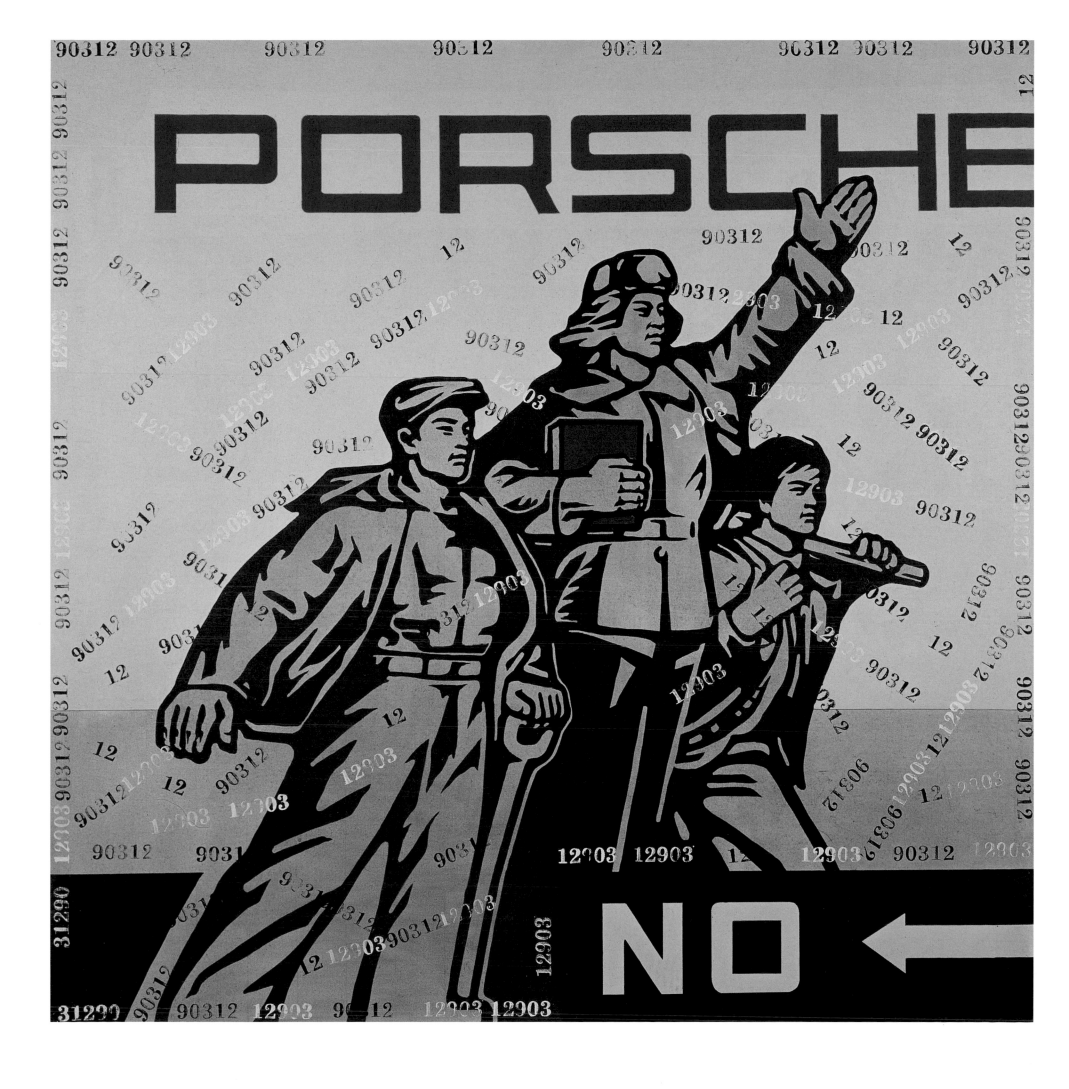

SHI XINNING
A HOLIDAY IN VENICE - AT THE BALCONY OF MS. GUGGENHEIM, 2006
oil on canvas,
210 x 272cm (82 1/2 x 107in)

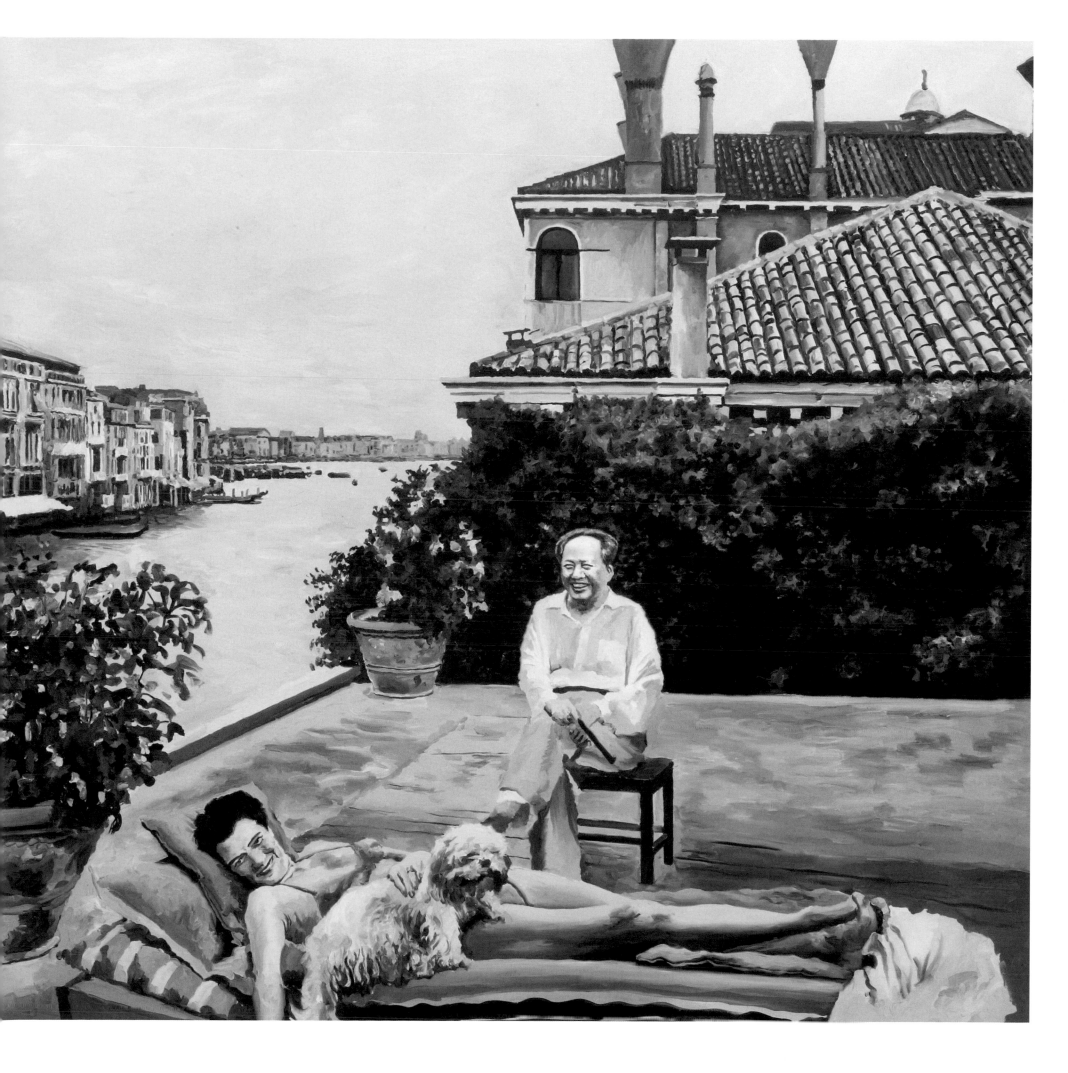

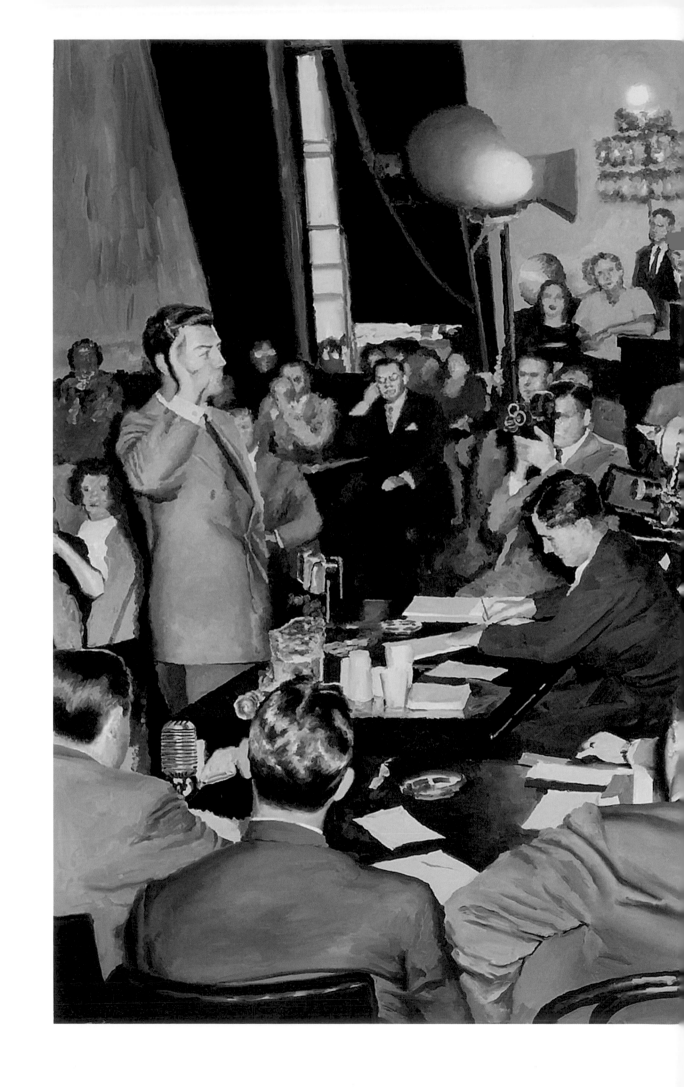

SHI XINNING
MAO AND MCCARTHY, 2005
oil on canvas,
256.5 x 381cm (101 x 150in)

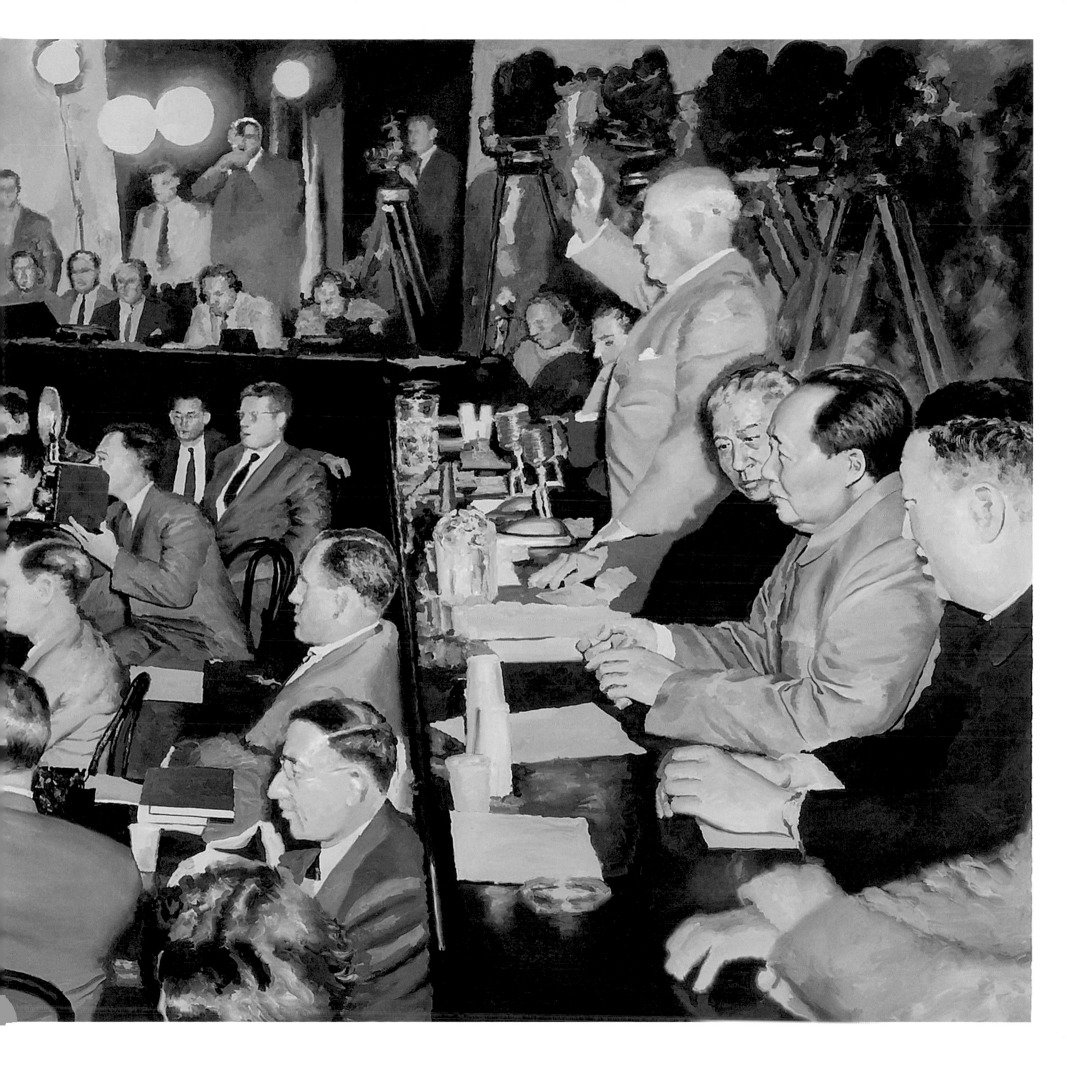

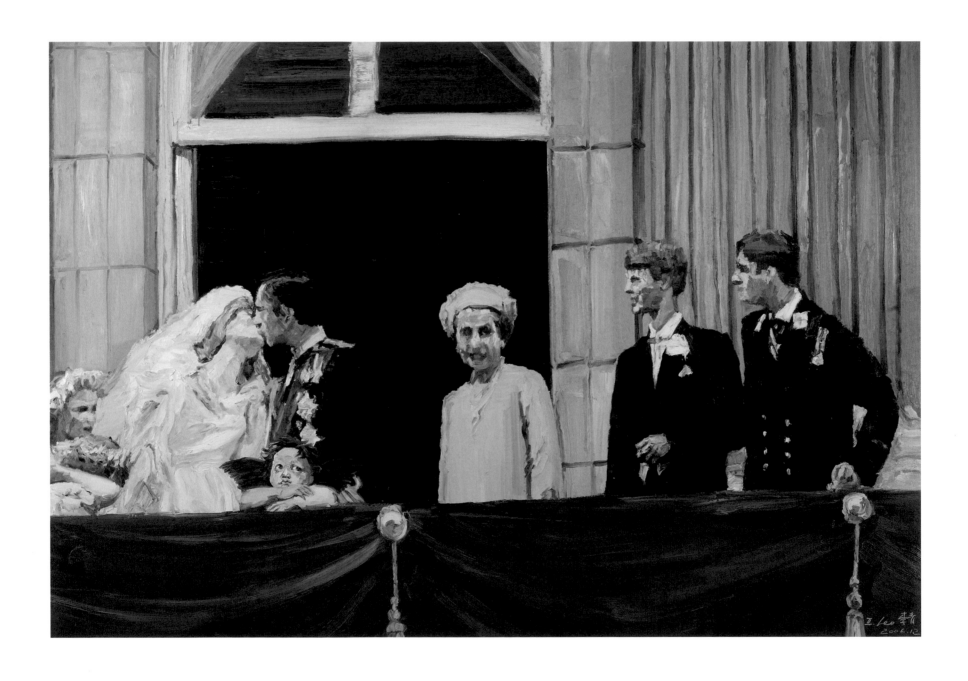

LI QING
WEDDING, 2006
oil on canvas,
190 x 275cm (74 3/4 x 108 1/4 in) each panel

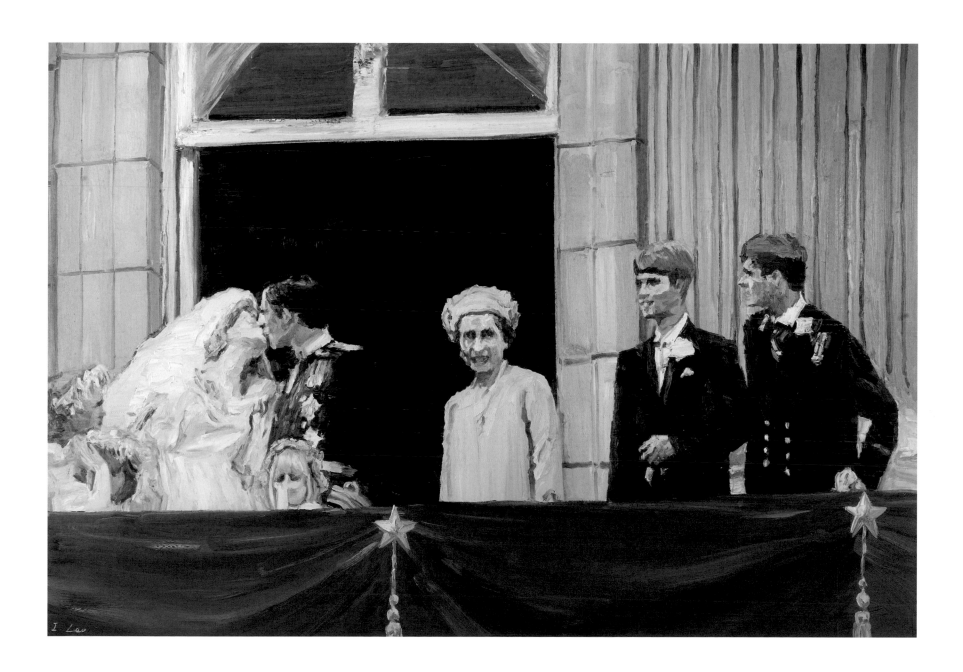

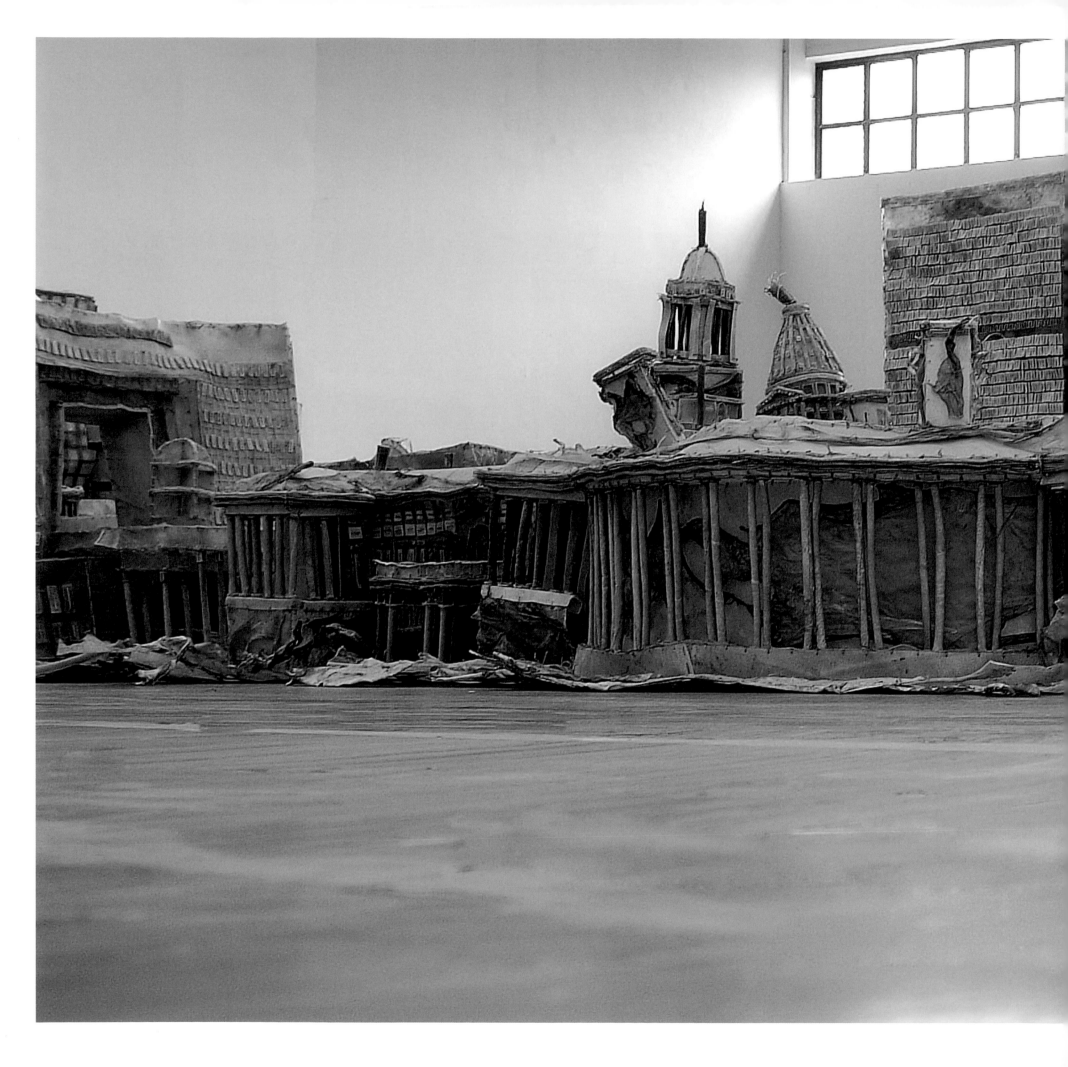

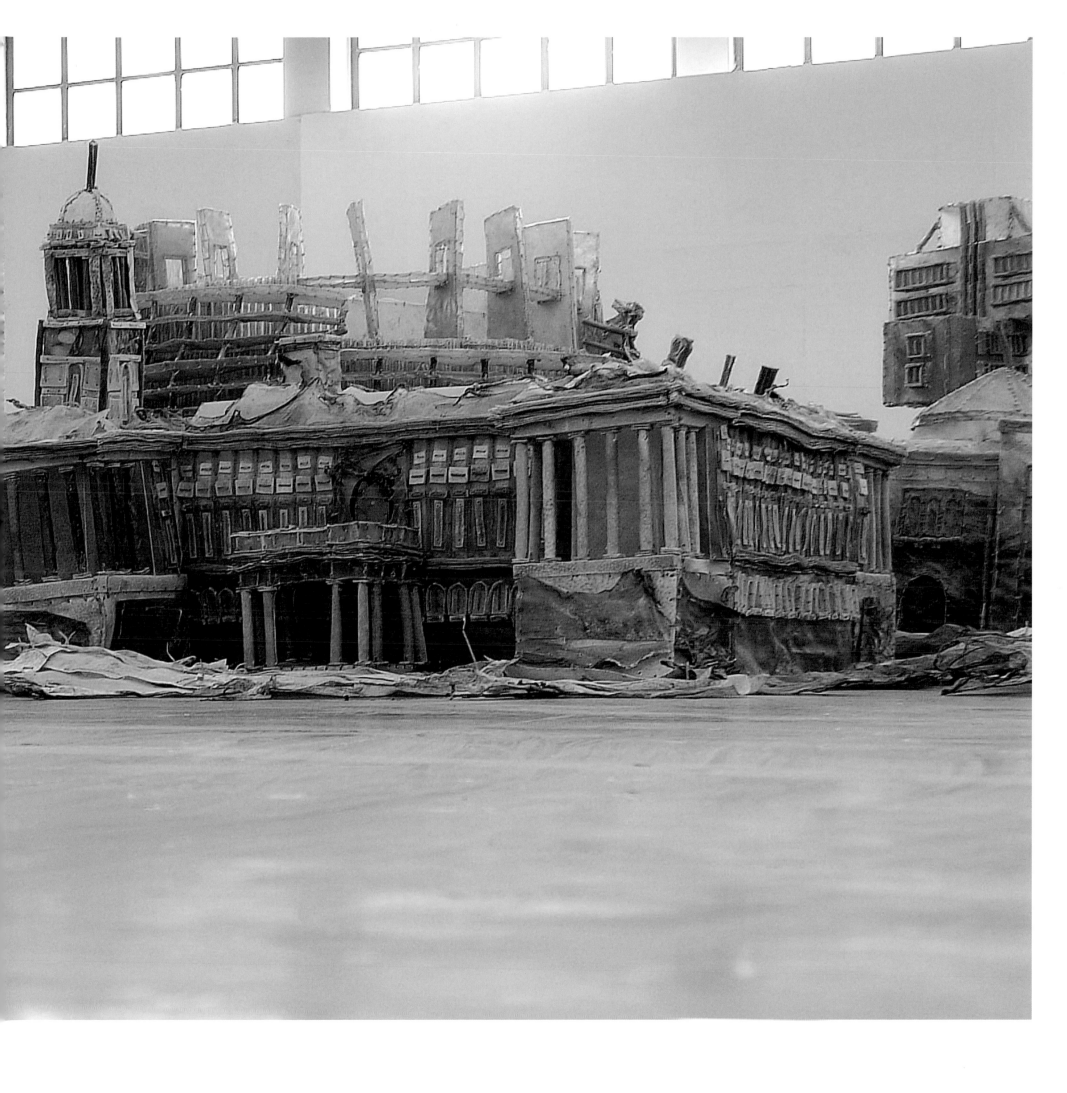

LIU WEI
LOVE IT! BITE IT!, 2005-2007
edible dog chews,
dimensions variable

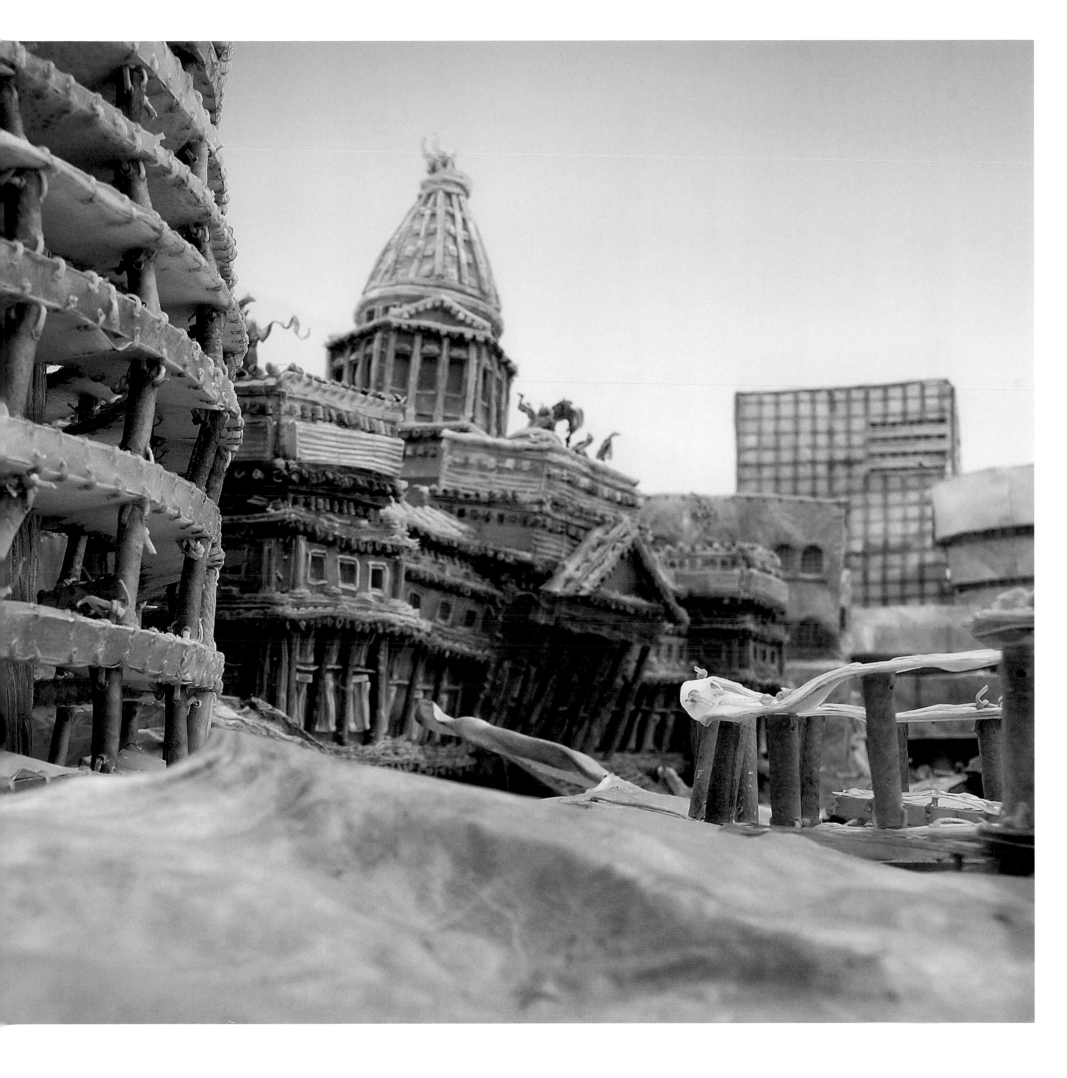

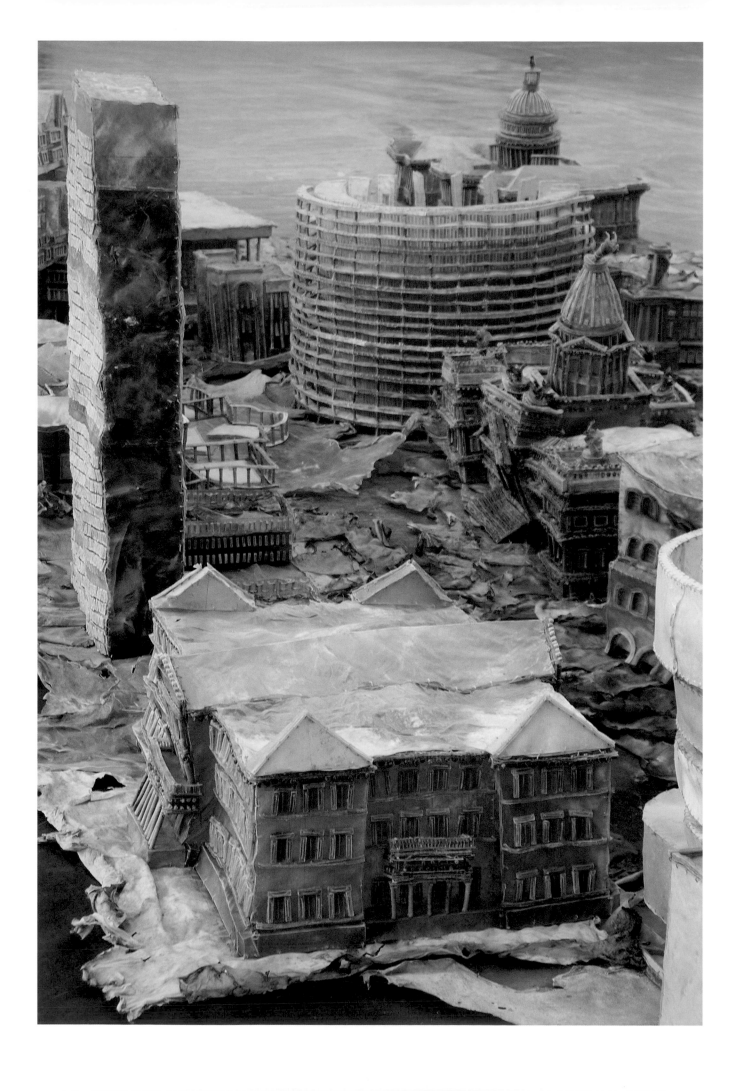

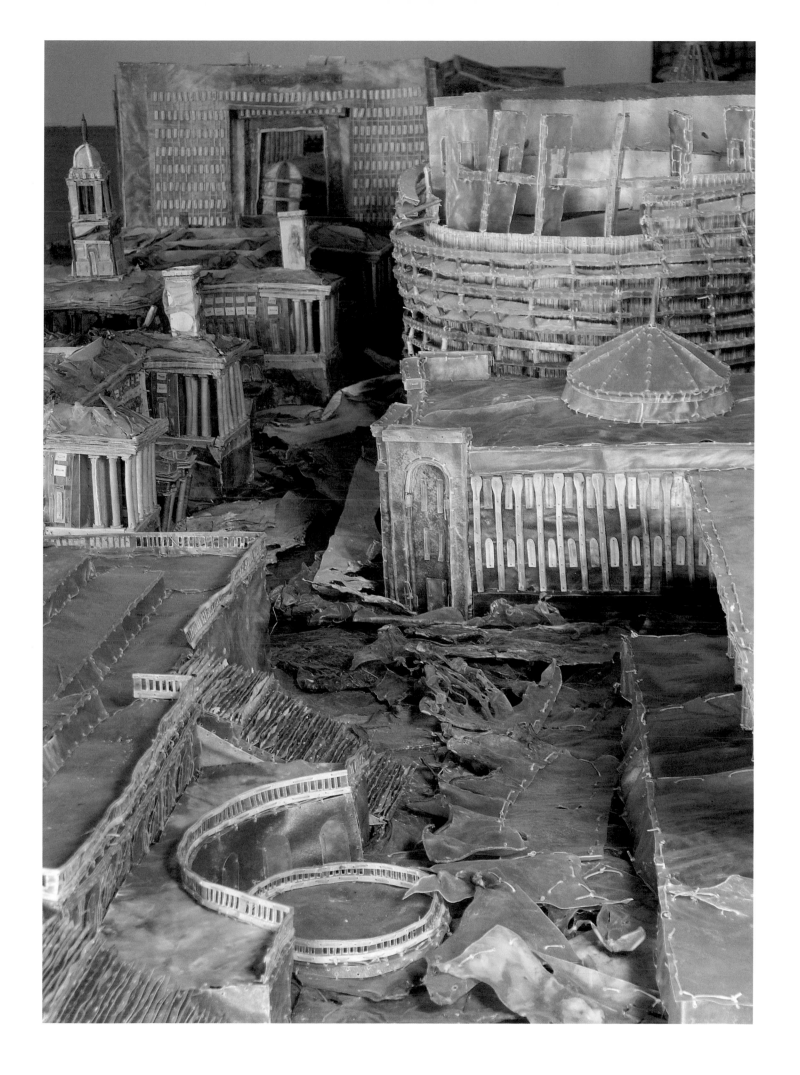

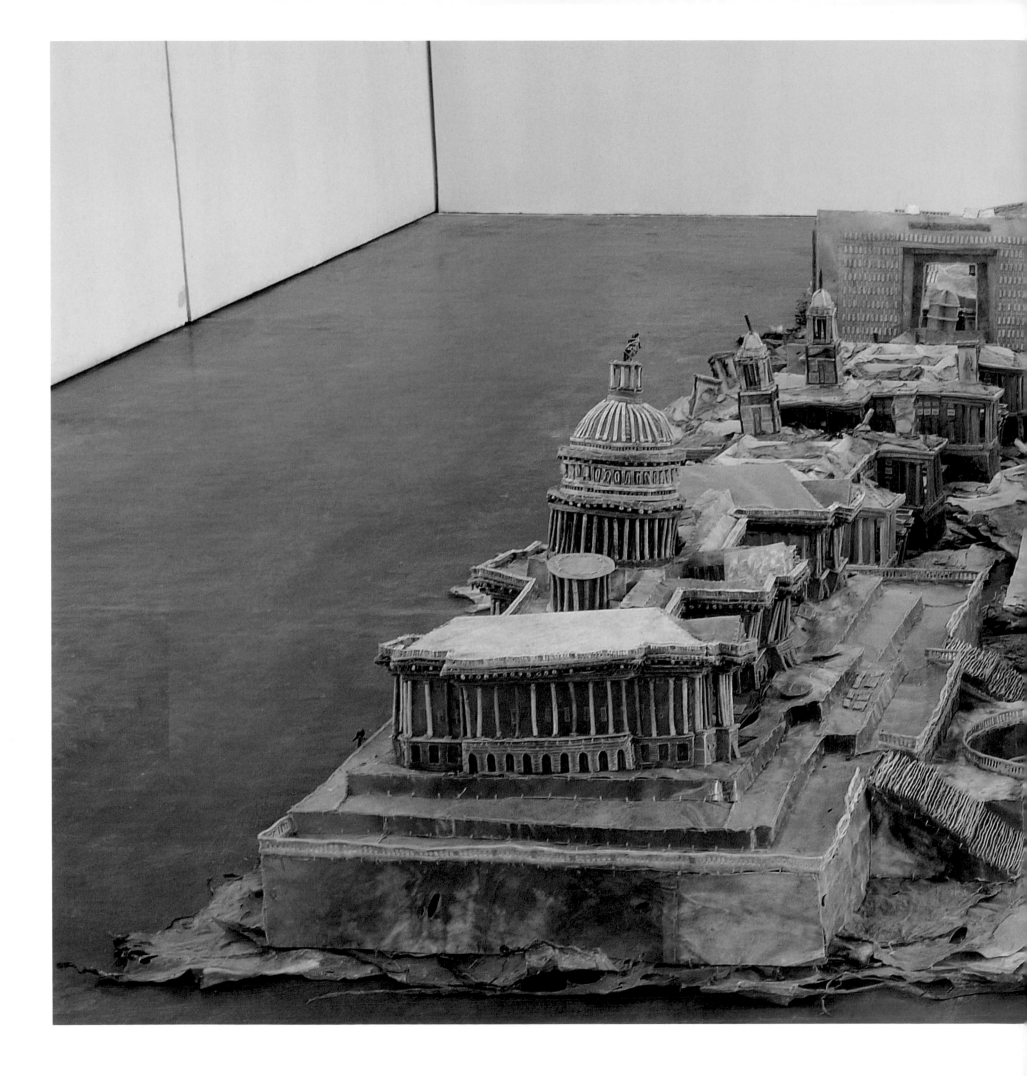

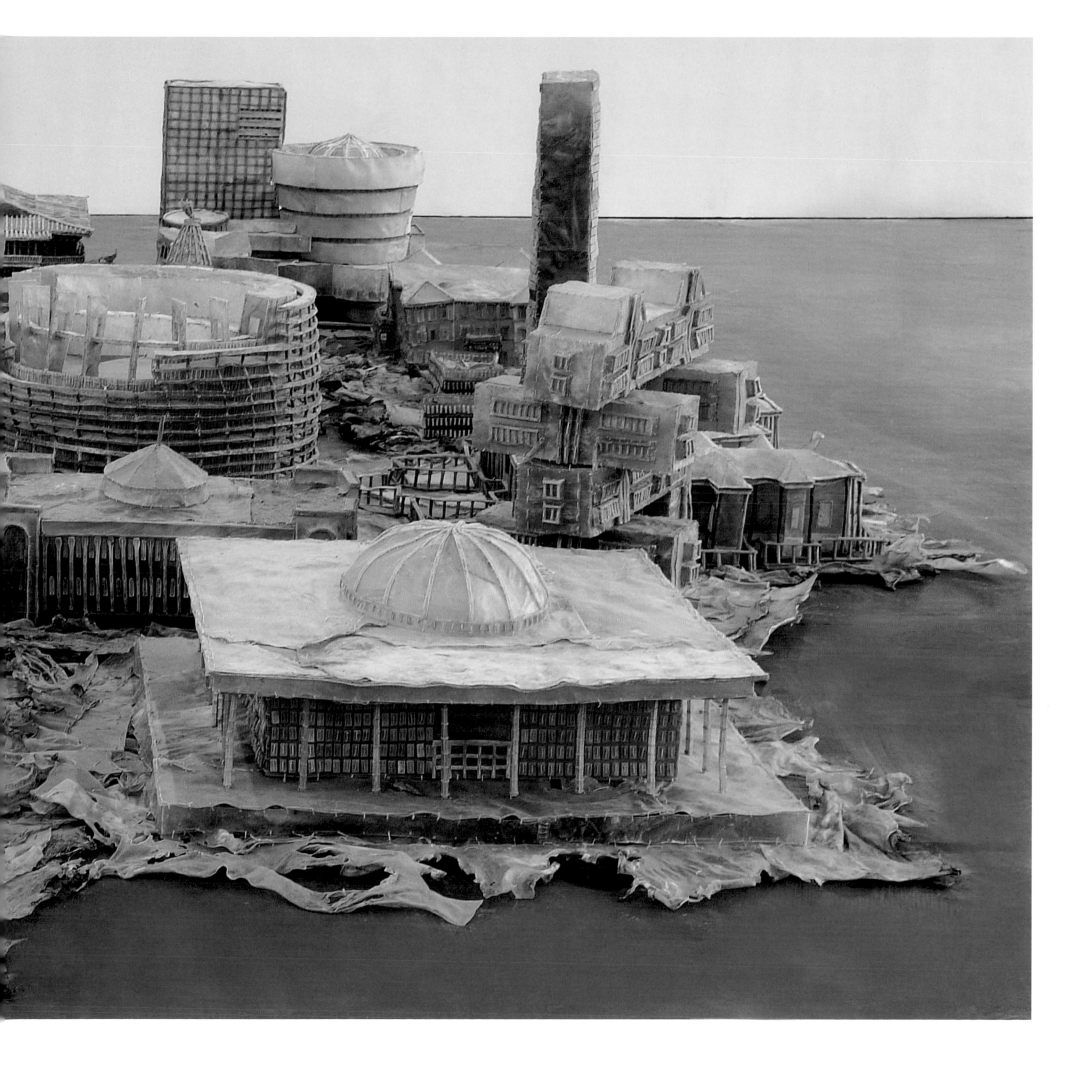

SAATCHI GALLERY

革命在继续

THE REVOLUTION CONTINUES

NEW ART FROM CHINA

INTRODUCTION BY JIANG JIEHONG

RIZZOLI
NEW YORK

苍鑫
CANG XIN
方力钧
FANG LIJUN
俸正杰
FENG ZHENGJIE
李青
LI QING
李松松
LI SONGSONG
李演
LI YAN
刘耕
LIU WEI
缪晓春
MIAO XIAOCHUN
彭禹
PENG YU
邱节
QIU JIE

沈少民
SHEN SHAOMIN
史金淞
SHI JINSONG
石心宁
SHI XINNING
孙原
SUN YUAN
王广义
WANG GUANGYI
吴山专
WU SHANZHUAN
向京
XIANG JING
尹朝晖
YIN ZHAOHUI
岳敏君
YUE MINJUN
曾梵志
ZENG FANZHI

展望
ZHAN WANG
张大力
ZHANG DALI
张海鹰
ZHANG HAIYING
张宏图
ZHANG HONGTU
张洹
ZHANG HUAN
张鹏
ZHANG PENG
张晓刚
ZHANG XIAOGANG
张小涛
ZHANG XIAOTAO
张远
ZHANG YUAN
郑国谷
ZHENG GUOGU

革命
在继
续

THE REVOLUTION CONTINUES

姜节
泓

JIANG JIEHONG

On 25 July 1935 HMS *Suffolk*, carrying a thousand articles of Chinese art packed in ninety-three specially made steel-lined cases, finally moored at Portsmouth Dockyard. Under a heavily armed escort the imperial treasures from the Forbidden City were unloaded by Royal Marines and transported to the Royal Academy of Arts in Piccadilly for the International Exhibition of Chinese Art due to open that November. This was the first exhibition of Chinese art officially organised by the Chinese government to be shown in the West. The great beauty of Chinese art was no doubt appreciated in Burlington House; however, it seemed that China had remained completely outside European developments in modern art. The Western view of Chinese art had not changed for centuries – Chinese art represented to the West a world of dazzlingly beautiful porcelain and jade or unreadable cursive calligraphy and paintings layered with poetic reference.

Although there seemed to be little or only very gradual change in Chinese art, when indeed change came it would appear sudden and radical to outsiders, especially to those who appreciated the

'decorative objects'[1] brought to Burlington House in 1935. The transformation of Chinese art was not the result of Western influence, but the result of China's social, political and cultural conflicts that had raged since the beginning of the twentieth century. The introduction of Western ideology alone could not shape contemporary Chinese art. The changes were born through China's great revolutions.

The artistic revolution began when Chen Duxiu criticised literati paintings in 1917 and advocated that art should be used to serve the masses. It was believed that the 'passive' literati ideology of escaping from the reality would not meet China's current needs. Realism, however, could expose the hardships of the nation, reflect its problems and lead towards a better future. The subsequent New Culture Movement (*xin wenhua yundong*) was dominated by a spirit of rejection. The long tradition of Chinese art was challenged. No movement other than the Cultural Revolution itself would present such a challenge to China's thousand-year cultural legacy.

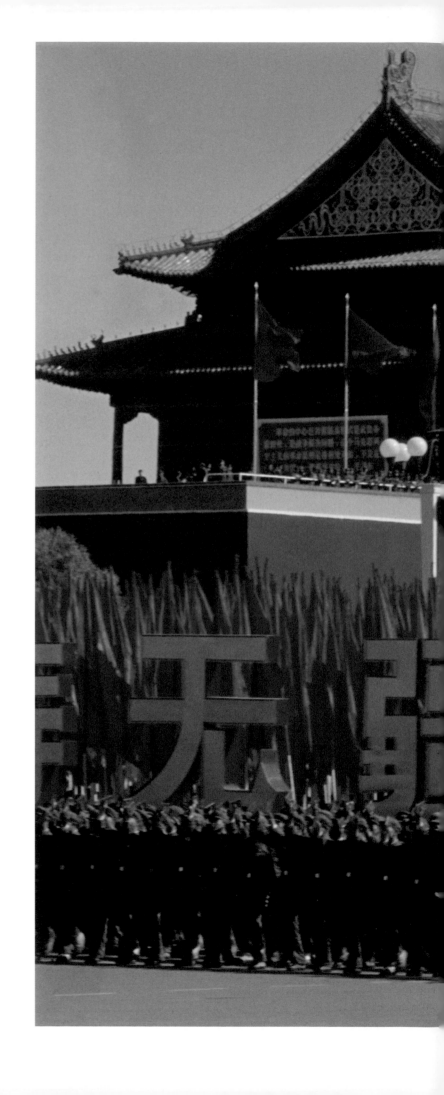

Weng Naiqiang, Parade on Tiananmen Square on National Day, 1966

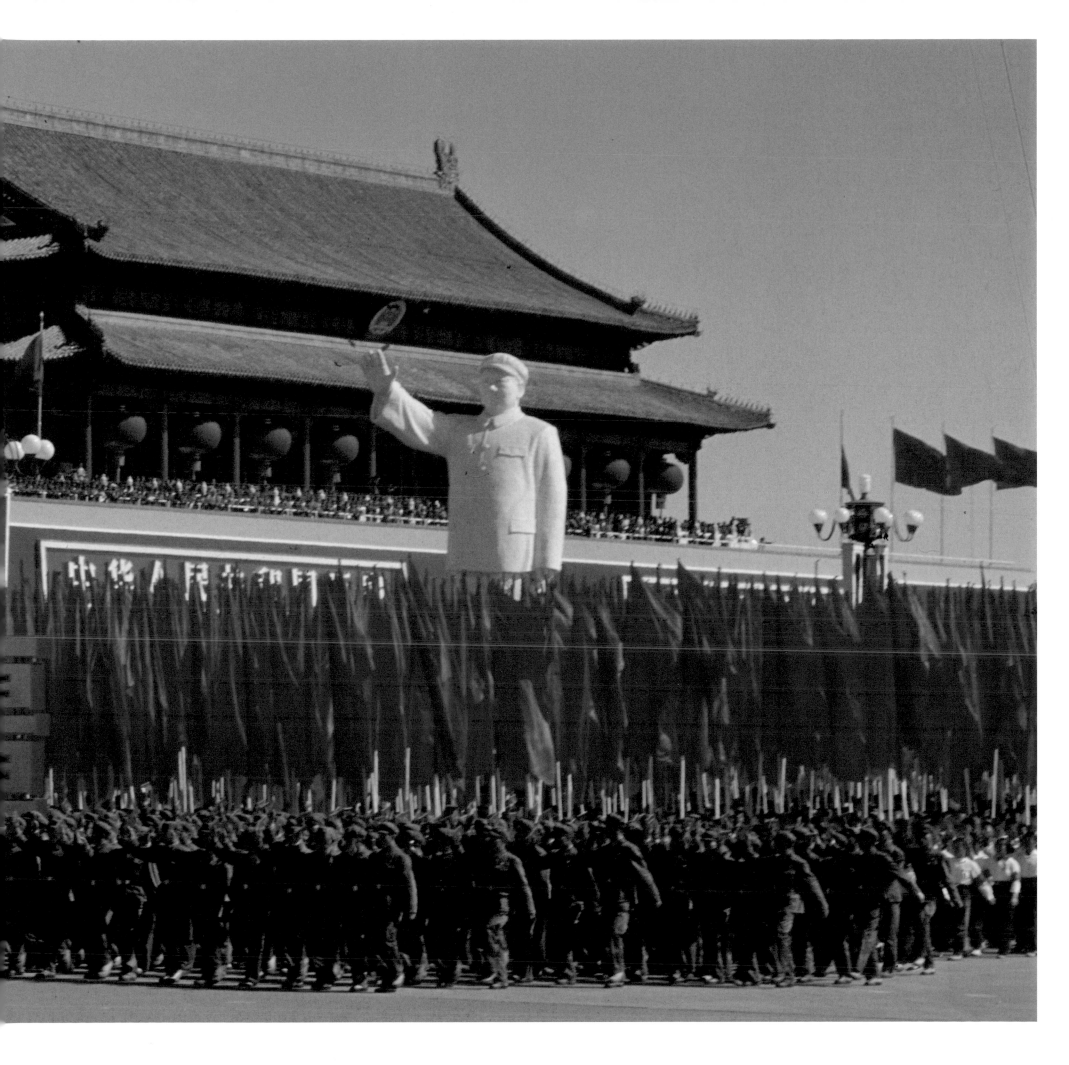

文化革命

THE CULTURAL REVOLUTION

Though the beginning of the Great Proletarian Cultural Revolution (*wuchan jieji wenhua dageming*) was not a precise event, it is usually accepted that the Cultural Revolution was launched under the guiding principles of the so-called *May the Sixteenth Circular* of 1966. The revolution lasted until the death of Mao Zedong and the fall of the Gang of Four in 1976. In 1981 it was officially defined as a 'ten-year turbulence' (*shinian dongluan*).

On 1 June 1966, the editorial of the *People's Daily* stated, 'The Proletarian Cultural Revolution is going to thoroughly eliminate all the old ideas, old culture, old customs and old habits of the exploiting classes, which have corrupted the people for thousands of years, and to create and construct the proletarian new idea, new culture, new customs and new habits among the masses.'[2] The Red Guards immediately moved into action in response and pioneered a mass movement nationwide.

The colossal upheaval was legitimised by Mao's indoctrination. He had instructed his young followers that 'all the truths of Marxism can be summed up in one sentence, "to rebel is justified" (*zaofan youli*).' In the beginning the Red Guards of the Middle School attached to Tsinghua University, the founders of the revolutionary organisation, declared, 'revolution is to rebel, which is the soul of Mao Zedong's *Thoughts*... Dare to think, dare to say, dare to do, dare to smash and to revolt, all in all, dare to rebel. It is the most fundamental and valuable quality of proletarian revolutionaries, and the principle of the Communist partisanship.'[3] The principle of rebellion was then adopted as a licence by the Red Guards and as a driving force with which they hoped to change ideology, living attitudes and the visual culture of daily life.

When Mao accepted the Red Guard armband presented by a student representative, Song Binbin, on 18 August that year, his full support and encouragement of the Red Guards became visible and he was regarded as their Red Commander. The next morning, the Red Guards rushed on to the streets of Beijing to eliminate the 'Four Olds' (*sijiu*). The summer months of 1966 became a disaster for

Chinese culture and a national humiliation. Over ten million homes across the country were searched, private property was confiscated and numerous treasures destroyed. These included calligraphy and paintings dating back to early dynasties, ancient books and archives, gold, silver and jade artefacts and jewellery. In addition, public properties and national treasures, relics, historical architecture and sculpture were also attacked. By the end of the Cultural Revolution, in Beijing alone 4,922 of the 6,843 officially designated 'places of cultural or historical interest' had been destroyed, by far the greatest number of them in August and September 1966. The actions of the Red Guards soon turned into the 'red terror' (*hongse kongbu*), with which people of 'bad' class background were criticised, humiliated or worse.

The literal meaning of 'Cultural Revolution' is surprisingly positive. It can even be interpreted as an attempt to re-establish the foundation of Chinese culture. Later, however, the period is often referred to by many as the 'ten lost years', in which the 'old' had been washed away, yet the 'new' was valueless. The visual productions of the Cultural Revolution – billboard paintings, woodcut prints, slogans, 'model operas' (*yangban xi*), Mao's portrait, badges and books, the Red Guard uniforms and 'large-character' posters – were simply seen as political instruments of no aesthetic importance. Consequently the period has been generally ignored by Chinese art historians. The *Chinese Art Almanac*, compiled by the China National Art Gallery, omits the years 1966 and 1967 entirely, suggesting a complete gap in history. Until 1971 absolutely no art exhibitions were recorded across the country.[4] But in reality the period was not a void but rather a social climax leading, in time, to a radical change in Chinese art.

Since the cost of such a change is incalculable, one wonders what the change actually brought to Chinese culture. Contemporary Chinese art has developed so rapidly after the Cultural Revolution – this new dramatic transition is a natural eruption after a decade of repression, whilst the subsequent emergence of a radical new Chinese art can be understood as an extension of Mao's legacy of rebellion.

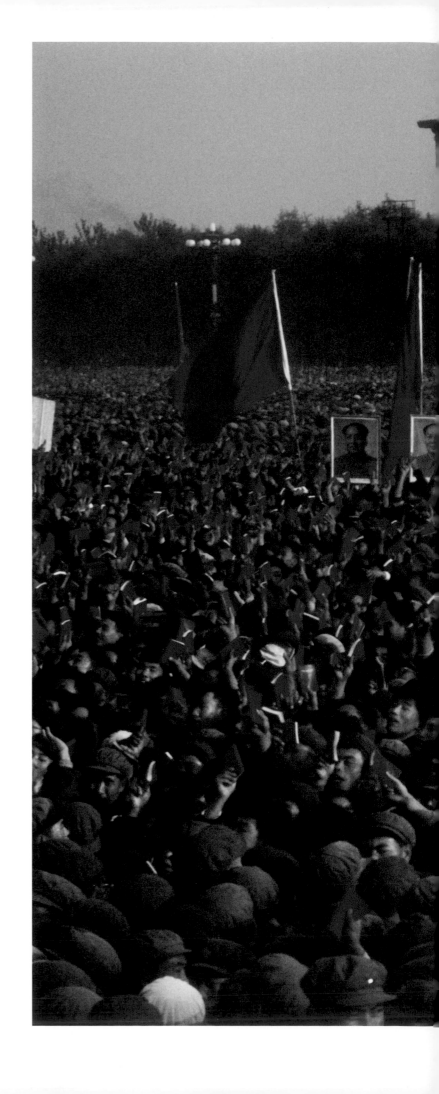

Weng Naiqiang, *Chairman Mao reviewing Red Guards on Tiananmen Square*, 1966

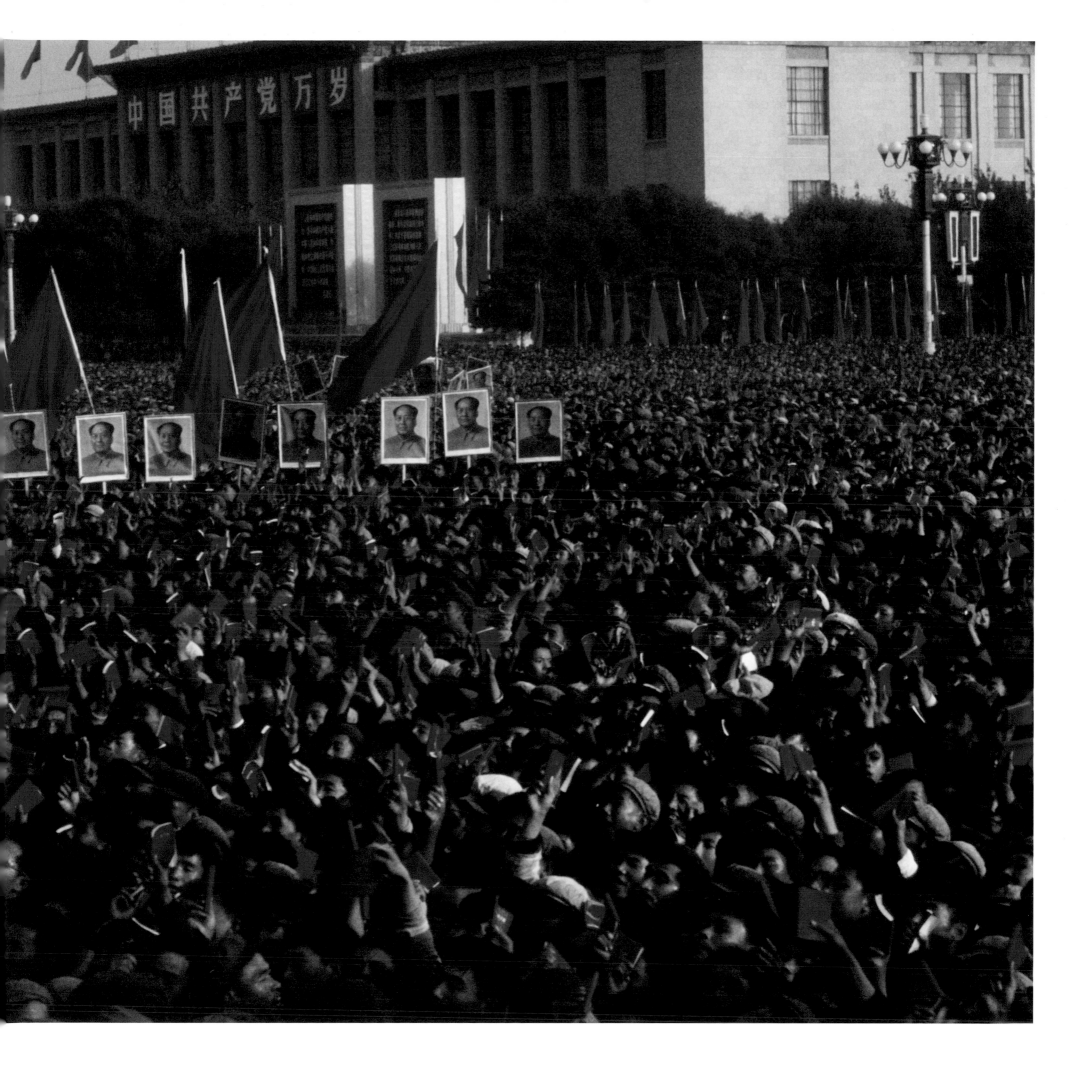

Cai Guo-Qiang, Dream, 2002

红
RED

It is forty years since the launch of the Cultural Revolution, yet the memories of the time are still clear. The colour was red. When the popular slogan read, 'the whole country being awash with red' (*quanguo shangxia yipian hong*), the colour represented the people's enthusiasm for a communist utopia. Although Communism and the red banners of the Soviet revolution came from outside China, red is a colour rooted in Chinese culture. It has been inherited, reinterpreted and reborn throughout Chinese history, oscillating between the visual language of folk life and political society, tradition and modernity. The use of the colour culminated during the Cultural Revolution, its symbolic significance glorifying the regime, urging on the believers, and heightening the sense of 'Chineseness'.

Every Red Guard with a Mao badge and a copy of the red book, *Quotations from Chairman Mao (Thoughts)*, fervently attempted to turn the country into a 'red sea' (*hong haiyang*). In just a few days on the streets of Beijing Red Guards had painted the doors and walls of houses and shops red. 'Slogans were written in red on all available surfaces. Red paper banners declaring devotion to Mao covered the walls of shops, homes and dormitories. The stores, government offices, tea shops, noodle restaurants and various eating places were so completely covered that it was impossible to tell which was which.'[5] The red phenomenon of the Cultural Revolution was executed on an enormous scale. Its dynamic was both public and private. The flags and slogans dominated the public spaces, while Mao badges, red books and Red Guard armbands adorned individuals. The colour totally permeated everyday life. Red then far outweighed the literal meaning of a physical colour to become a complex trigger suggesting fanaticism and terror, glory and agony, illusion and disenchantment.

Cai Guo-Qiang, one of the most acclaimed Chinese artists, has been an international player of the 'Chinese card' (*zhongguo pai*), appropriating Chinese cultural and political symbols in such works for the Venice Biennale as *Bring to Venice What Marco Polo Forgot* in 1995, *The Dragon Has Arrived* in 1997 and *Venice's Rent Collection Courtyard* in 1999. The use of red has been one of the artist's common devices. Red flags fired out from the base of a pagoda by electronic fans offer the image of a roused creature, or the power of a

Cai Guo-Qiang, The Dragon Has Arrived!, 1997

revolutionary China, suggesting the presence of the title – *The Dragon Has Arrived!*. His 2002 installation *Dream* was constructed from a huge, billowing red sheet on the floor, hung with red paper lanterns in the various shapes of cars, aircrafts, rockets, washing machines, pianos and McDonald logos. These folk craft objects from the artist's childhood were colliding with the revolutionary force of the man-made red sea. This combination of the re-fabricated image of the red utopia with childlike longing and today's material aspirations was entirely enveloped in the colour red.

The original revolutionary excitement of the colour red can be re-experienced in today's public culture. *The Red Era Centre* in Chengdu was designed in 2000. 'Like Cui Jian's rock and roll music,' the architect Liu Jiakun responded, 'the Centre was largely inspired by the revolutionary energy of the Cultural Revolution. I attempted to bridge this legacy with the life of China's new generation.' 'Youth', 'passion' and 'rebel' became the keywords throughout the design process. The colour red, suffusing the space, has a quality that can represent all the elements of this vocabulary.

When 'The Theory of Lineage' was proposed by the Red Guards in June 1966, red became a signal of individual social status. 'We were born under the red flag, grew up in the red family, and received a full red revolutionary education… We are not only the "born red" (*zilai hong*), but we are also red in the present, red in the future, red forever, and red to the end, worldwide,'[6] they proclaimed. People could be recognised politically by discovering how their family backgrounds conformed to the 'Five Red Categories' (*hong wulei*) of workers, peasants, soldiers, revolutionary cadres and martyrs. The image of worker-peasant-soldier became a popular device, widely used in propaganda, for the representation of red. The image appeared in the massive productions of Red Guard publications and on gigantic billboards. The shapes of sunflowers, representing people's loyalty towards Chairman Mao (the Red Sun) appeared frequently on popular designs in sets of three or seven as metaphorical patterns. These designs symbolised respectively 'The Three Loyalties' (*san zhongyu*): to Mao, to Mao's *Thoughts* and to his proletarian revolutionary line, as well as the infinite faithfulness of seven hundred million people to the Chairman.

Wang Guangyi's series of paintings *Great Criticism* first appeared in 1990. The artist juxtaposed revolutionary symbols and slogans and the worker-peasant-soldier images of the Cultural Revolution with famous brands of Western products – Coca-Cola, Marlboro, or Omega. This apparently arbitrary combination of political and commercial signs sharply satirised both the red ideology and the new craze for Western consumer products prevalent in China since the 1980s. The artist's own artistic voice has now in effect been branded to create a 'history of criticism' as the revolutionary valour continues to be displayed in his more recent works in 2006, *Materialist's Art* (page 42) and *Art Go* (page 45).

The sunflower plays a key role in the narrative of Shen Shaomin's series of paintings from 1987, which reflects the experience of his childhood and youth in the red era. The series as a whole was a self-portrait revealing his 'personal understanding of life and love'. In his *Lab* series in 2005 (page 46), Shen's fifty sunflowers were sculpted in bone and metal and demonised by the hybrid appearance of both plant and animal origins. They were individually placed in glass tubes like coffins as if they presented 'scientific' evidence. Their cadaverous colour suggested a tragic end like the death of the red era itself. The question remains as to the survival of their spirit.

Previous page:
Liu Jiakun, The Red Era Centre, 2000-01

Weng Naiqiang, Propaganda on Chang An Avenue, 1967

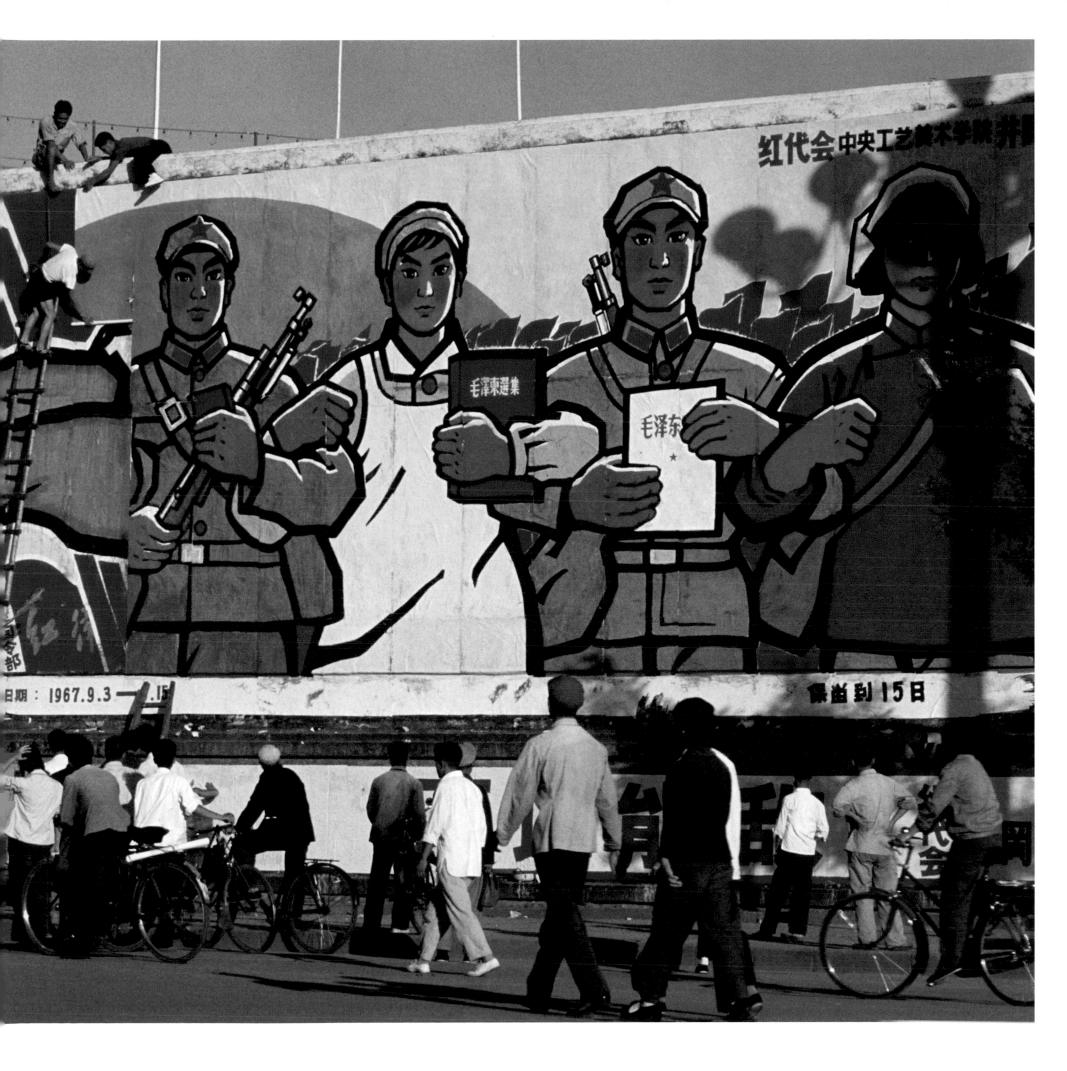

WANG GUANGYI
GREAT CRITICISM: MATERIALIST'S ART, 2006
oil on canvas,
300 x 400cm (118 x 157 1/2 in)

WANG GUANGYI
GREAT CRITICISM: ART GO, 2006
oil on canvas,
160 x 200cm (63 x 78 3/4 in)

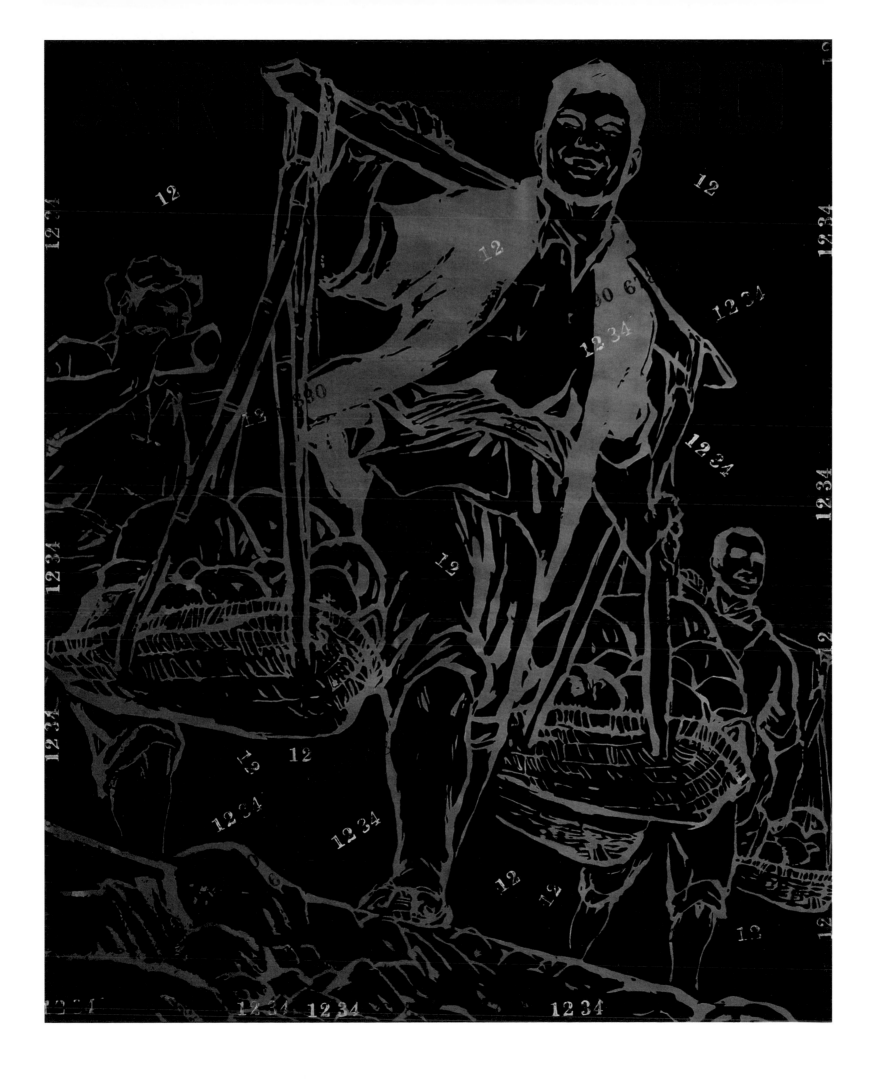

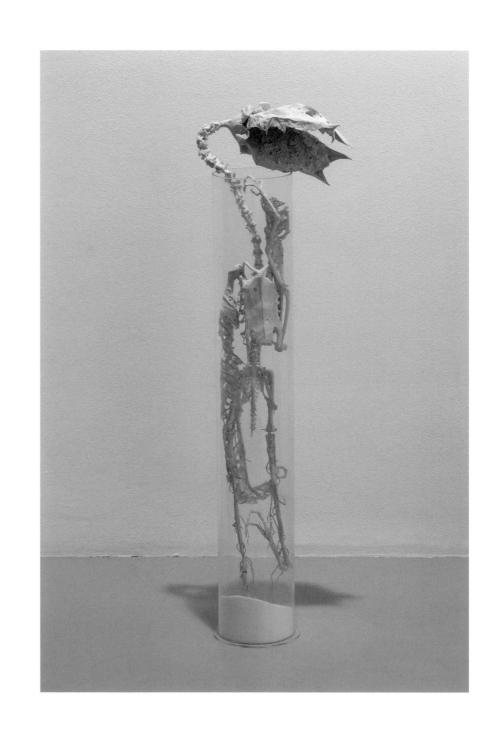

SHEN SHAOMIN
EXPERIMENTAL STUDIO NO.2 - SUNFLOWER, 2005
bone, bone meal, glue
130 x 15cm (51 x 6in)

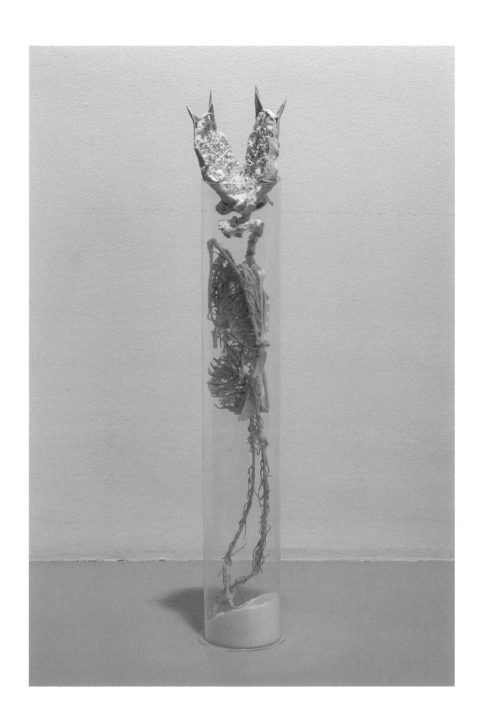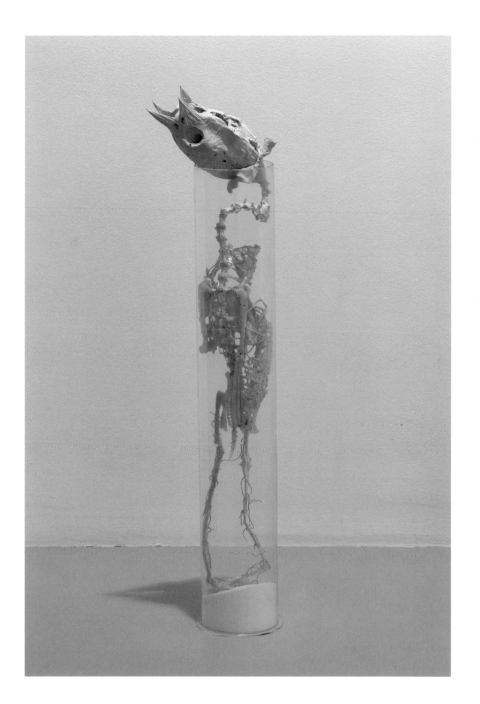

毛
MAO

The vision of a 'red sea' was accomplished not through the ubiquitous colour red alone, but through those images like the worker-peasant-soldier, the sunflowers and, most importantly, the image of Mao himself, that implied red. An exchange was developed between the use of a descriptive and realistic image and the application of the simple abstraction of the colour red. Ultimately, on the one hand, the colour red would be humanised and easily accommodated in daily life. On the other hand, a realistic image of the figure of Mao would be reduced to an omnipresent ghost.

On 1 October 1949, when Mao ascended the balcony of Tiananmen, the Gate of Heavenly Peace, which once stood as the gate to the exclusive realm of the Qing dynasty palace, The Forbidden City, he declared the foundation of the People's Republic of China to the thousands gathered beneath him in Tiananmen Square. 'The Chinese people have finally stood up!' The heroic appearance of Mao in front of the former imperial buildings asserted his power as leader and heralded a new era.

The cult of Mao had been fostered since he took charge of the Chinese Communist Party in the 1930s. It could not have reached its peak during the Cultural Revolution without visual propaganda, in which Mao was praised as the 'Four Greats' (*sige weida*), namely, the Great Teacher, the Great Leader, the Great Commander and the Great Helmsman. He was metaphorically worshiped as the Red Sun. At the climax of a subsequent performance of the song-and-dance pageant *The East is Red*, a portrait of Mao copied from a photograph taken by the American journalist Edgar Snow in 1936 was blown up to about thirty feet high. The following verses were sung:

> The east is red, rises the sun,
> China has brought forth a Mao Zedong.
> For the people's happiness he works,
> Hooah hay yah…
> He is the people's liberator.

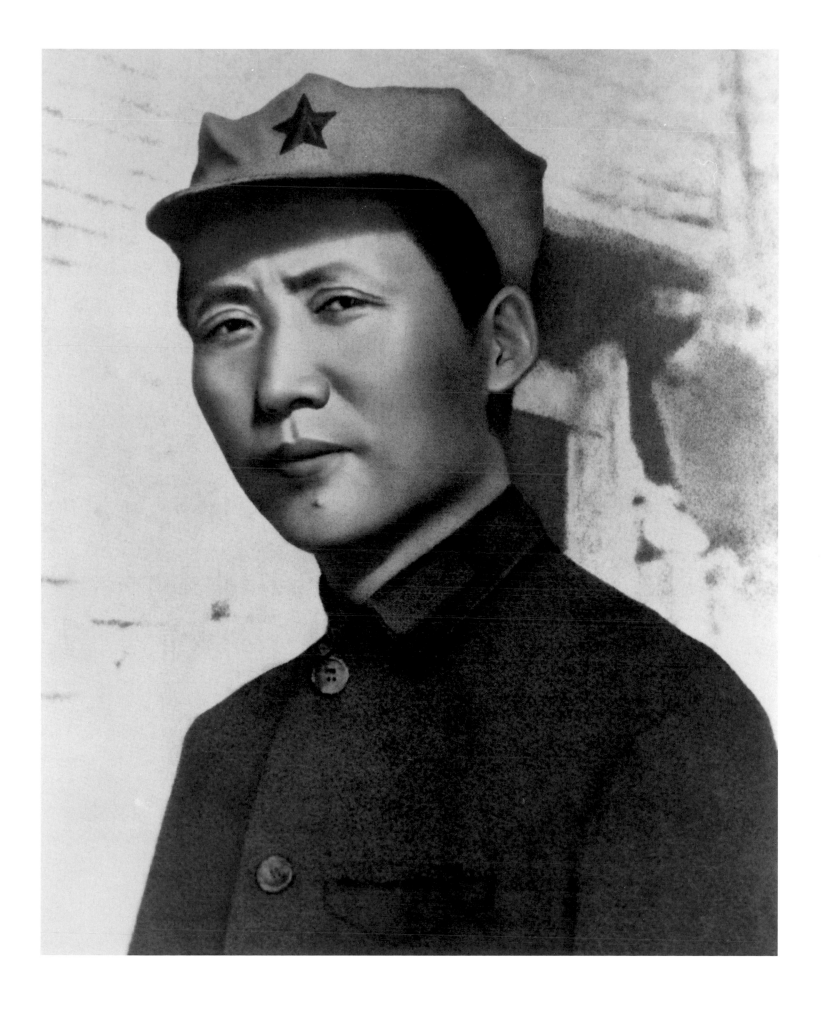

Previous page:
Edgar Snow, Mao Zedong photograph, 1936

Mao badges, 1967-1969

Opposite page:
Xiao Zhuang, Red Guards from Nanjing Junior College celebrate the success of the first nuclear missile launch, 1966

50

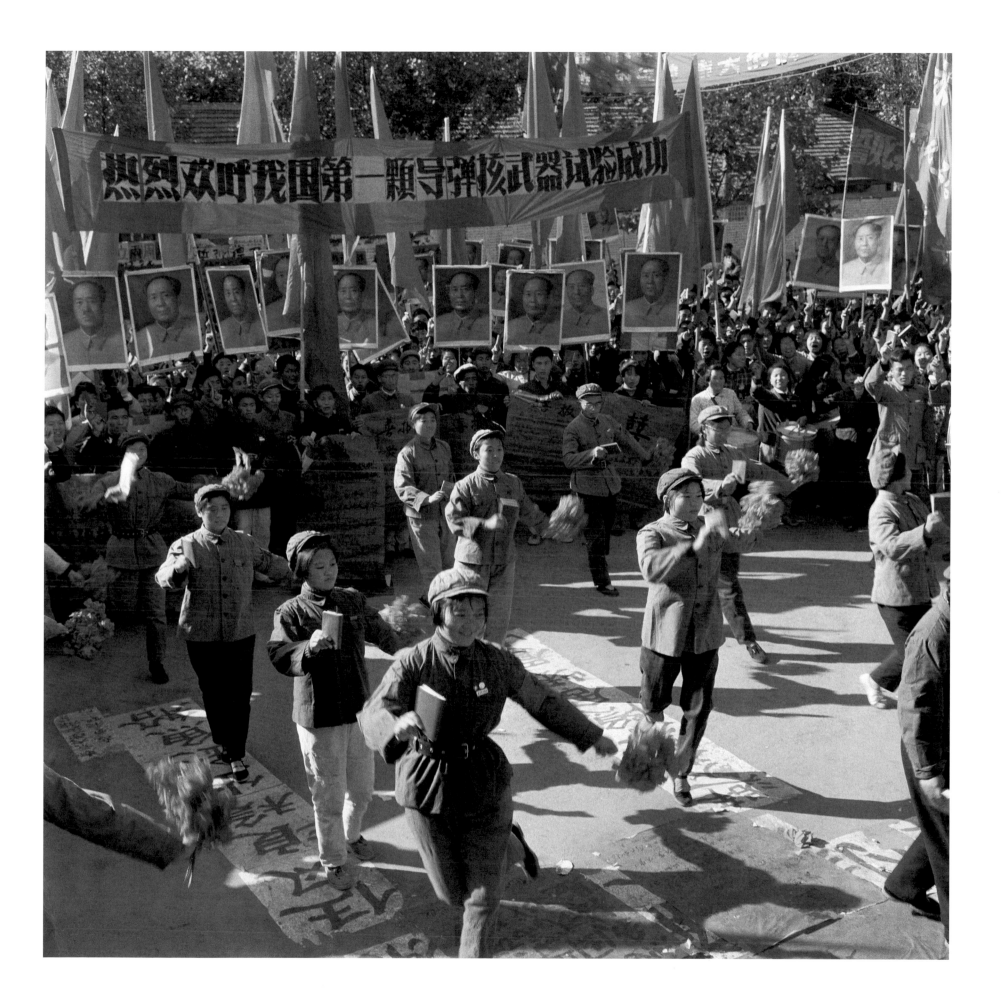

Jiang Jiehong, Tiananmen, 2000

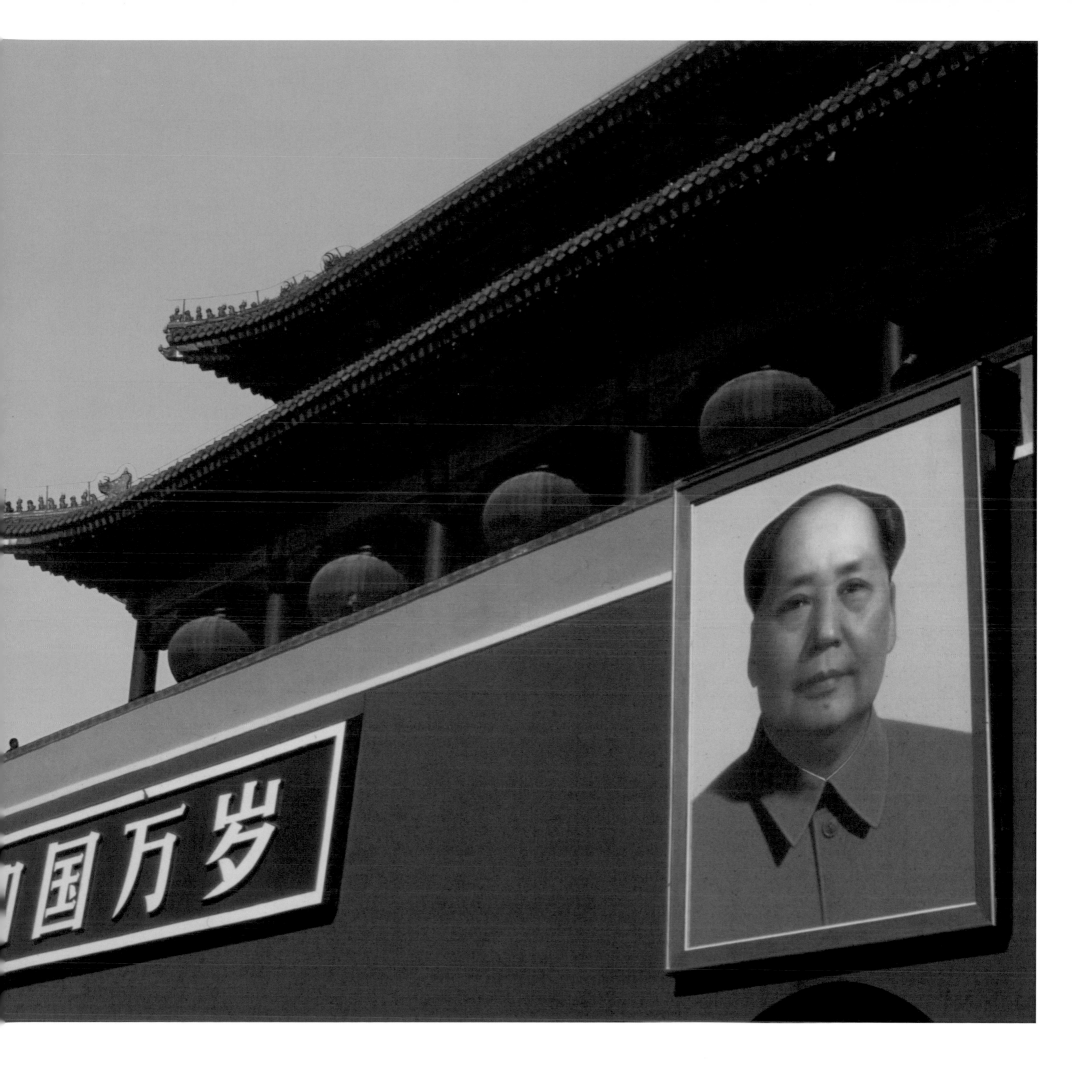

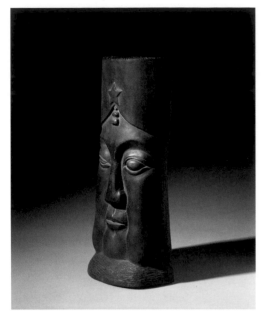

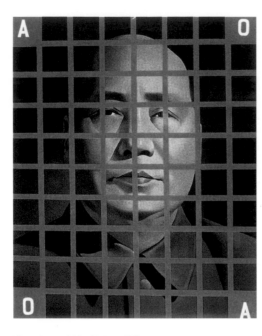

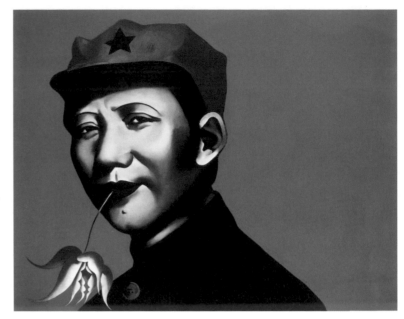

Wang Keping, *Idol*, 1978

Wang Guangyi, *Mao Zedong*, 1988

Li Shan, *Rouge Series*, 1993

Once the image of Mao had pervaded both public and private life, the leader was transformed into a new 'god' for the nation. During the Cultural Revolution 2.2 billion copies of the 'standard portrait' (*biaozhun xiang*) of the Chairman were printed. More than 2.8 billion Mao badges, or four for every man, woman and child in the nation, were manufactured. Those prints and badges appeared both in public spaces and the home. Inescapable in daily life, these icons provided people with a sense of constant access to the Chairman. His face and the dignity of his gaze remain on the Tiananmen Tower today.

Representing Mao's image critically would have been an extreme act of artistic rebellion, particularly just after the end of the leader's regime. The wood sculpture *Idol*, completed by Wang Keping in 1978, only two years after Mao's death, was a daring and pioneering work and the first gesture to challenge the sacred image. In 1979 Chinese viewers would have recognised the significance of the pentagram engraved on the forehead of a hybrid form somewhere between Mao and Buddha in the exhibition of the Star group on the street outside the National Art Gallery in Beijing. The event, it can be claimed, was the first 'unofficial' art exhibition in China.

Ten years later, in 1988, Wang Guangyi produced his monumental series of paintings, *Mao Zedong*, re-presenting the Chairman's 'standard portraits' on five large canvases. The divine images were overlaid with a thick red grid, which previously would have remained invisible. The lines were practical guides for duplicating, enlarging and so glorifying Mao. Here they served as a frame for measurement or analysis. The rationale was simple: by exposing the grid and bringing it out from beneath the surface of the picture to the forefront, the image was transformed from an object of worship to the subject of judgement.

Yu Youhan experienced the years of the Cultural Revolution while studying in Beijing at the Central Academy of Arts and Crafts (later the Academy of Art and Design, Tsinghua University). To Yu, Mao could mean everything –'a great leader of the nation, a symbol of China or the East, a book of culture or a particular period of history'. He

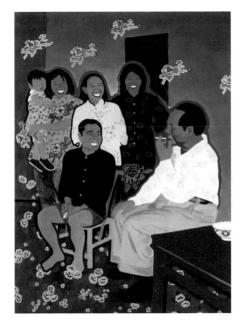

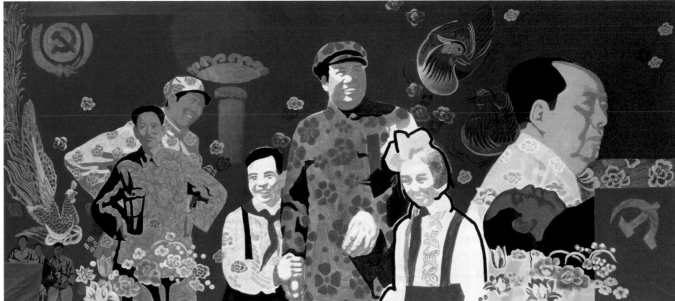

Yu Youhan, *Talking with Hunan Peasants*, 1991 Yu Youhan, *The Life of Mao*, 1989

claimed, 'sometimes Mao is avant-garde, but sometimes rather conservative.' During the period of the Red Guard, Yu painted huge images of the Chairman on a wall of more than 120 square metres opposite the Tiananmen Tower. After the 1980s, Yu restarted to paint Mao based on some official photographs, but in an entirely different way. The 1991 work *Talking with Hunan Peasants*, derived from a 1950s photograph, depicted Mao sitting comfortably with a family of cheerfully admiring peasants in his home village of Shaoshan in Hunan. *The Life of Mao* in 1989 attempted to summarise the key stages of Mao's political development through the most familiar historical moments. The colourful patterns were obviously the artist's own invention, inspired by the paper-made flowers used as spiritual rewards. The patterns were imposed on Mao and the other figures, floating everywhere in the painting to create a fabric-like composition that recalls the decorative style of folk art, whilst the flowery space represents, in Yu's words, an 'unreal and hollow environment for an ideal society'.

Since he had been a propagandist from the years of the Great Leap Forward (*dayuejin*) 1958–60 Li Shan had painted the image of Mao many times in his youth. In his series *Rouge* from 1989, he subverted the sacred image. Instead of his normal frugal appearance, Mao wears a star cap the vulgar colour of rouge and carries a flower in his seductively painted lips. Mao's gaze seemed to suggest an unknown story. When the Chairman was feminised, or in the artist's words, '*yanzhi hua*' (rouged), his divinity was demolished.

In Liu Dahong's 1991 series of *Four Seasons*, Mao's image was derived from official photographs and revolutionary paintings such as *Chairman Mao Goes to Anyuan*, Liu Chunhua's famous painting from 1968, which had been distributed across China in an edition of 900 million reproductions. The form of the series was adopted from a traditional set of scroll or screen paintings and the Chairman was depicted in the unlikely atmosphere of literati or fairy landscapes populated with a variety of legendary figures. Of all the characters in the series, Mao was the most absurd. *Continues on page 66*

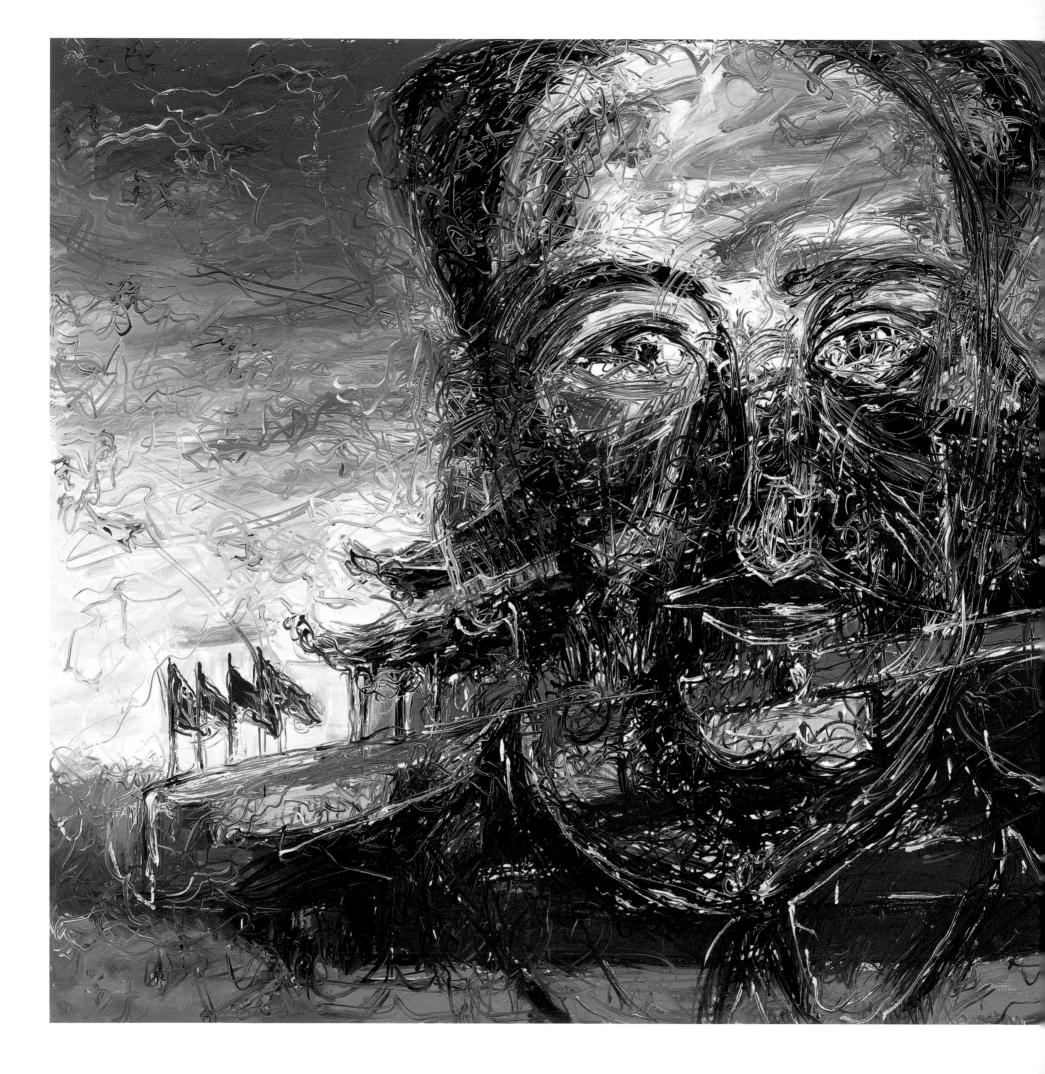

ZENG FANZHI
TIANANMEN, 2004
oil on canvas,
215 x 330cm (84 1/2 x 130in)

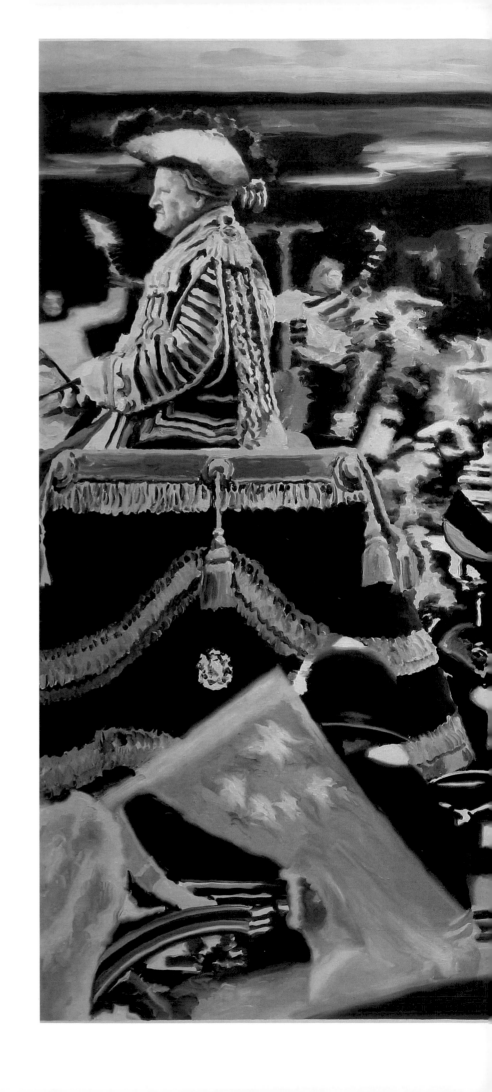

SHI XINNING
ROYAL COACH, 2006
oil on canvas,
210 x 317cm (82 1/2 x 125in)

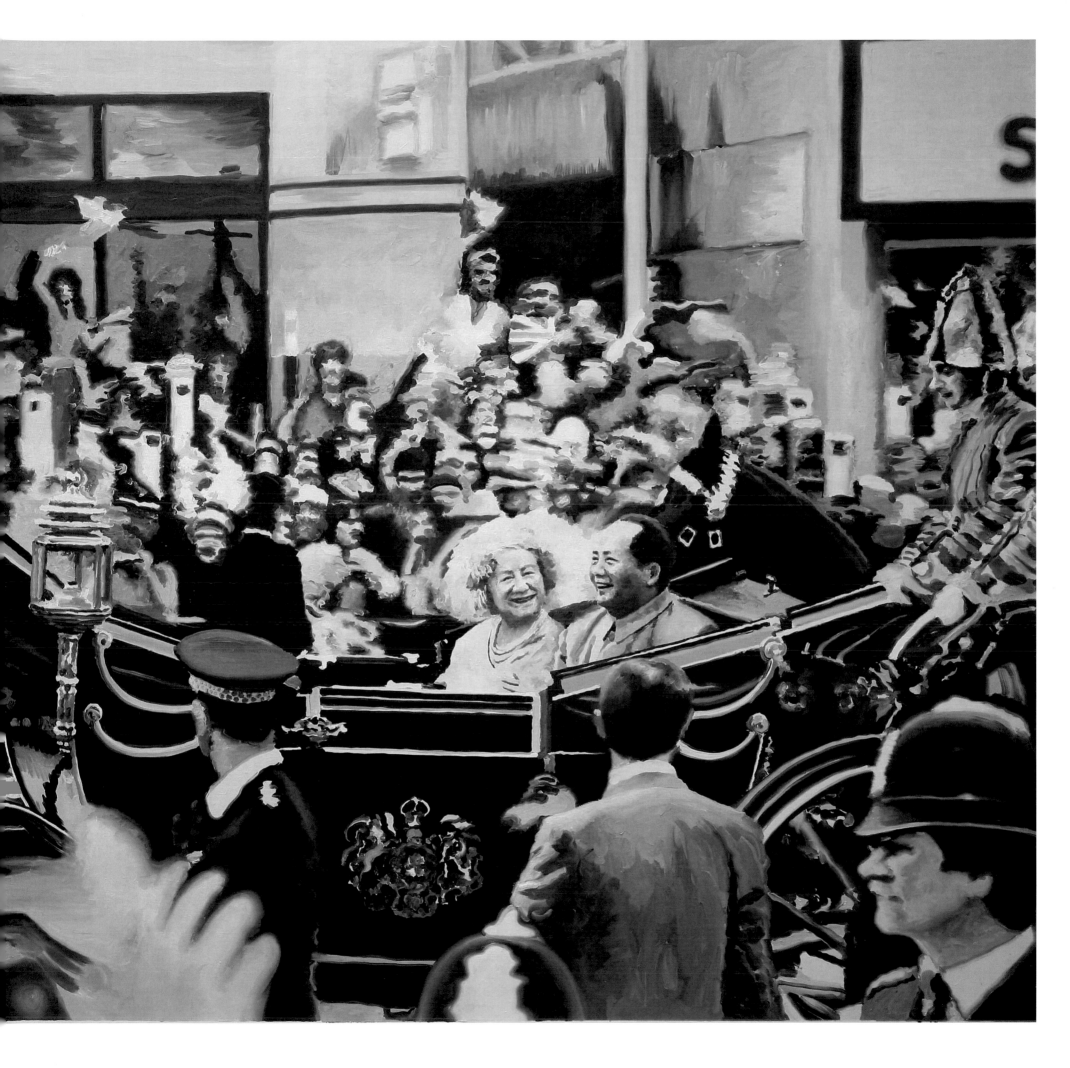

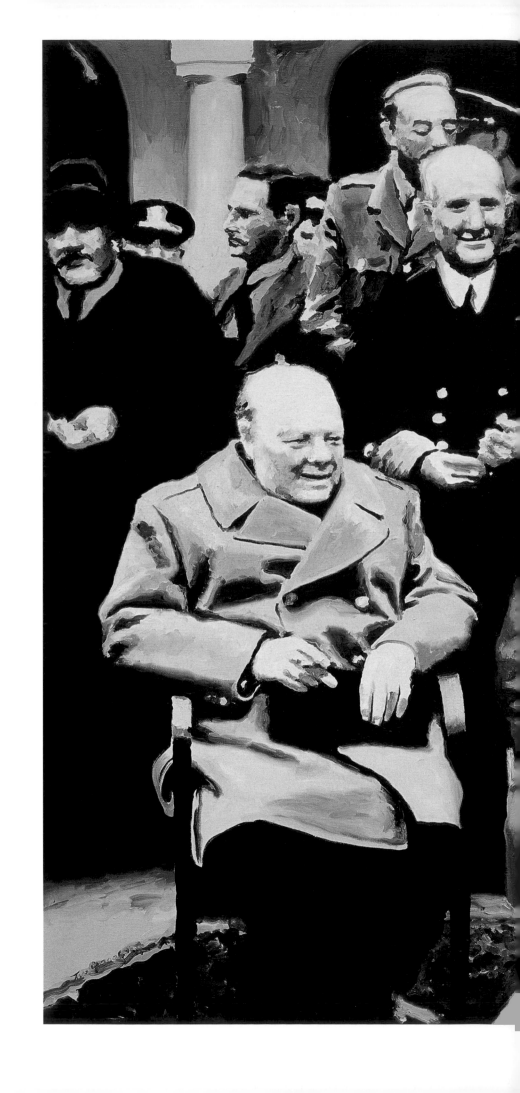

SHI XINNING
YALTA NO.2, 2006
oil on canvas,
210 x 317cm (82 1/2 x 125in)

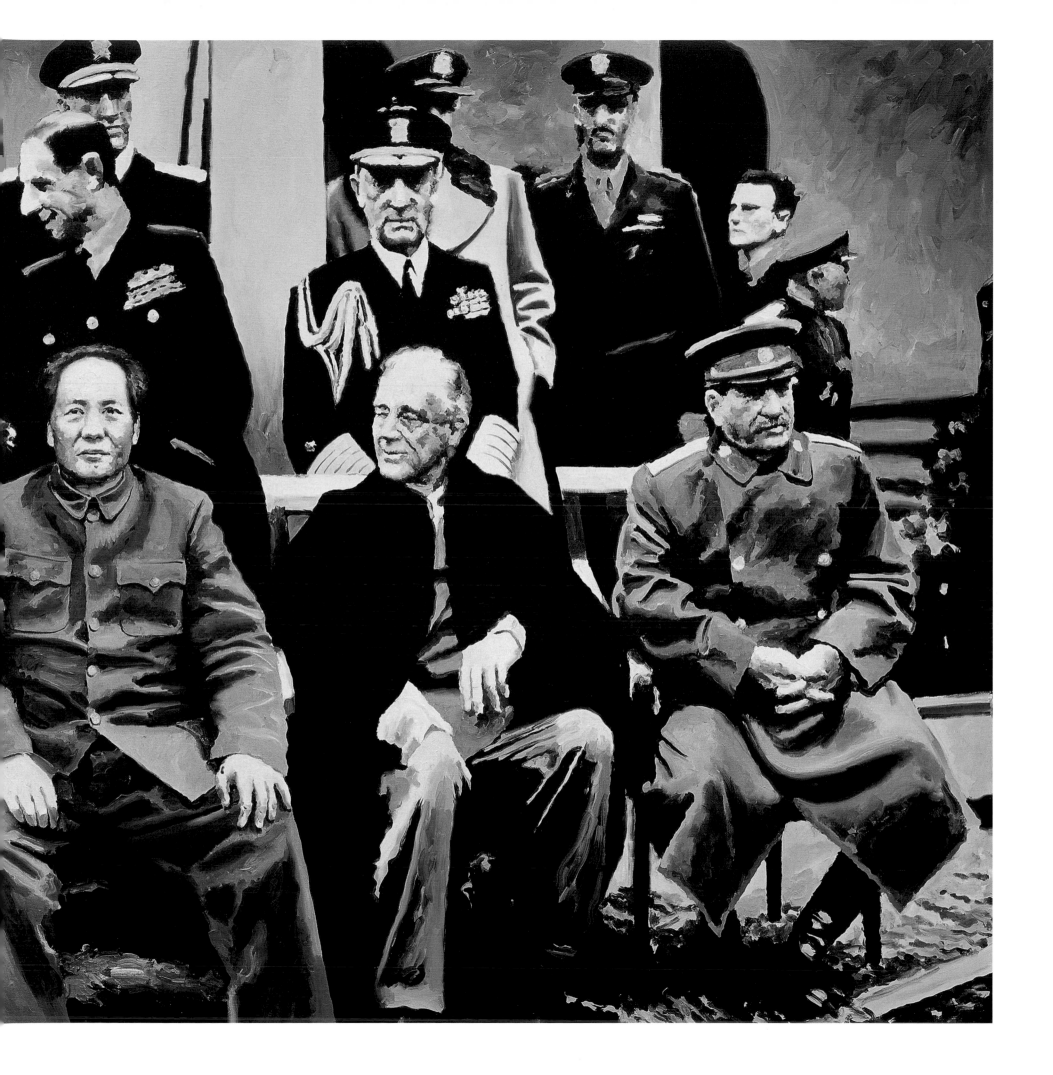

ZHANG HONGTU
LONG LIVE CHAIRMAN MAO SERIES #29, 1989
acrylic and quaker oats box,
24.4 x 12.7 x 12.7cm (9¹/² x 5 x 5in)

QIU JIE
PORTRAIT OF MAO, 2007
lead on paper,
250 x 168cm (98 1/2 x 66in)

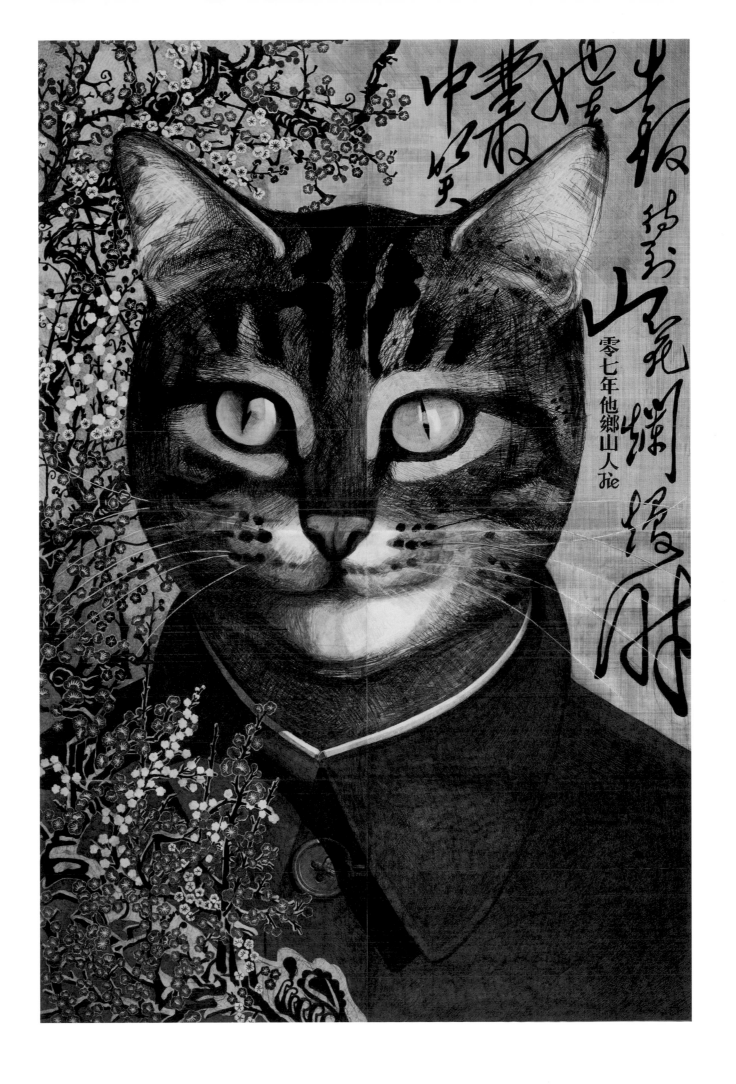

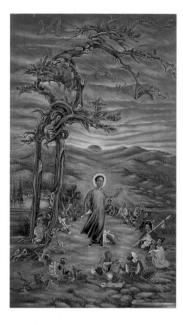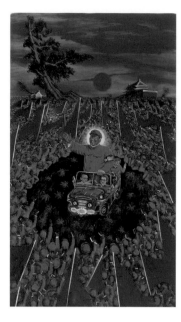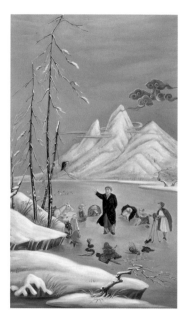

Liu Dahong, *Four Seasons: Spring, 1991* **Liu Dahong**, *Four Seasons: Summer, 1991* **Liu Dahong**, *Four Seasons: Autumn, 1991* **Liu Dahong**, *Four Seasons: Winter, 1991*

Between 1989 and 1991, the years when the '*Maore*' (Mao-craze) phenomenon, a nationwide revival of the Mao cult, was at its height, more than 73 million copies of the 'standard portrait' of Mao were produced.[7] Mao's image has never in fact disappeared from Chinese art. It has become an inextinguishable symbol. If the early works appropriating Mao suggested a tone of domestic rebellion, now the image has become a useful instrument with which to proclaim loudly in the international arena. For example, in the 2004 work *Tiananmen* (page 56), Zeng Fanzhi skilfully weaves his scribbled Mao with other iconographical imagery of the Tiananmen Tower. Shi Xinning manipulates his virtual narratives, by re-picturing key moments in the Western memory with the insertion of Mao. Rather than digitally manipulating the new composition photographically, the artist faithfully paints the narrative. At the Yalta Conference (page 60), or in the carriage of the Queen Mother (page 58), Mao finally finds his dignified place amongst the distinguished figures of the twentieth century, or indeed, inspects the Western world with confidence.

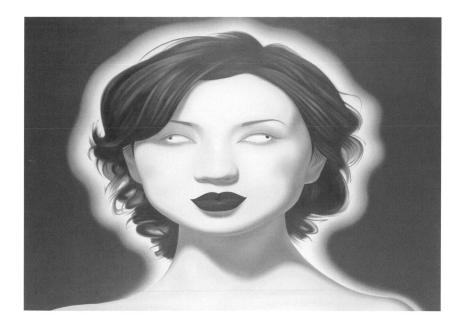

Feng Zhengjie, *China Series No.3*, 2006

When considering the different forms of idolisation in Mao's era and during the years of economic development since the 1980s, the painter Feng Zhengjie found the authority of the idol particularly suspicious. What could have been hidden behind the deceptive faces? In order to explore the 'truth', the artist produced anatomical images of the idols – Chairman Mao, soldier Lei Feng and the pop singer Cui Jian. Whatever the ideology of the idol, the process of establishing the idol was consistent. Once the old idol was gone, a replacement would always be expected. Since starting the series *China* in 2000, Feng has been concentrating on iconic beauty and making his faked idols assume an element of reality. Auras are shining in the background to glamorise the falsity, while the colours are applied in the paintings like stage lights to embellish the expressions and gestures. At the same time the viewers are entertained and their needs and desires reflected. The helplessly unfocused eyes of the idols suggest the emptiness beneath the surface (Pages 202–209).

In Buddhist temples, the artist Zhang Huan had witnessed the devoted crowd kneeling down before the silent statues and was curious about this spiritual communication. After Buddha and other religious idols were considered as the 'Olds' to be eradicated during the Cultural Revolution, inevitably Mao became the single subject of the people's worship. Today in China, the tons of incense ashes that have to be removed on a daily basis are evidence of the renewed proliferation of religion. Although the face of the idol has changed, the devotion of people remains. Incense ashes have been collected by Zhang and used to replicate two thirds of his own head on a large scale. The approach of the work proposes an essential shift – from the intangible to the concrete, from abandonment to revival and from the person praying to the blessed. The work also touches on the transformation from a man to a 'god'. The wheeled status of the *Ash Head* implies mobility and therefore the possible ubiquity of power, whilst the deficient head 'speaks' perfectly of silence (Page 68 and 71).

ZHANG HUAN
ASH HEAD, 2007
mixed media and incense ash,
228 x 227 x 244cm (89 3/4 x 89 1/4 x 96in)

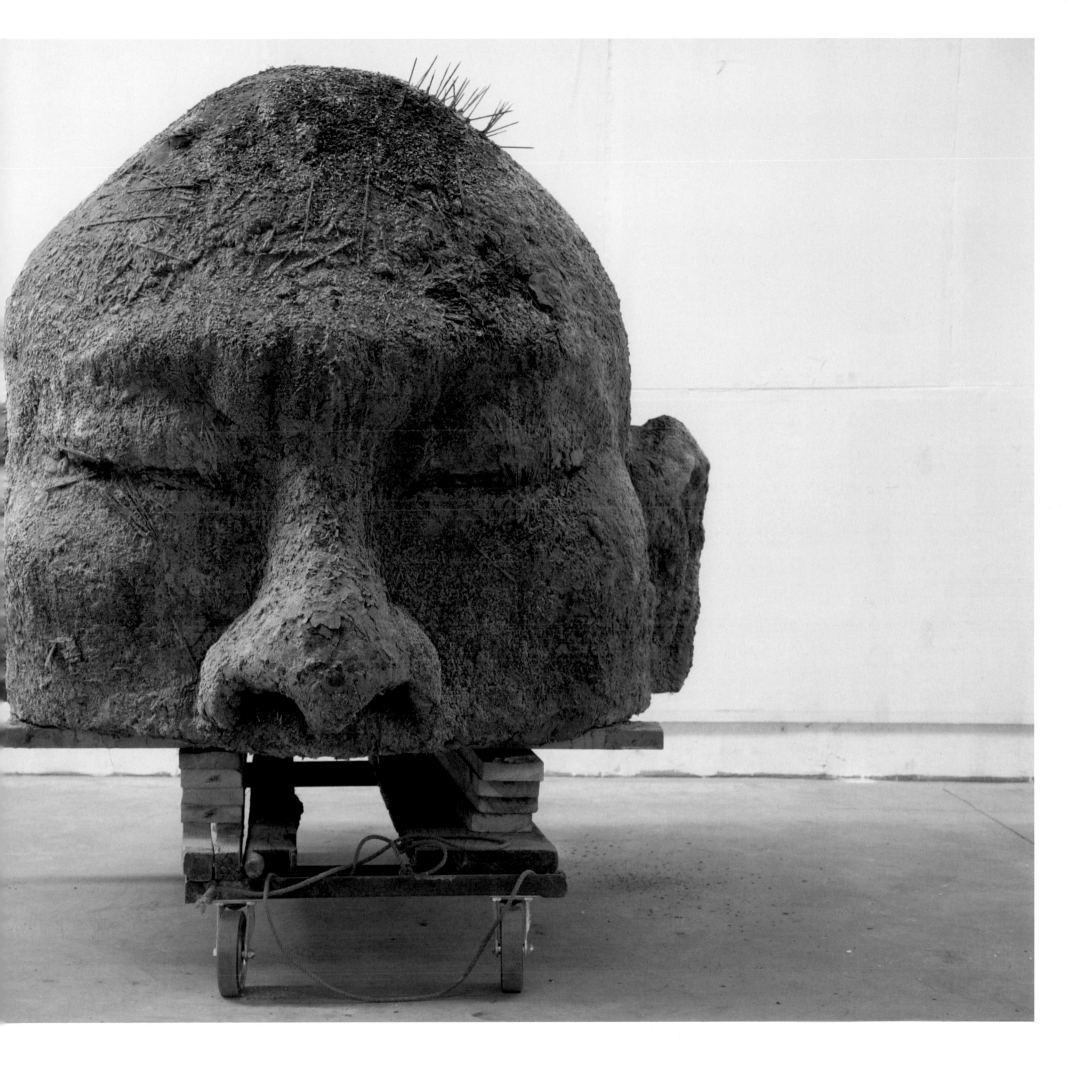

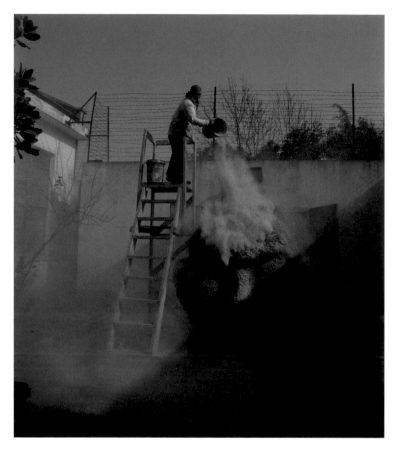

Zhang Huan, Ash Head, work in process, 2007

In the early 1990s Xiang Jing was trained in some of the best realistic techniques at the Central Academy of Fine Arts, one of the most prestigious art institutions in China, where the legacy of Soviet sculpture had been well maintained. Over a five-year study period, large-scale 'revolutionary' gestures were taught as an essential sculptural vocabulary. In order to break away from the ideology of monumental art, Xiang Jing started to look at contemporary life. She began to sculpt 'non-heroic' figures of more or less life size. By 2003 she had arrived at a turning point and moved on from a passively 'non-monumental' approach to an actively 'anti-monumental' strategy, which maximised the visual energy that she could deliver. *Your Body* (page 242) from 2005 is presented as 'only a female nude, nothing else', but it is eerily gigantic. The nudity, with its vulnerability, seems inadequate or even contradictory to the heroic size. In another 2005 work *Giantess*, an enormous goddess-like effigy sits peacefully with her unfocused gaze. Not only have the clothes, accessories and social status been removed, but so too the narratives, aesthetics and symbolism of the work. During the long process of making such huge sculptures, Xiang insists on the notion of 'the first speed' (*diyi sudu*) to generate an immediate force, a purely visual impact, in which, as she believes, 'one would have no time to evade or reflect, but only to receive the 'meaninglessness' instantly, in full, at a first glance'. In fact, the monumentalising of insignificance and the enlargement of femininity have created a challenging response to revolutionary idolism and indeed to the patriarchy of the cult figure.

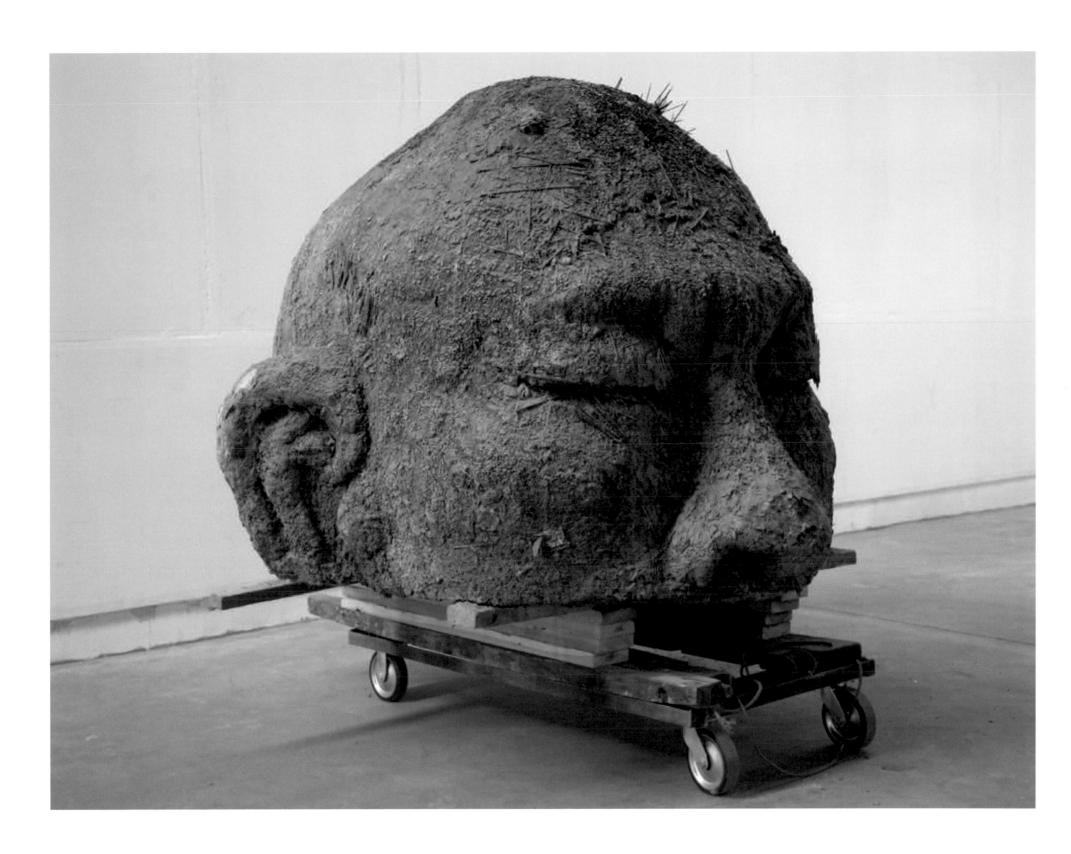

ZHANG HUAN
ASH HEAD, 2007
mixed media and incense ash,
228 x 227 x 244cm (89 3/4 x 89 1/4 x 96in)

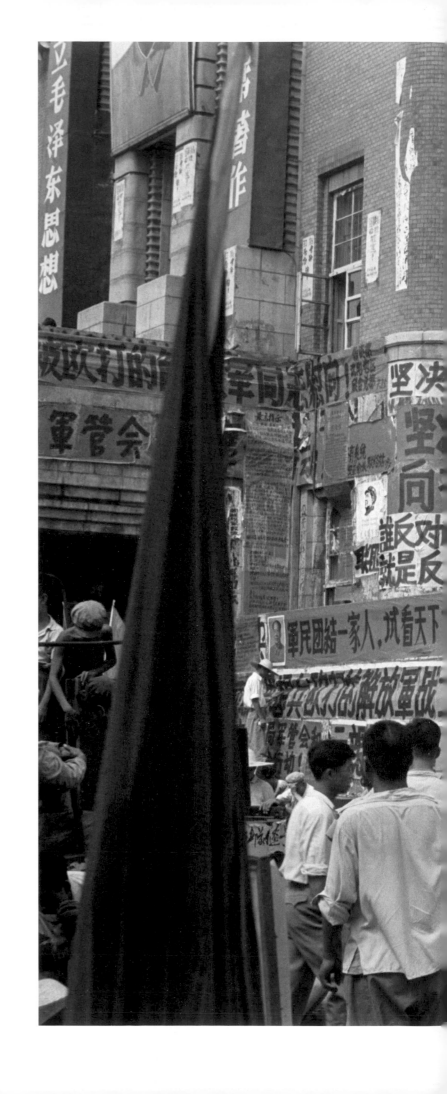

Jiang Shaowu, Big-character posters in Red Flag Square, Shenyang, 1967

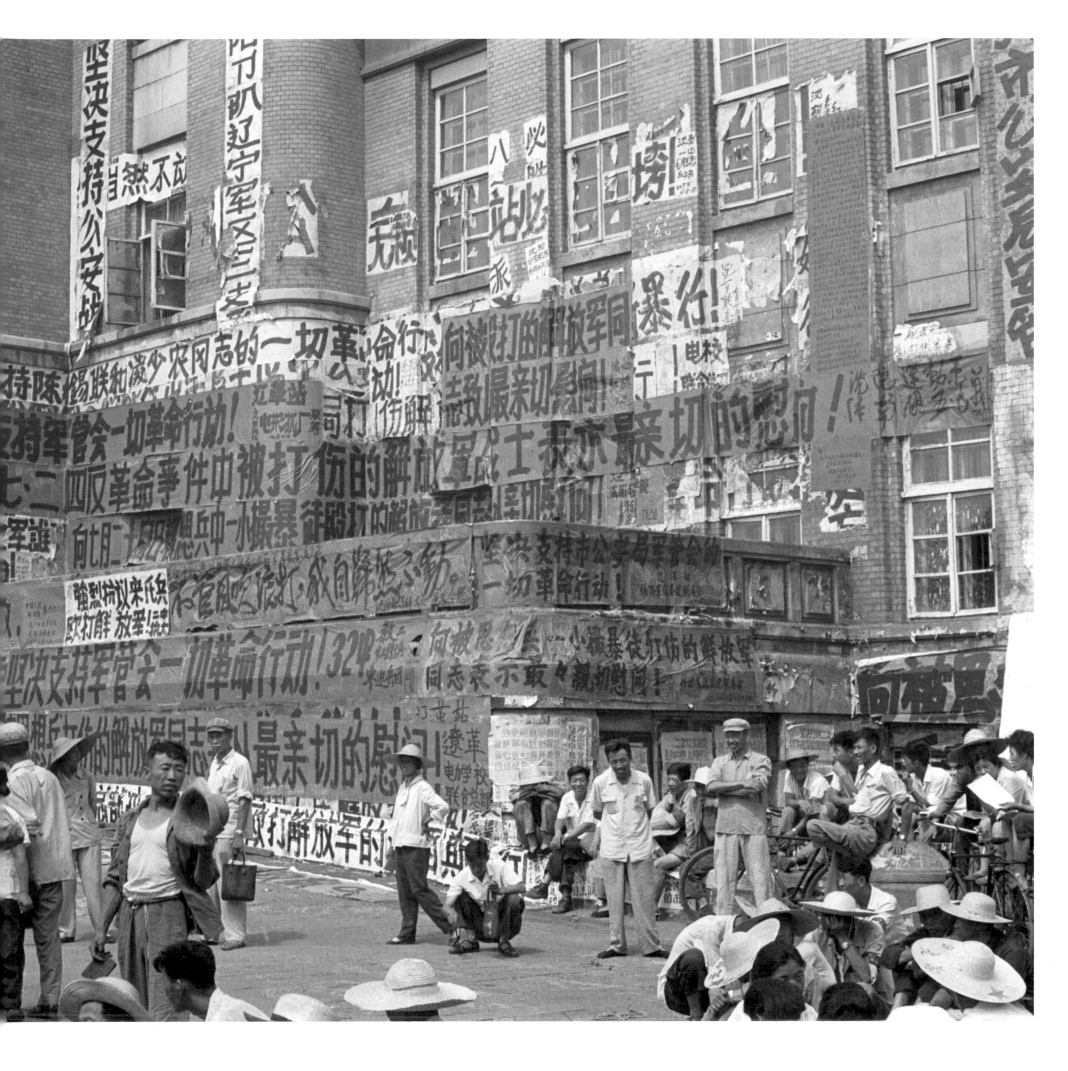

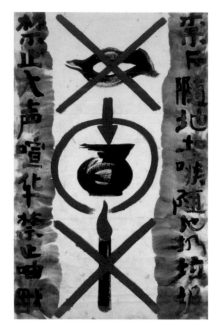

书
写

THE WRITING

Since the early twentieth century the simplification of many traditional
Chinese characters, the result of one of the government-enforced
curriculum changes, has been a controversial issue in cultural and
political circles. The aim was to reform and popularise the Chinese
language in order to prepare an educational foundation for ambitiously
cultivating a new ideology on the ground of a five thousand year old
culture. Tradition was to be disturbed, and finally it became
indefensible during Mao's unprecedented mass movement.

The first Marxist-Leninist 'big-character' poster (*dazi bao*), put
up at two in the afternoon of 25 May 1966 at Peking University,
brought the Cultural Revolution to public attention. Within just half
a day, more than one thousand 'big-character' posters appeared
spontaneously all over the campus. The 'big-character' poster was
used as a common medium in the political struggles of Mao's era, yet
it only reached its peak in the Cultural Revolution. Of various sizes,
some consisting of no more than a few sentences, others containing
massive treatises of thousands of characters, the posters declared
campaigns and offered criticism of factions and the denunciation of

individuals. When this bottom-up 'mass voice' was fully supported
by Mao, chaos followed. In Tsinghua University alone 65,000
posters appeared on the Beijing campus in June. In the propaganda
sector in Shanghai 88,000 'big-character' posters had appeared by
15 June attacking 1,390 persons by name.[8] They covered almost all
available surfaces. The daily flood of slogans, directives, invectives
and moral aphorisms created an overwhelming new visual landscape.

The portrait of Mao and the image of the worker-peasant-soldier
represented a key visual aspect of the Cultural Revolution. The images
of written text, including Mao's calligraphy alongside political slogans,
demonstrated the other obvious characteristic of the time. In both
media Mao successfully exploited mass coverage and maximised their
effects.[9] One naturally expects to read when viewing the handwriting
of Chinese texts, which were always supposed to carry literary
meaning. The artistic value of calligraphy can sometimes overpower
its content, especially in those texts written in a cursive style or those
that have survived as mere fragments of a masterpiece. However, as
the writer Wu Hung suggested, 'all traditional calligraphers conducted

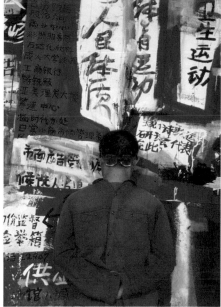

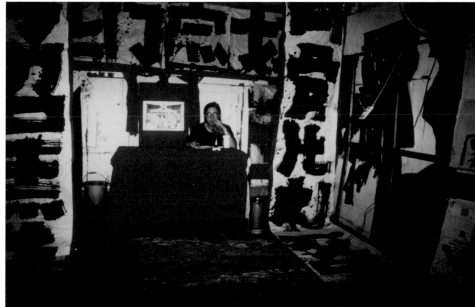

Wu Shanzhuan, Untitled, 1987

Wu Shanzhuan, Criticism Conference, 1988

this transformation in one way or another, but none of them tried to completely divorce form from content. A radical departure from this ancient tradition only occurred in contemporary Chinese art.'[10] It is curious that this divorce of text from its meaning occurred after the Cultural Revolution and one wonders what viewers actually 'saw' in the 'big-character' posters. The illegibility of the poster was a direct result of the words being mis-written, either by mistake or deliberately to insult or to denigrate opponents' names. Also, when layers of paper were being posted up, torn off and overlaid on walls, any literary content would have been diminished by the only partial appearance of the poster. The survival of the 'big-character' poster and its exhaustive coverage in public spaces during the political campaigns provided a constant visual element in daily life, which by its sheer presence became a backdrop not a legible message.

The Cultural Revolution was identified as 'a great revolution that touches people to their very souls',[11] and the writing became an instrument capable of delivering visual violence as well as political message. Given the visual power of the Chinese written character, it

is no surprise that the potential of the written word would be revisited by the avant-garde Chinese artists of the late 1980s. Wu Shanzhuan reflected that 'the Chinese character is the most significant element, in terms of its ability to shape people's thinking or to influence the national psychology.'[12] Xu Bing argued that Mao's cultural revolution infringed on the most deeply rooted element of the culture, the language, 'because the Chinese language directly influences the methods of thinking and understanding of all Chinese people. To strike at the written word is to strike at the very essence of the culture.'[13]

In 1984 the artist Gu Wenda used traditional calligraphic techniques to compose 'mis-written words' (*cuobie zi*) in his *Pseudo-characters* series, containing upside-down, reversed or wrongly written elements, in challenge to the formal elegance and status of calligraphy. In his 1987 installation, *A Game in which the Audience Serve as Chessmen on a Suspended Chessboard*, obviously inspired by the visual impact of the Cultural Revolution, large black characters with political or religious meanings, like those of the revolution

Continues on page 80

Gu Wenda, A game in which the audience serve as chessmen on a suspended chessboard, 1987

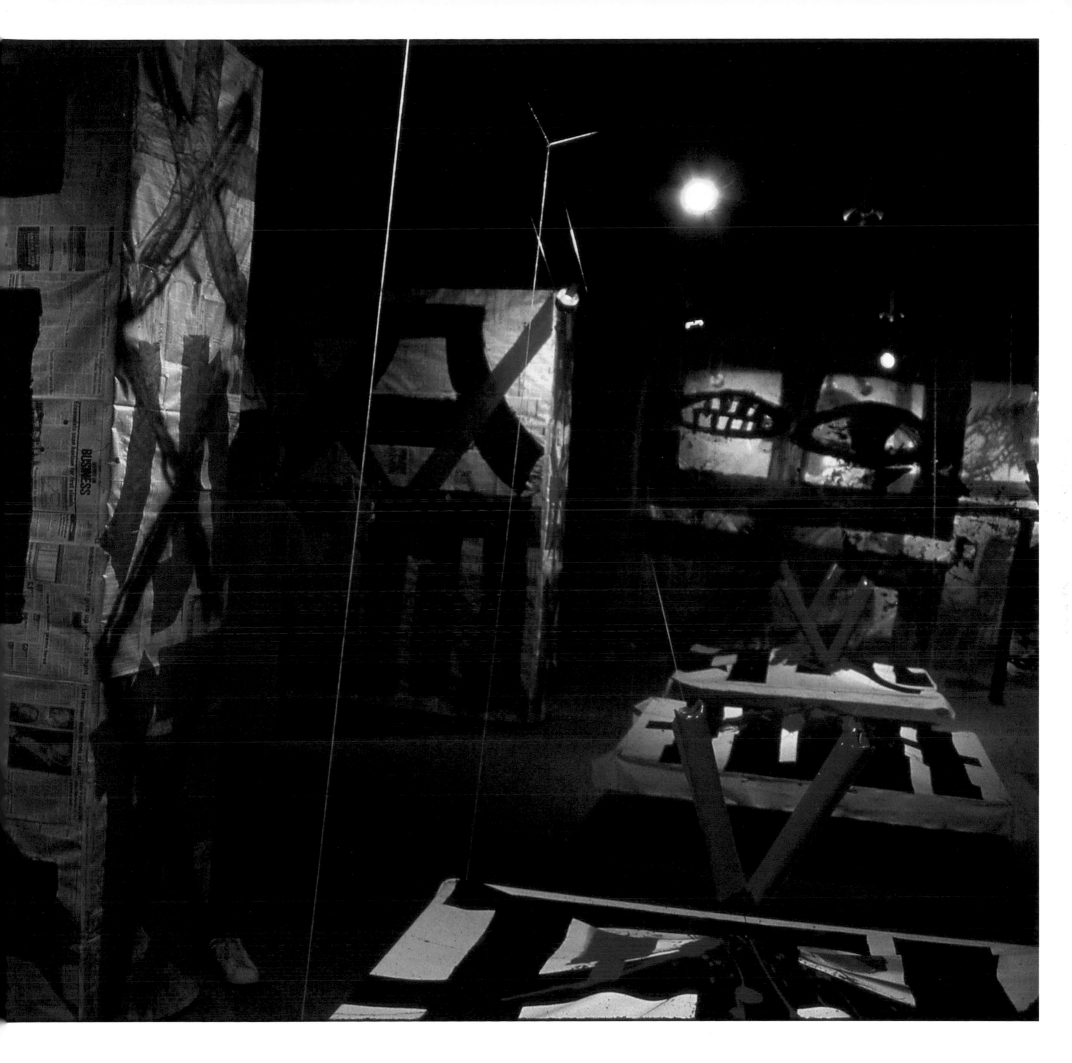

Wu Shanzhuan, *Red Humour*, 1986

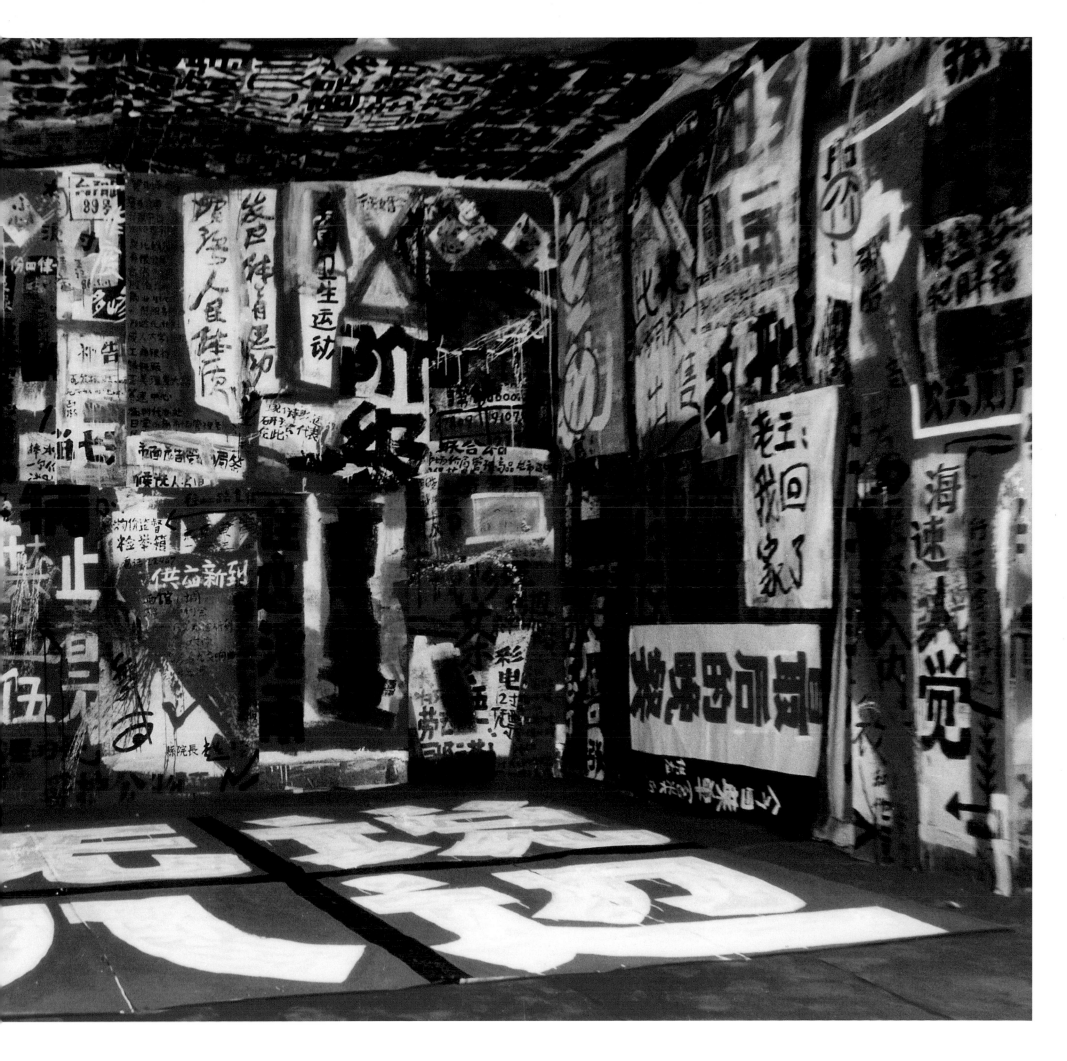

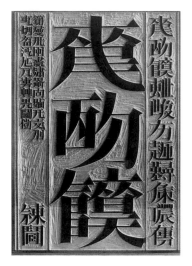

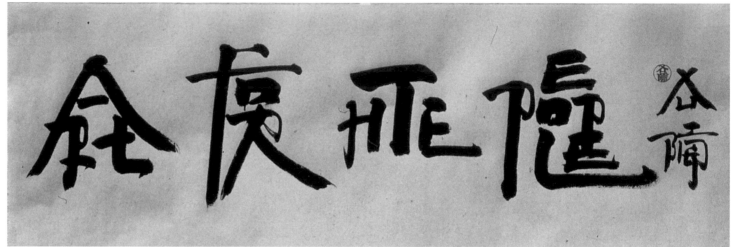

Xu Bing, Book from the Sky, 1988

Xu Bing, Square Word Calligraphy: Art for the People, 1996

(*geming*), were reversed or crossed out with red lines. The artist was in effect releasing powerful, disruptive energy to elevate his calligraphy to a monumental level. The incorrectness of the written words became a challenge to orthodox culture.[14]

Wu Shanzhuan has been described as the first artist of 'political pop art' (*zhengzhi bopu yishu*). The installation *Red Humour*, created at the artist's Zhoushan studio in 1986, presented a windowless room in which new 'big-character' posters covered everything. They contained texts on subjects as varied as political terminologies, price notices, advertisements, newspaper headlines, Buddhist doctrines, or weather forecasts, written by the artist and his visitors. The absurd combination of nonsense and terror recalled the visual violence of the Cultural Revolution and ironically deconstructed revolutionary ideology. In the same year Wu Shanzhuan also experimented with inventing fake words, which he termed 'character figures' (*zi xiang*), in an attempt to destroy completely any possibility of 'reading' and so establish the written language as an independent visual presence. In the 1988 work *Criticism Conference*, Wu sat in an interior environment surrounded by a series of large 'non-words' that superficially evoked the visual memory of earlier political struggles, yet at the same time mocked

the struggles by the very illegibility of the counterfeit slogans.

Trained as a woodcut printmaker, Xu Bing spent many years of intensive work hand-carving more than two thousand movable wooden print-types to finally accomplish his *Book from the Sky* in 1988. Just like Wu Shanzhuan's nonsensical 'character figures', the characters for the *Book from the Sky* can be understood neither by Westerners nor Chinese. The artist's exquisite workmanship became vital in the composition of a 'lie'. It seemed that the harder Xu worked on the fake writing, the more the semantic significance of the Chinese characters could be removed and the better 'meaninglessness' could be achieved. The installation consisted of hand-scrolls, books in the traditional thread-bound format and large panels masking the wall. In 1996 Xu designed a system of the *English Square Word*, which could use Western letters to resemble Chinese characters, so in effect he could recompose English words in a calligraphic format, in what he described as a more approachable learning method for foreigners. This project appears as a compromised development for cross-cultural communication. The training process of *English Square Word* not only introduces the Chinese aesthetics of brush writing, it assimilates the 'other' and presents cultural orders in an overtly international context.

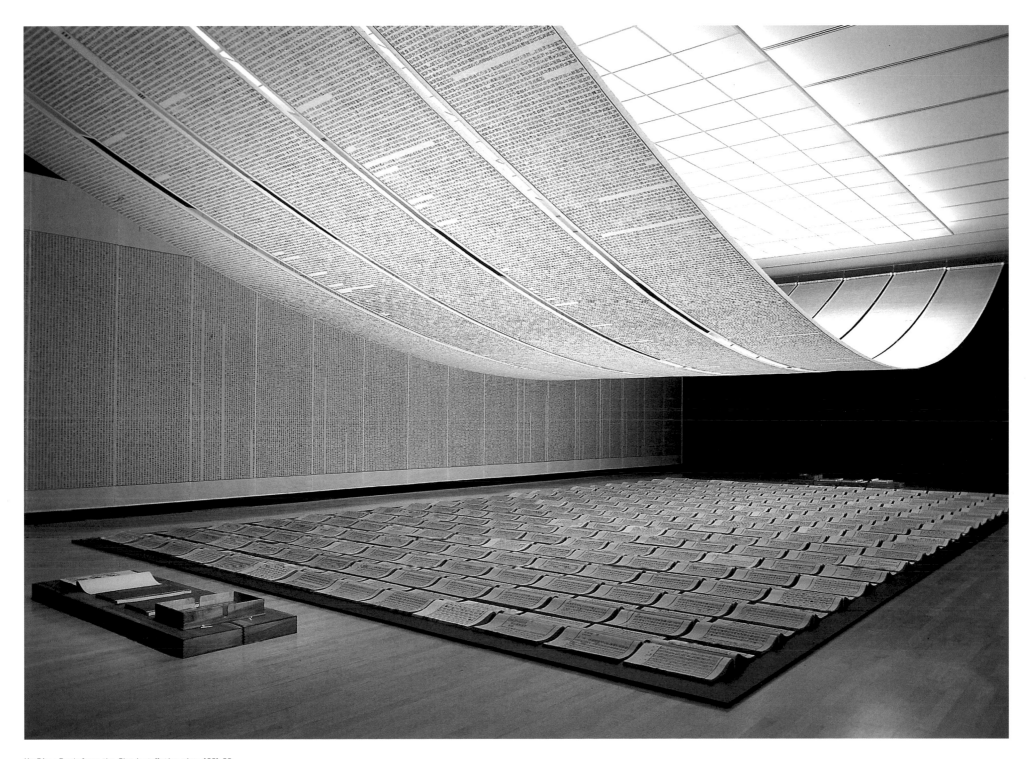

Xu Bing, Book from the Sky, installation view, 1991-92

Following page
Qiu Zhijie, Copying Orchid Pavilion Preface a Thousand Times, 1992-95

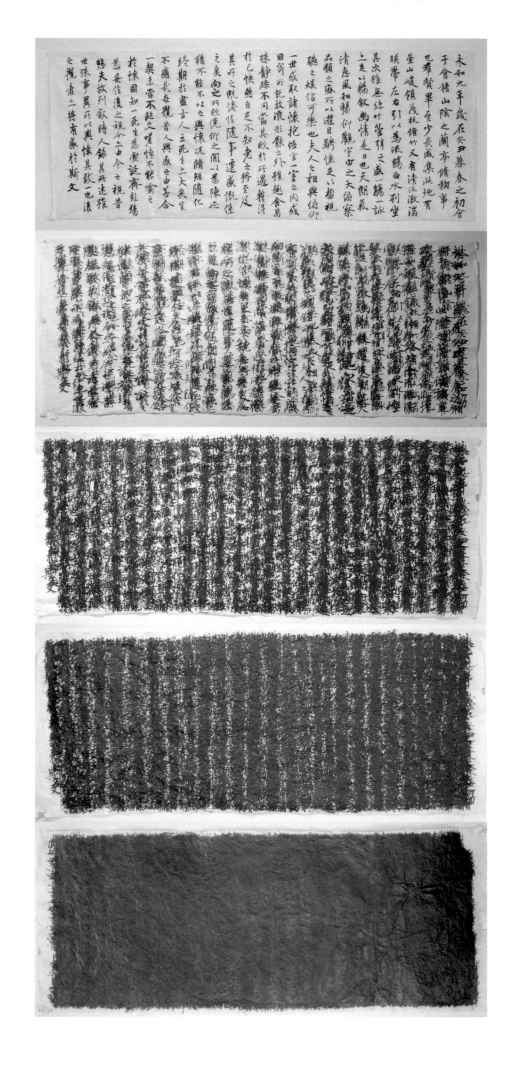

As the legacy of 'character working' carried on, Qiu Zhijie claimed to be a member of the second generation of 'character workers' (*wenzi gongzuozhe*) in the art world. In his most important early work, *Copying Orchid Pavilion Preface a Thousand Times*, Qiu spent three years (1992–95) writing Wang Xizhi's *Orchid Pavilion Preface*, the celebrated classic of Chinese calligraphy, a thousand times on the same sheet of paper, which ultimately turned pitch black. In his 1997 work *Tattoo 1*, a large character *bu* (no) was written in bright red across the artist's body and the wall behind him. Wu Hung recorded that 'they create the illusion that his body has strangely disappeared, and the character has become independent, detached from the body and the wall. In other words, this character rejects the ground and makes the person invisible.'[15] The artist later commented that 'it was perhaps not the wit of manipulating illusive disappearance or "invisibility", but simply a Chinese face together with a Chinese character that won the international acclaim.' The combination would remind us of the visual power of Chinese characters in the political propaganda. The visual violence is further emphasised by the arbitrariness of the strokes and the penitent human body.

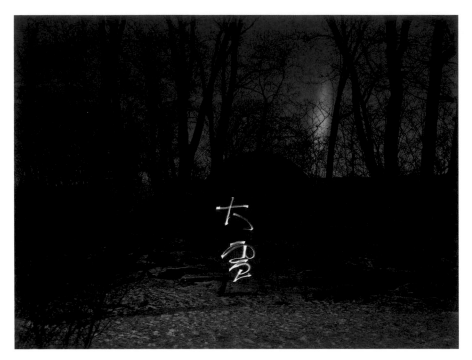

Qiu Zhijie, *Light Calligraphy: Heavy Snow*, 2005

Qiu Zhijie, *Light Calligraphy: Grand Cold Day*, 2005

In the ongoing project *Light Calligraphy*, begun in 2005, Qiu has created a new medium for Chinese calligraphy, 'light in the air', which allows him to 'write' without ink and brush but with an electric torch. A trace of light based on calligraphic movement can be photographically recorded by extending the time of exposure. 'When the shutter opens,' the artist notes, 'light could then travel in a space... and become a character, a sentence or an epigraph carrying literary meaning that interacts with the scene. *Light Calligraphy* can sometimes be descriptive, sometimes irrelevant but poetic, and sometimes it can stand for memorising the past or predicting the future.'[16] The work brings us back to the legacy of literati landscape paintings with their written inscriptions and literary approach to the visualisation of an earthly paradise. But here Qiu has reached a wider range of possibilities for envisaging, reassessing and criticising 'reality' through his new calligraphy.

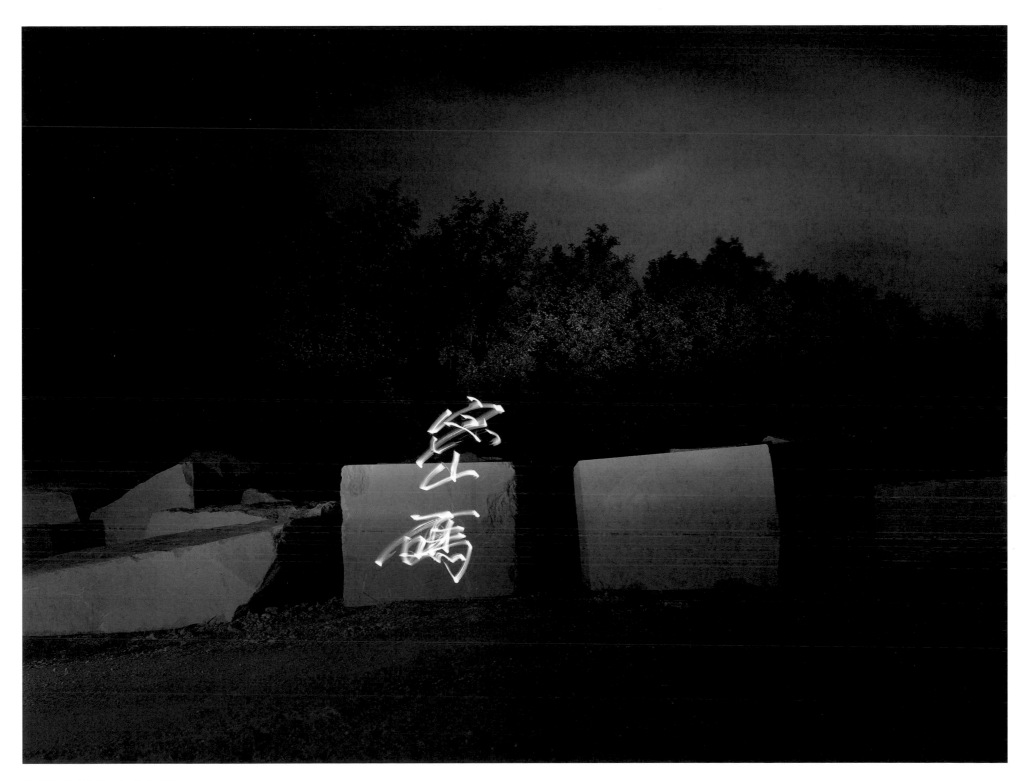

Qiu Zhijie, Light Calligraphy: Code, 2005

集体

THE COLLECTIVE

The word 'collective' (*jiti*) can be read literally as 'grouped (*ji*) individuals (*ti*)', or read ideologically by being extended with a suffix, as 'collectivism'. 'Collectivism' has been defined as 'the thought of selflessness towards the collective interests of the proletarian world outlook ... the nucleus of communist morality that was formed by the proletariat during the production and class struggles, the absolute opposite to capitalist individualism.'[17] The concept of the collective was developed as a primary belief in the People's Republic as a means for people to learn, understand and share their lives.

In China, since the advent of the People's Republic in 1949, mass assemblies have become a familiar and prominent phenomenon of political movements. Sociological and political interpretations of the notion of 'collectiveness' in China sometimes refer to this phenomenon as a 'family' movement. Other interpretations refer to the collective as a 'criterion' of daily life constructed as an idealistic identity for the people. The ideology of collective life is not necessarily entirely distinct from any individualism, but it represents a kind of conformity with which the individual can be recognised and valued with legitimate status. The visual environment of the cult of Mao did not create a solely solemn atmosphere. Paradoxically it presented liveliness and boisterousness consistent with traditional Chinese celebrations. It provided carnivals of nationalistic excitement that represented a liberation from, and transformation of, conformity. Yet the atmosphere was framed within the confines of that conformity.

After three years in a studio taking identity photos (*zhengjian zhao*), Bai Yiluo began to concentrate on the individuals of the 'collective'. Though his subjects – workers, peasants, soldiers, students and intellectuals – came from different backgrounds, they all conformed consciously or unconsciously to an unspoken rule and presented an image of an 'ordinary' individual before the camera. In his 2001 project *People*, Bai sewed his collection of some 3,600 ID photographs together with red silk thread to form a 15-square-metre sheet of portraits. Though no longer recognisable as individual, the subjects were dignified and made heroic within the new collective. The sepia-toned photographic scrolls *Family Register* by Shao Yinong and Mu Chen appeared in 2000 and show their family members all dressed in the jackets of Mao suits (*Zhongshan suits*) paired with their choice of lower garment. They present the literal embarrassment

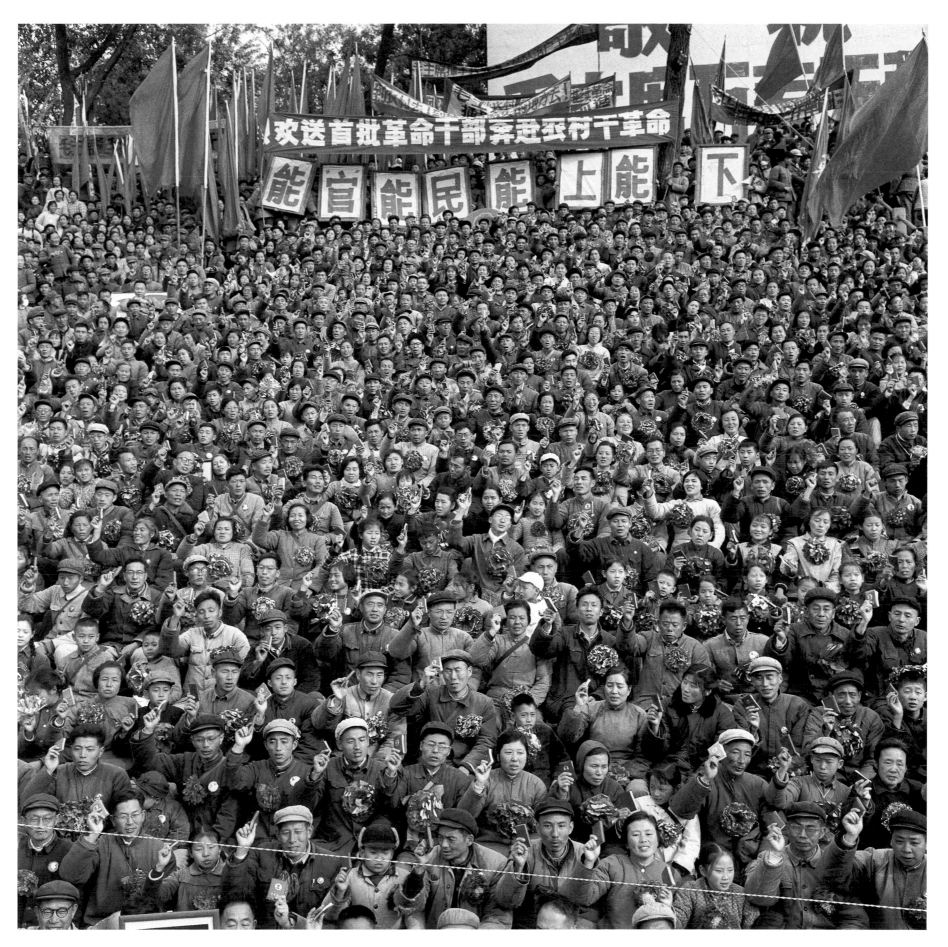

Xiao Zhuang, A party to celebrate the departure of educated youth to the countryside to work and live, Nanjing, 1969

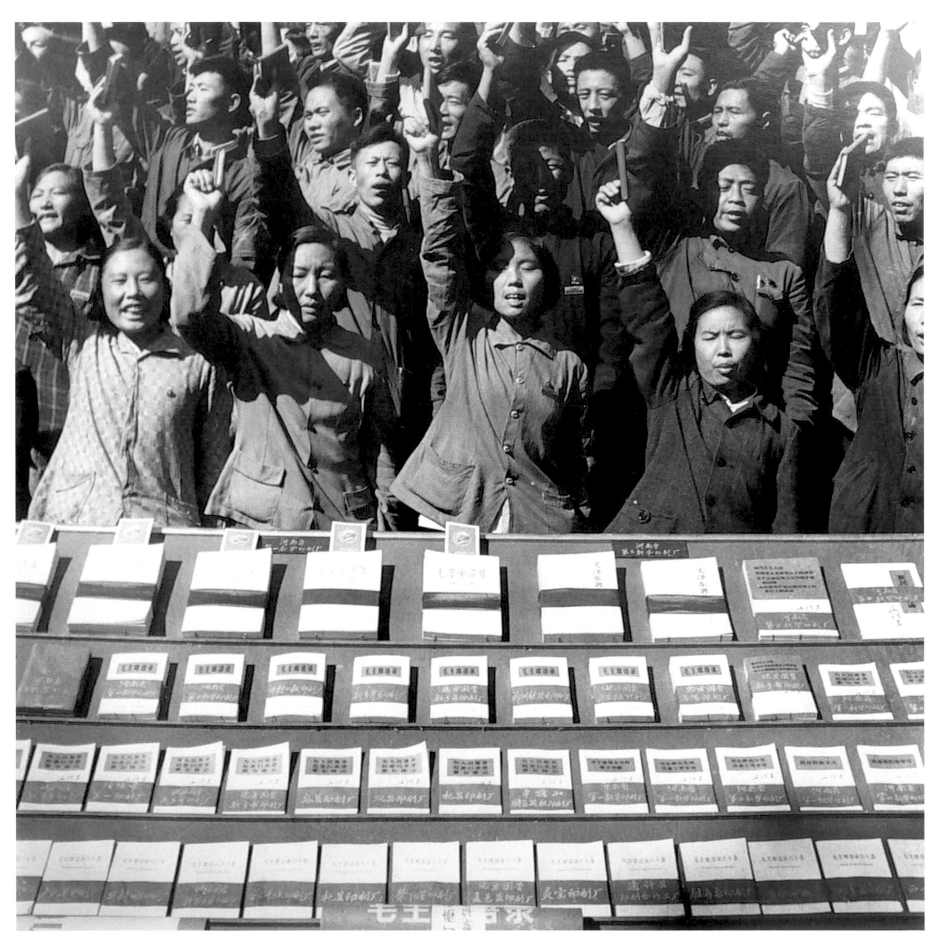

Wang Shilong, Publication of the fifth volume of the book of quotations of Chairman Mao, 1972

of the conflict between the appearance of past conformity and an appearance driven by today's new market economy. The variety of contemporary individuality below is instantly deadened by the imposition of revolutionary uniformity above.

During Mao's era the concept of 'family', deeply rooted in the Chinese culture, was transposed to a more intimate version of the 'collective'. Family photos, a private medium, would be taken according to a formula that satisfied an official sense of public aesthetics, so presenting an idealistic social model. Zhang Xiaogang reinterpreted old family photographs from the Cultural Revolution into his series of paintings *Big Family* (page 92), which first appeared in 1993. Rather than rendering any individual characteristics, the artist depicted a mono-appearance. Some unexpected red lines threading through the images connect the nameless and expressionless subjects, who are defined entirely by the force of collectivisation. The pair of portraits in his 2005 series *Comrade* (page 236) likewise fail to reveal any particularity at all, but offer, instead, the 'collective identity'.[18] Signature splotches of colour fall on the faces like the effects of theatre lights or like reminiscent birthmarks. They are all that remain of individuals after identities have been swept away in the revolutionary fervour of a generation, and they make explicit Zhang's reflection on the continuous 'conflict between the notions of *simi hua* (private) and *gonggong hua* (public)'.

Li Songsong has re-shaped historical images of official assemblies and public groups. The source pictures have been found in archives, in old publications and on the Internet. Li's early work *The Square* (2001) depicts, with tear-like brush strokes, thousands of mourners standing in Tiananmen in September 1976 after the death of Mao. In order to 'flatten the spatial depth and fracture the pictorial coherence', the artist began to divide his paintings into square and rectangular patches. *The Decameron* (page 94) (2004), the title lifted from Boccaccio, showing the National People's Congress held in the Great Hall of the People, was painted in ten separate sections. This method enabled Li to consider the content of each section separately. Some parts were even painted upside down. His thick layers of paint literally bury national memories or, indeed, re-shape the visual power of the collective. *Continues on page 100*

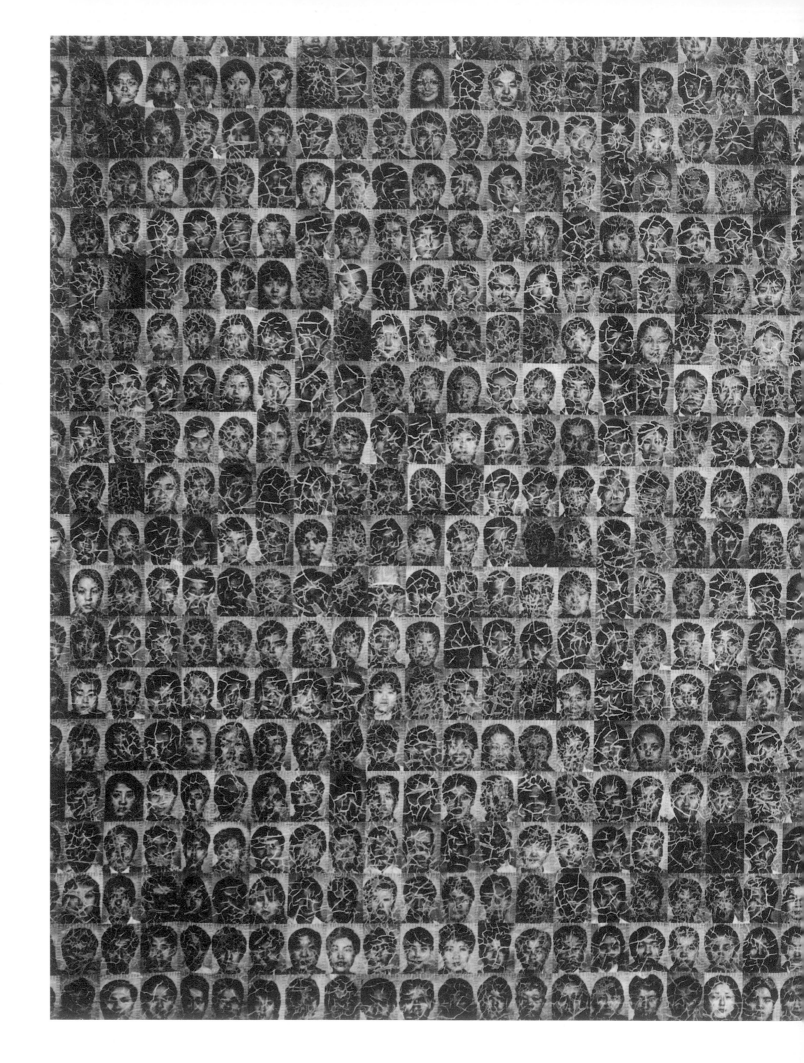

Bai Yiluo, People, photographic installation, 2001

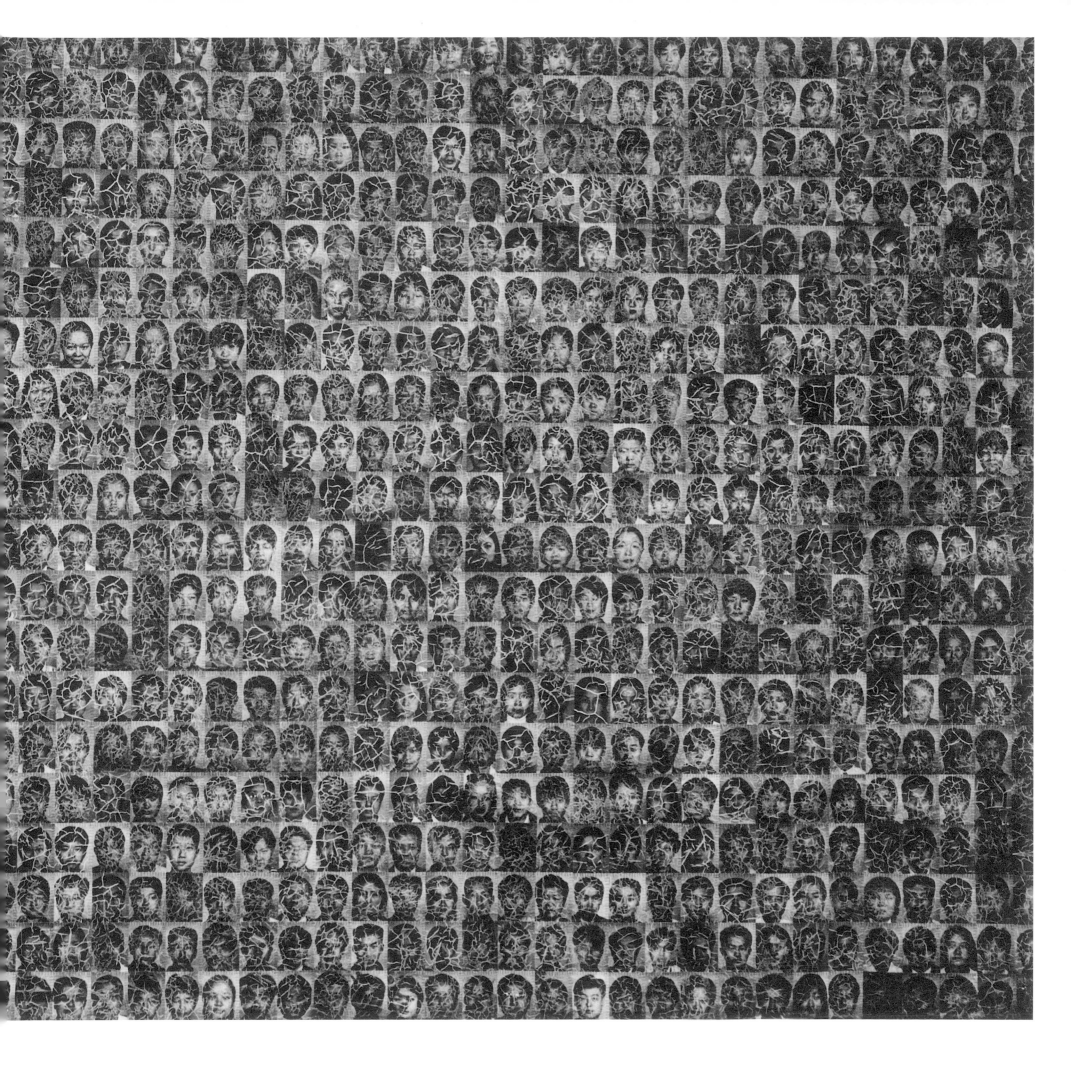

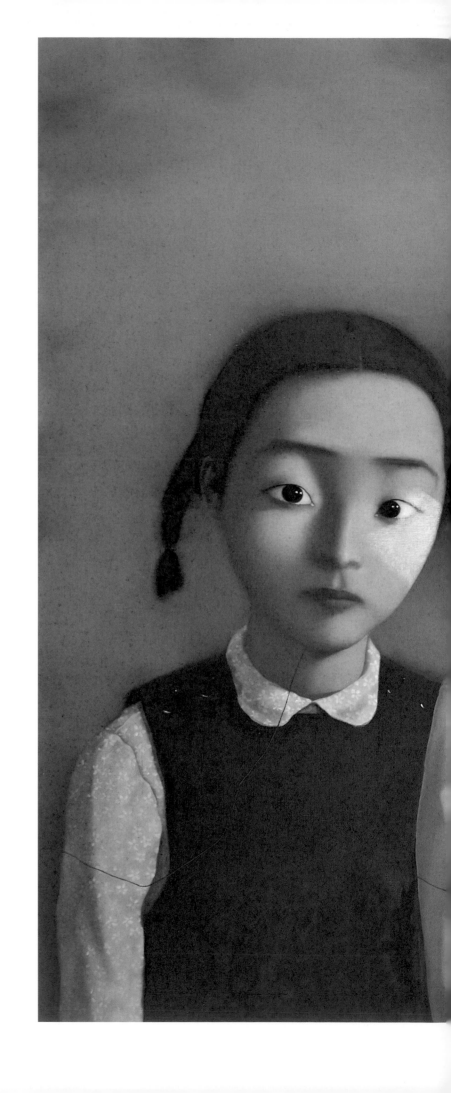

ZHANG XIAOGANG
BIG FAMILY, 1995
oil on canvas,
179 x 229cm (70 1/2 x 90in)

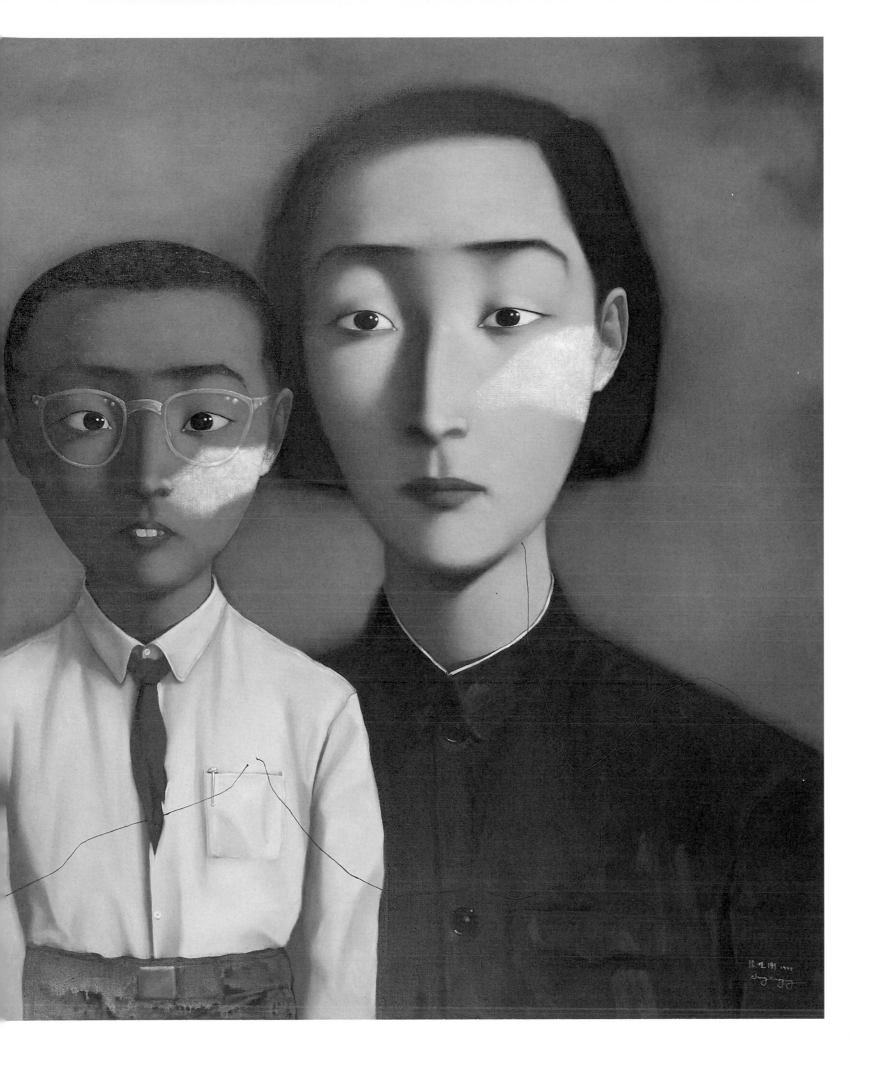

LI SONGSONG
THE DECAMERON, 2004
oil on canvas,
170 x 210cm (67 x 82 1/2 in)

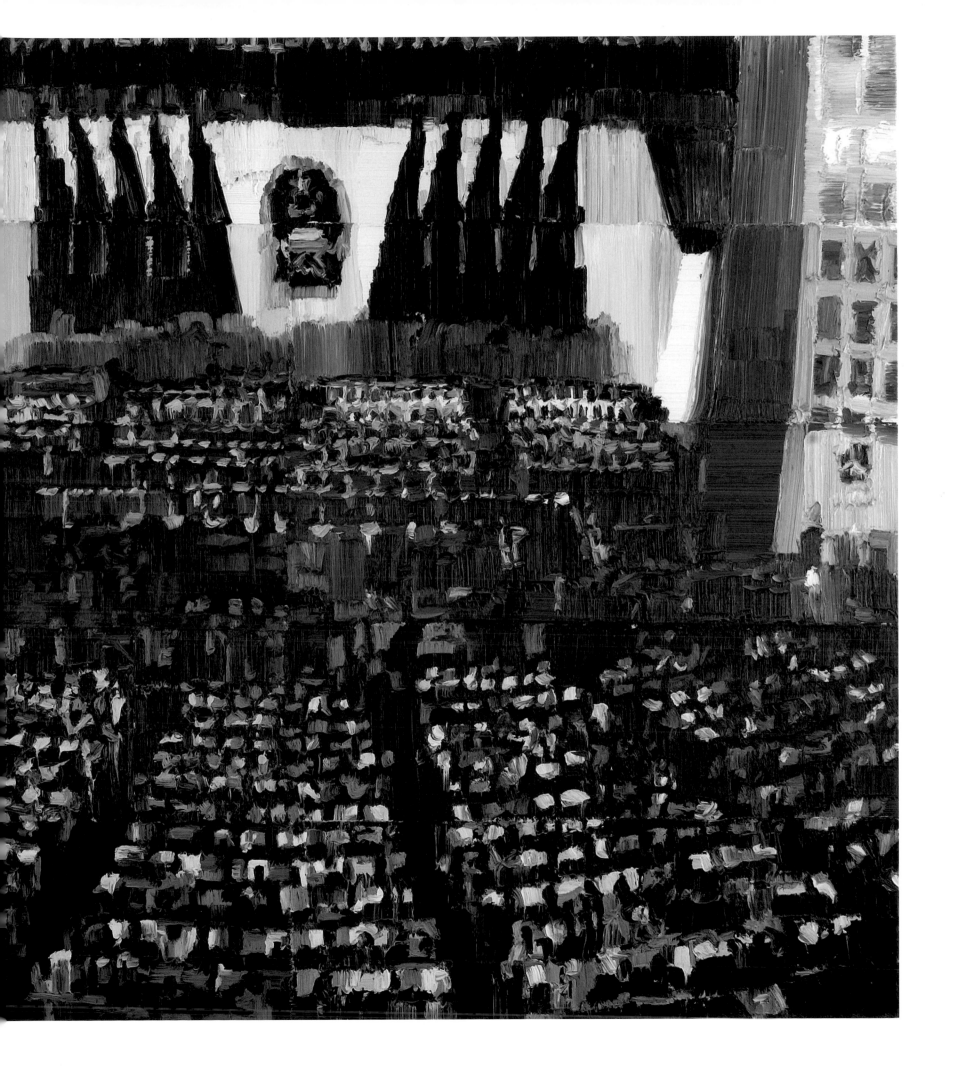

LI SONGSONG
WE DO TALK ABOUT POLITICS LIKE THIS, 2007
oil on canvas,
260 x 470cm (102 1/2 x 106 1/4 in)

YUE MINJUN
UNTITLED, 2005
oil on canvas,
220 x 200cm (86 3/4 x 78 3/4 in)

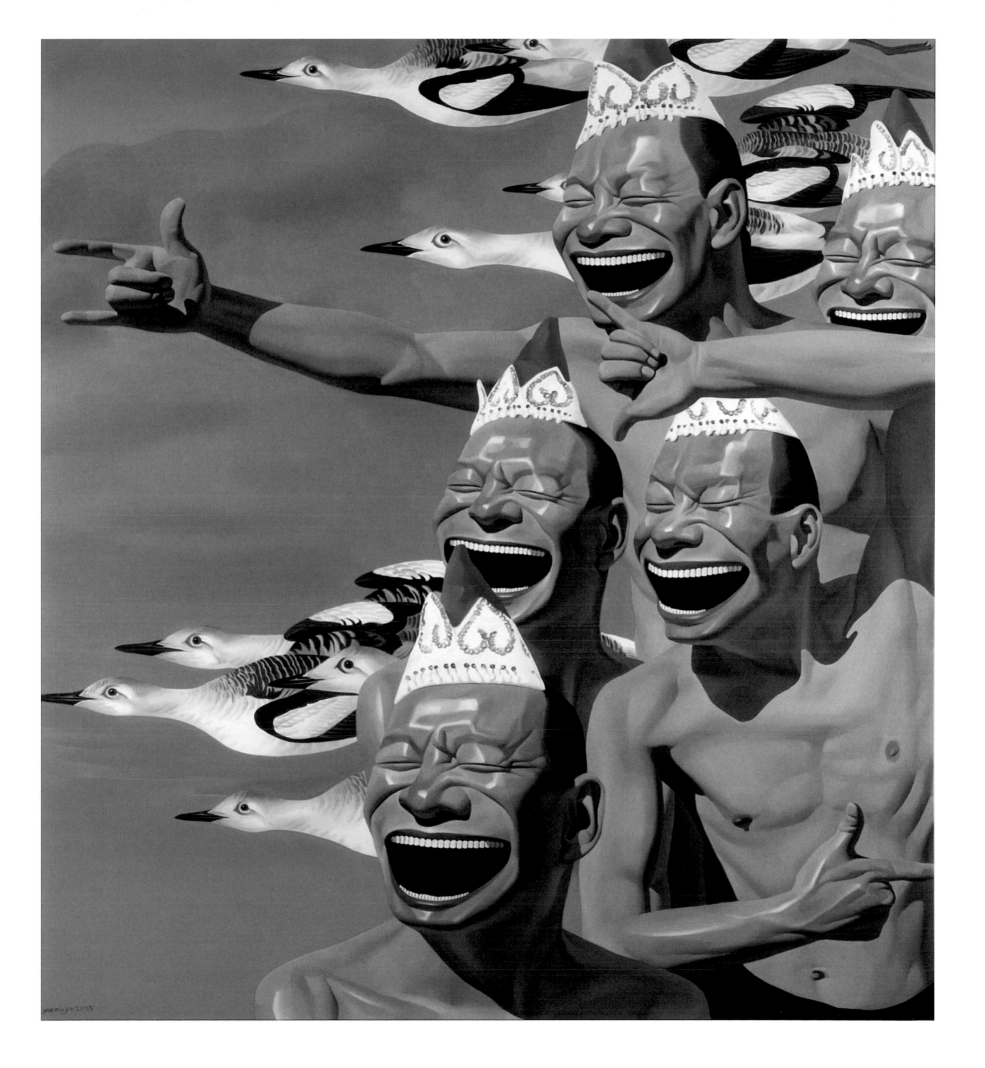

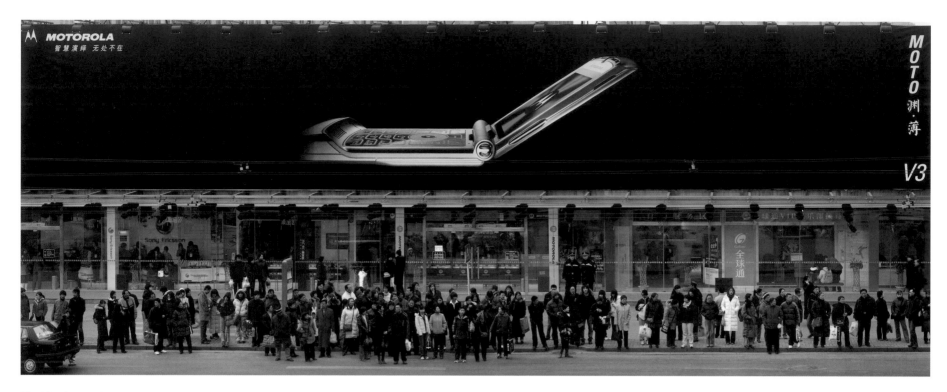

Miao Xiaochun, Await, 2002

Opposite page
Miao Xiaochun, Rise, 2006

Yue Minjun has introduced his own image into his work since 1993. By duplicating his image he has made the ultimate personal collective, a crowd of 'me'. For example, in *I am Chinese* from 2000, his many selves are presented as a parade of hysterical bodies. They look light-hearted and humorous, but in fact the work questions fanaticism. By constantly cloning his self-image, he elevates the power of the individual to the heightened power of the collective. In Yue's 1999 work *Contemporary Terracotta Warriors*, a cohort of replicas with glowing and intimidating faces embody the historical energies of the imperial army of the Qin dynasty and the mass movements of the Maoist years. In 2005 works such as *Between Men and Beasts* and *Backyard Garden* (page 246) the artist's cynical guffaw is his personal response to the absurdity of the endless assemblies of the past. The frantic laughter from the 'self-collective' sounds cheery, but a sinister terror lurks behind the manic grin (page 98).

In 2006 Miao Xiaochun created a radical kind of 'collective' by substituting some four hundred figures from Michelangelo's *The Last Judgment* from the Sistine Chapel and manipulating them into a computer-developed 3D image of his own (pages 259–67). The 'collective' of the artist then entered a new mythical space. The artist's image for all the figures effectively erased the identities of Michelangelo's angels, saints and sinners. In the video version of *The Last Judgment in Cyberspace*, the artist takes advantage of the time-based medium to maximise the visuality of the limitless and shapeless space, and has his own 'collective', populated by both the damned and the blessed, traversing the infinite that has no start or end.

An era of 'neo-collectivisation' has emerged. 'If the collective fanaticism was political during the Cultural Revolution, it turns out to be economic after the open-door policy,' commented Miao Xiaochun. 'Everyone used to have a little red book in their hand. Today it is a

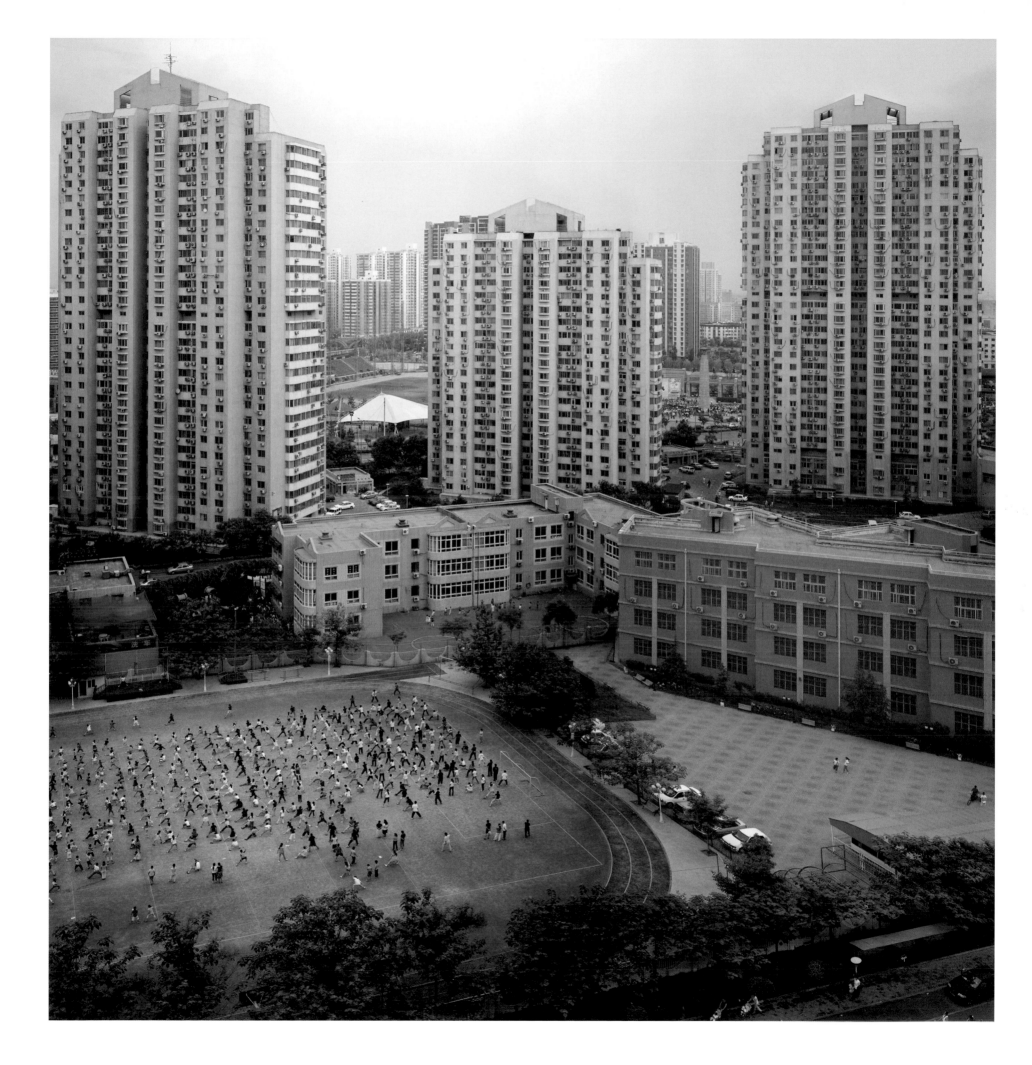

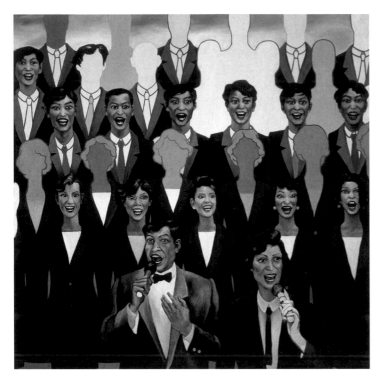

Wang Jinsong, A Big Choir, 1991

Opposite page
Yang Zhenzhong, Spring Story, 2003

mobile handset. This is the indispensable link between the "individual" and the "collective".' The high-rise blocks of the new Beijing and the excitement of today's urban life are heightened in the 'documents' created by Miao's gigantic digital photographs. The enormous assembly he demonstrates reveals the prosperity of the new China. The gala of consumerism mirrors the carnival of the old collective.

The collective activities of everyday life are the subjects of the paintings by Wang Jinsong. His 1992 painting *A Big Choir* portrays the familiar moment when the uniform crowd – same dress, same gesture and same cadence – sing vigorously. Unfinished figures and unattended seats pointedly become the focus of the picture. 'The reality of China,' Wang noted, 'is a system of unification where the appearance of the great collective dominates. The political or economic forms of the collective and the memories of collective history offer me my vocabulary as an artist.' His most recent hand-scroll painting of 2007 depicts a different kind of street scenery from the

advanced Chinese city, where conformity is evident in the movements of Western dance or Chinese traditional Tai Chi. The 'collective' has become more than a nostalgic image. Its manifestation is an ongoing story and a source of renewed strength.

Yang Zhenzhong's video work *Spring Story* was completed in 2003. The performance, involving more than 1,500 workers from a Siemens factory in Shanghai, subtly revealed a sense of the collective unconscious. Each employee recited a word or phrase from Deng Xiaoping's 1992 Southern Campaign Speech in the order of the speech itself. Cumulatively the speech was read as it was originally intended, but the process was like adding tiny jigsaw pieces to complete the whole picture, or like passing endlessly through the production line to reach a completed image of manufactured achievement. The individual efforts, spelled out in meaningless fractional utterances, were finally recognisable as they unexpectedly formed a grand statement.

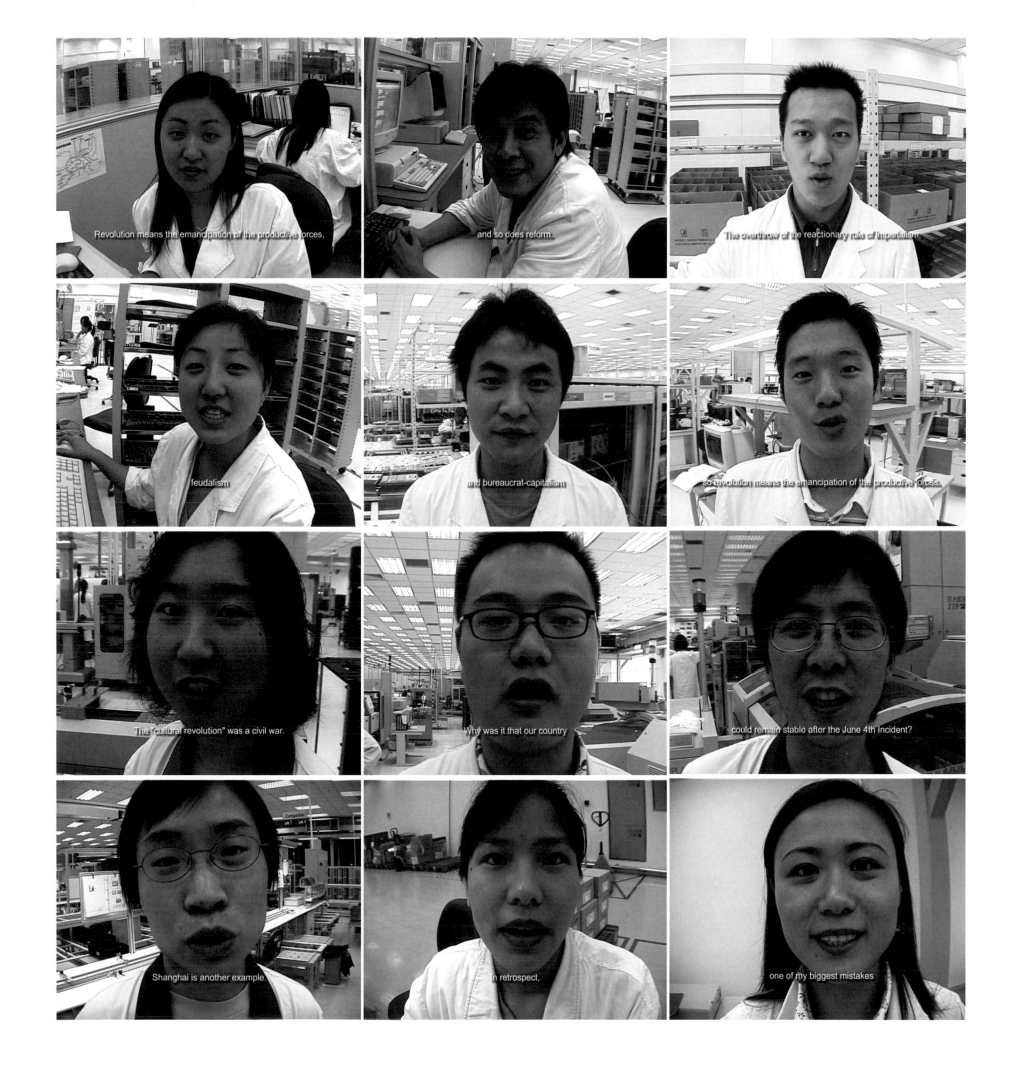

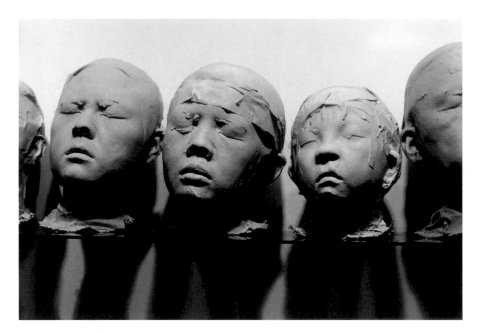

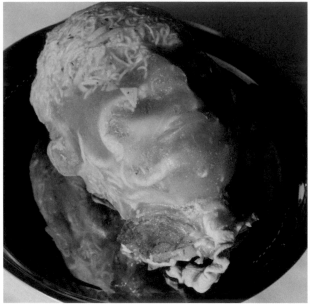

Zhang Dali, One Hundred Chinese, 2000

Zhang Dali, Immigrant Workers, 2000

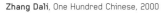

Zhang Dali closely followed a group of migrant workers (*min gong*) who had travelled from all over rural China to earn a living on the construction sites of the developing cities. First, in 2000, he cast the heads of these workers in aspic containing their daily food, such as meat jelly and instant noodles. These heads had an horrific appearance and sickening texture. He then spent two years casting the heads of one hundred migrant workers in resin. He declared, 'These are casts made on the bodies of real people. These are living examples of our era, true and without revisions... Peeling off the coats of shining varnish one by one shows us that we are just like them. We share the same pressures of the collective.'[20] In his ongoing project *Chinese Offspring*, started in 2003, he has already portrayed more than 130 migrant workers in the various postures of life-size resin sculptures (page 166). These individuals are duplicated constantly, or, in the artist's words, 'documented as specimens of their souls'. Being suspended upside down only emphasises the uncertainty of their life, the lack of control over their destiny and finally their submission to the invisible power of the collective.

ZHANG DALI
CHINESE OFFSPRING, 2003-2005
15 life size cast figures, mixed media,
average height 170cm (67in) each

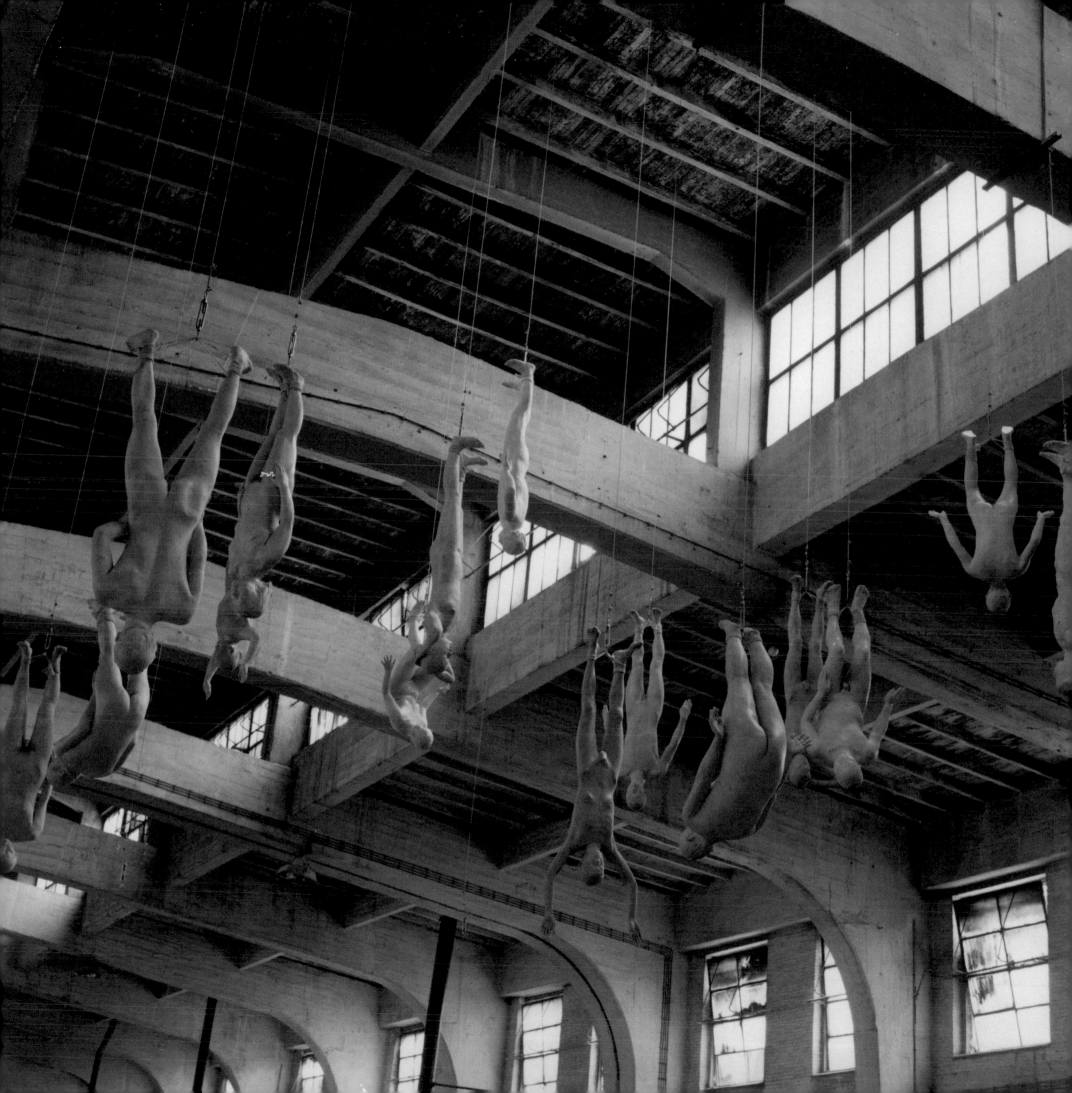

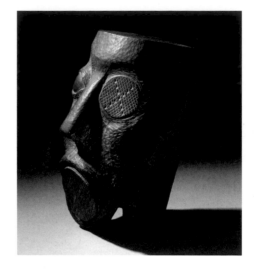
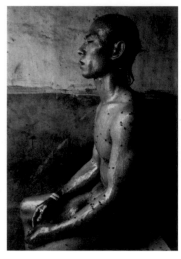

Wang Keping, Silence, 1979　　　　　　　　**Zhang Huan**, Twelve Square Metres, 1994

反叛

'To rebel is justified.'
Mao Zedong

Mao's last revolution provided more than the nostalgic element of redness, the ubiquitous presence of his portrait, the visual power of a public script and the strength of the collective identity. His spirit of rebellion has continued in a subversive form of creativity that distinguishes the new Chinese art.

For generations of Chinese the idea of rebellion instantly recalls the tale of Monkey King, the fearless hero of the Ming dynasty novel *The Journey to the West* by Wu Chengen, who starts his career by challenging the ruling power and 'making troubles in heaven' (*danao tiangong*). During the Cultural Revolution, the spirit of the Monkey King was adopted to encourage the young Red Guards in their struggle. The Monkey King's subjugation of monsters and demons became a symbol for defeating the opponents. The Red Guards at the middle school attached to Tsinghua University claimed, 'Revolutionaries are Monkey Kings, their golden staffs are powerful, their supernatural

powers far-reaching, and their magic omnipotent, for they possess Mao Zedong's great invincible *Thought*. We wield our golden rods, display our supernatural powers, and use our magic to turn the old world upside down, smash it into pieces, pulverise it, create chaos, and make a tremendous mess – the bigger the better!... Long Live the Revolutionary Rebel Spirit of the Proletariat!'[21]

'Order and disorder, obedience and rebellion, are recurring themes in Chinese political culture, sometimes opposed to each other but as often yoked together,' commented John Gittings.[22] If revolutionary change is stimulated by constant revolt, then rebellious eruptions are always born from a period of gestation in marked silence. However, the silence of post-Mao art displays no qualities of peace, neither of timidity, nor of deadness. The silence is a measure of the containment of the energy that lies ready, like a coiled spring, for release in a sudden explosion.

This sense of silence can be witnessed in Zhang Xiaogang's expressionless portraits, in Bai Yiluo's collective patterns and in Zhang Dali's faceless figures. It was depicted as early as 1979 by

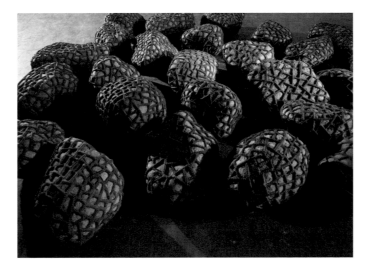

Xu Zhen, *Rainbow*, 1999

Sui Jianguo, *Earth*, 1991

Sui Jianguo, *Kill*, 1996

Wang Keping in a carved wood sculpture of a man with his mouth tightly blocked and one eye blinded. An unforgettable mood of suffocation can be traced directly back to the years of the Cultural Revolution. The silence has also been demonstrated in artists' use of their own and others' bodies. In *Twelve Square Metres*, performed in May 1994, Zhang Huan sat on a village public toilet for two hours, naked and covered in a visceral liquid of fish and honey that attracted flies, seeking 'the certainty of his own existence through acts in which he underwent physical and mental pain.'[23] Xu Zhen's 1999 video *Rainbow* shows a person's back being slapped violently, gradually swelling to various shades of red. The artist then edited out each frame that showed the slap itself, destroying any sense of a 'document'.[24] The back of the anonymous body is detached from any voice, whilst the next strike comes from an undefined authority.

Sui Jianguo is the artist who has gone furthest into this sense of silence. In his 1991 work *Earth*, the artist spent two years of hard labour reshaping twenty huge boulders, each inlaid with a network of thick iron bars. The mammoth intertwining of these two separate materials was the source of the silence. In his later work he probed further into the resistance and toughness of materials. He hammered numerous small nails into wood and attempted to cover the surfaces of a tree stump and a table, but they collapsed. With *Kill* in 1996, he presented a large rubber sheet, fifteen metres in length, astonishingly bearing 300,000 nails. 'A piece of rubber played a passive role initially as the "victim" pierced by thousands of nails and unconditionally accepted all the "violence" and the "painfulness",' he claimed. 'After all the tribulation, however, this wordless object was then transformed. It was neither a receptive object any more, nor a mass of pieces of deadly cold metal, but instead it had become a hairy creature animated with aggressive energy ready to attack others.'

The silence is always accompanied by the possibility of rebellion. In 1979 and 1980 sixteen exhibitions of avant-garde art were held in Beijing, Shanghai and Xi'an. Two exhibitions of the Star group, which included Huang Rui, Wang Keping, Ma Desheng and Ai Weiwei, defined a position further from the official Chinese art world than

any other since 1949. It was a turning point in the history of post-Mao art. On 27 September 1979, the first Star show had been staged in the street outside the National Art Gallery in Beijing. Two days later the exhibition was removed by the police. The artists responded by holding a public demonstration on 1 October, the thirtieth anniversary of the People's Republic.[25] By rejecting the highly polished, socialist-realist style and the approach of depicting revolutionary and political events, the Star group had broken the silence. 'The Star Exhibition marked the beginning of two particular characteristics of modern Chinese art: a critical awareness of politics and culture, and a symbolism based on the fundamental techniques of realism,' wrote the historian Li Xianting. 'Graphic portrayal, philosophical meaning, and a somewhat grotesque presentation and expressiveness were emphasised,' he continued. 'This indicates that the rebellion against realism was the starting point for the artists but at the same time they remained bound, consciously or unconsciously, to this [realist] tradition.'[26]

The rebellious legacy of Mao's revolution has been inherited. The courage to be subversive was evident from the Star Exhibition at the end of the 1970s through the New Wave of 1985[27] to the post-1989 art.[28] From the lessons of Mao and their experience of the Cultural Revolution, the artists released their energy with a defiance accumulated under years of political oppression. The image of Mao was re-shaped; the sublime Chinese writing was destroyed. Discontent, derived from bitter memories coupled with a rage at conditions in today's China, was finally expressed. Overwhelmed by the presence of the high-rise buildings in the cities, Zhang Huan's *Donkey* (page 109) in 2006 presented a stuffed donkey fucking an image of a tumbledown Jin Mao tower. The actual tower is a landmark rising more than 1,200 feet over the newly developed Pudong area of Shanghai. In this mechanical installation the donkey enters the steel tower, its powerfully stretched penis moving in and out with a shrill sound. It is an explicit act of abuse. This is no calmly posed question about rapid environmental development, but a provocative challenge.

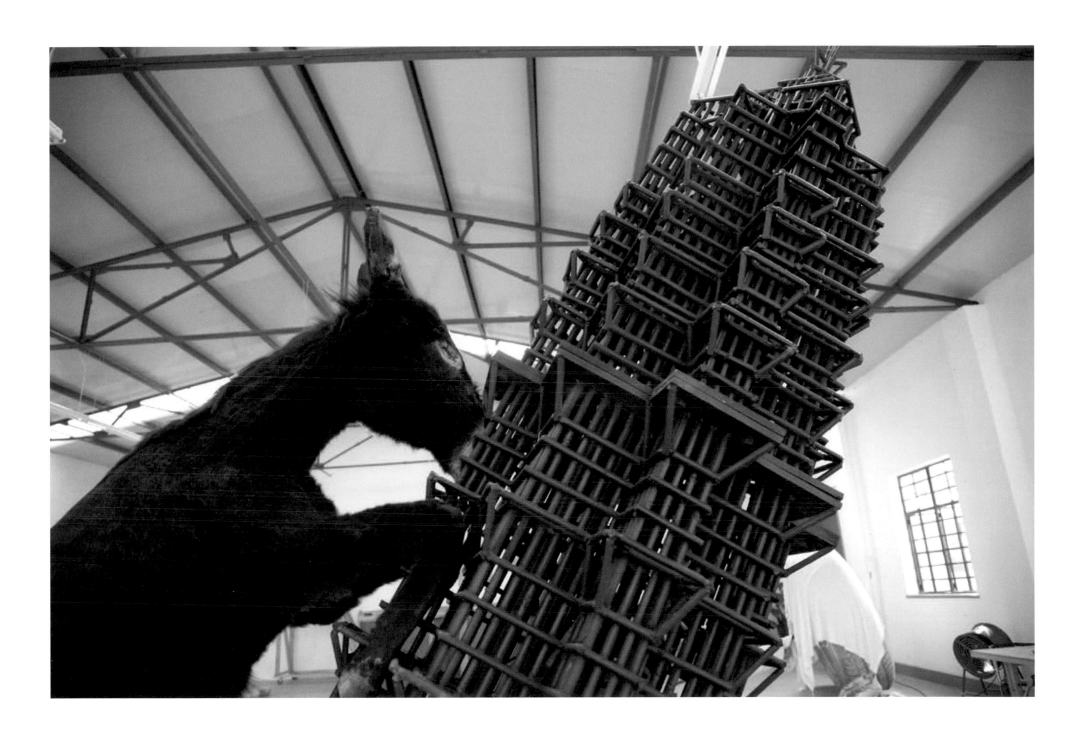

ZHANG HUAN
DONKEY, 2005
mixed media,
220 x 80 x 320cm (86 3/4 x 31 1/2 x 126in)

ZHANG HUAN
DONKEY, 2005
mixed media,
220 x 80 x 320cm (86 3/4 x 31 1/2 x 126in)

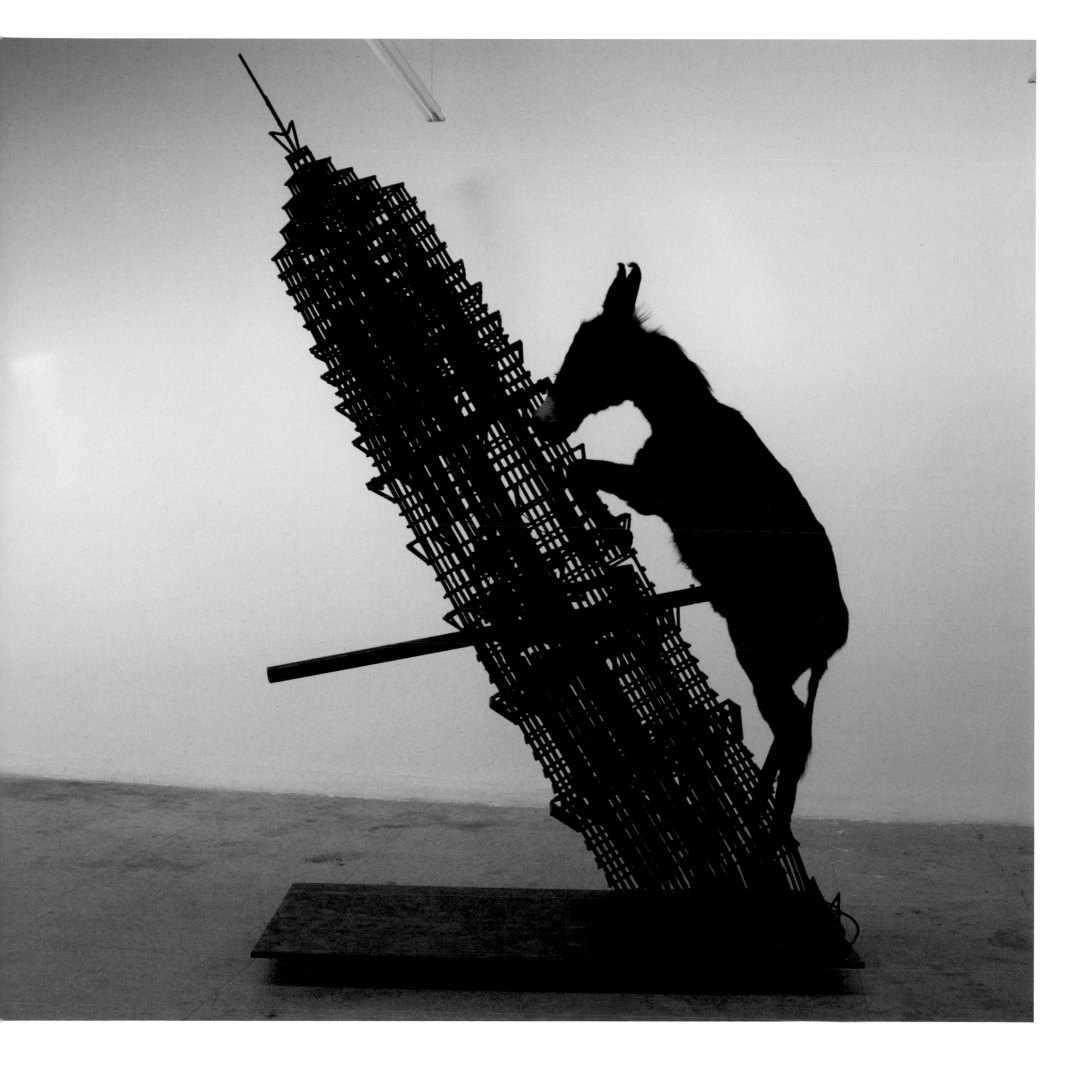

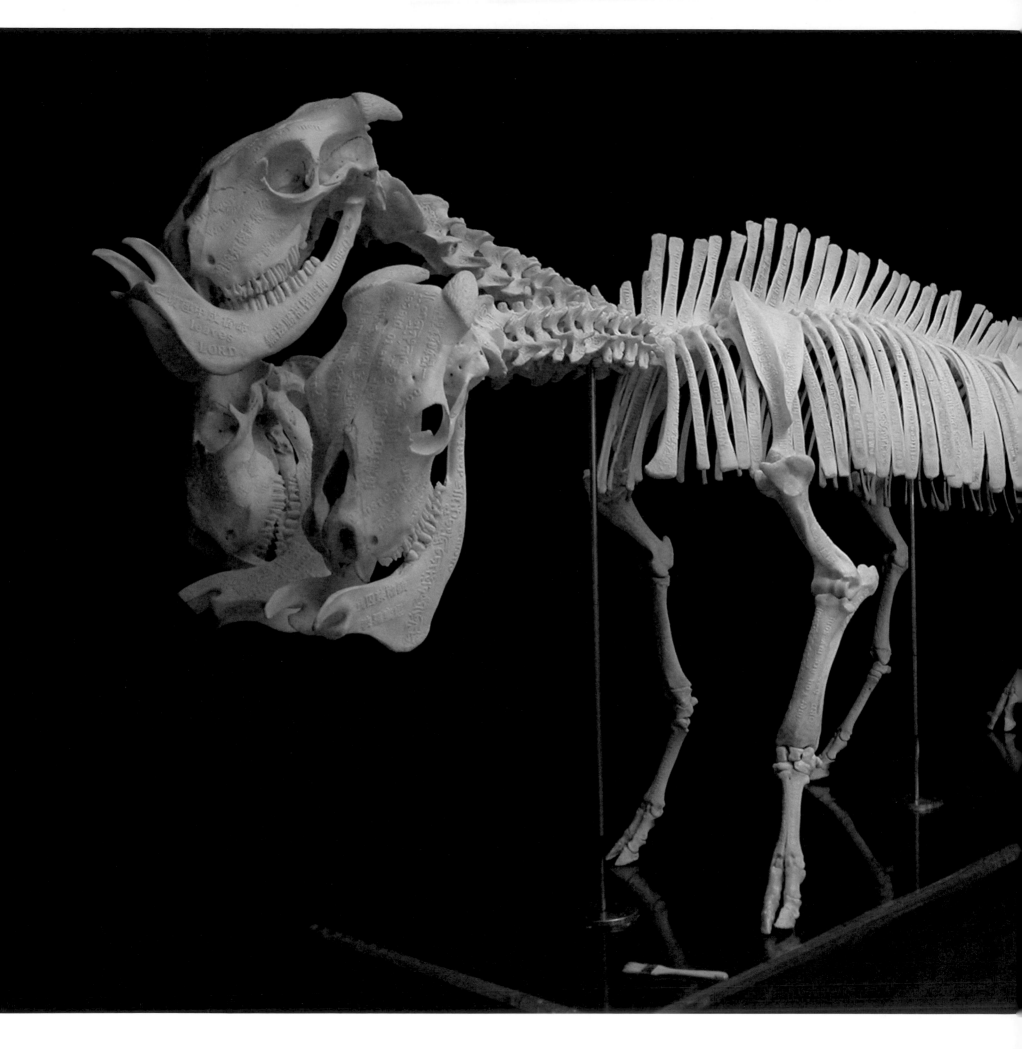

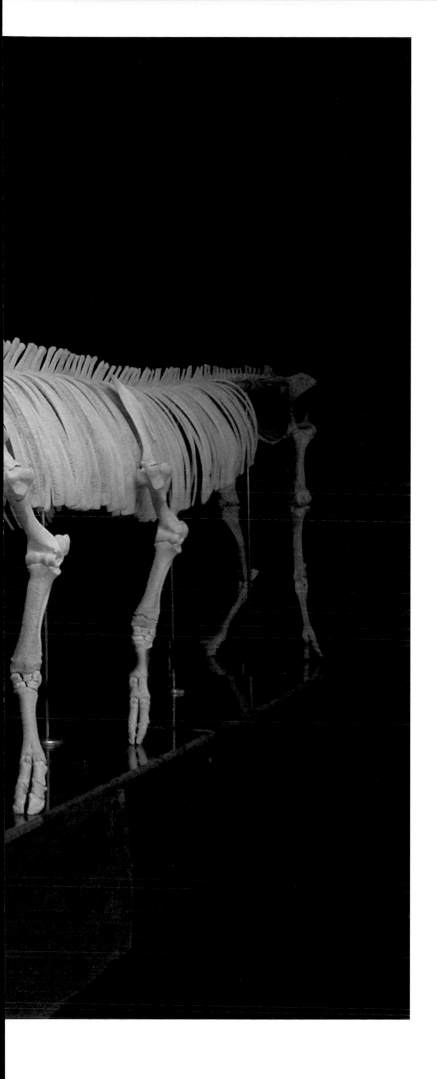

SHEN SHAOMIN
UNKNOWN CREATURE - THREE HEADED MONSTER, 2002
bone, meal, glue,
670 x 70 x 150cm (264 x 27 1/2 x 59in)

Shen Shaomin stocks up in his studio in Daqing with thousands of animal bones. Since 2003 the artist has been using his collection to construct skeletons of invented beings. The bones have been selected from cows and sheep and from small animals like rabbits and rats. His largest work, *Unknown Creature: Three Headed Monster* (page 112), completed in 2003, combines the bones from fifteen cows into a creature more than twenty feet long with four pairs of legs and three heads. Each bone has been neatly inscribed with fragments of text of either Buddhist, Islamic or Christian origin, written respectively in Chinese, Arabic and English (page 115). This animal re-arrangement and the new context for sacred language echo the revolutionary slogan 'Smashing the old and establishing the new'. Or as Chairman Mao taught, 'There is no construction without destruction' (*bupo buli*). It could stand as a metaphor for fatality or a celebration of creation. The silence and the clamour of rebellion are perfectly balanced.

Mao evaluated himself in his late years and pointed out only two significant achievements in his lifetime: the conquest over his opponent Jiang Jieshi (Chiang Kai-shek) and the Kuomintang, and the Cultural Revolution. After more than three decades since Mao's death it is widely agreed that the Cultural Revolution was a national tragedy. Most of its visual elements were no more than political instruments offering little of further cultural value. The Cultural Revolution is in fact frequently referred to as a 'cultural desert'. Mao's legacy has been deeply embedded by virtue of the sheer scale of the mass movement. The unlikely consequence is that it has equipped a new generation of artists with the audacity, if required, to be subversive. It has provided a young generation of artists with layers of visual complexity derived from reflection, reinterpretation and redefinition, and with a hunger for radical change. The revolution indeed continues in China's new art, through a spirit of rebellion.

1. 'The Chinese Art Exhibition: Decorative Objects', *The Times*, 17 December 1935, p. 12.

2. 'Hengsao yiqie niugui sheshen (Sweep Away All the Ox-demons and Snake-spirits)', *Renmin Ribao (People's Daily)*, 1 June 1966, p. 1.

3. The Red Guards of the Middle School Attached to Tsinghua University. 'Wuchan jieji de geming zaofan jingshen wansui (Long Live the Spirit of Proletarian Revolutionary Rebellion)', *Hongqi (Red Flag)*, vol. 11, 1966, p. 27.

4. China National Art Gallery (ed.). *Zhongguo meishu nianjian (Chinese Art Almanac)*. Nanning: Guangxi Art Press, 1993.

5. Yan Jiaqi and Gao Gao, D. Kwok (trans.). *Turbulent Decade: A History of the Cultural Revolution*. Hawaii: University of Hawaii Press, 1996, pp. 89–90.

6. Cited in Song Yongyi and Sun Dajin. *Wenhua dageming he tade yiduan sichao (Heterodox Thoughts during the Chinese Culture Revolution)*. Hong Kong: Tianyuan Shuwu, 1997, pp. 83–4.

7. See Barmé, Geremie R. *Shades of Mao*, London: An East Gate Book, 1996, pp. 4–9.

8. Macfarquhar, Roderick and Schoenhals, Michael. *Mao's Last Revolution*. Cambridge: the Belknap Press of Harvard University Press, 2006, p. 67.

9. Chang Tsong-zung, 'Mesmerised by Power', in Jiehong Jiang (ed.), *Burden or Legacy: From the Chinese Cultural Revolution to Contemporary Art*. Hong Kong: Hong Kong University Press, 2007, pp. 57–60.

10. Wu Hung. *Transience: Chinese Experimental Art at the End of the Twentieth Century*. Chicago: The David and Alfred Smart Museum of Art and The University of Chicago, 1999, p. 38.

11. 'Shiliu Tiao (Sixteen Points, the initial name for The Resolution of Proletarian Cultural Revolution by the Central Authority of Chinese Communist Party)', *Renmin Ribao (People's Daily)*, 9 August 1966, p. 1.

12. Wu Shanzhuan. '*Guanyu zhongwen (About Chinese Characters)*', *Meishu (Fine Art)*, 1986, Vol. 8, p. 61.

13. Xu Bing. 'The Living Word', in Britta Erickson (ed.), *Words without Meaning, Meaning without Words: The Art of Xu Bing*. London: University of Washington Press, 2001, p. 16.

14. Chang Tsong-zung, Op. cit., p. 65.

15. Wu Hung, Op. cit., pp. 173–74.

16. Artist statement, 2005, provided by Qiu Zhijie.

17. See *Cihai*, 1979.

18. The notion of *Collective Identity* was developed for a touring exhibition of contemporary Chinese art at the Chinese Arts Centre, Manchester, and Hong Kong University Museum and Art Gallery, Hong Kong, curated by the author in 2007.

20. Artist statement, 2003, provided by Zhang Dali.

21 '*Geming de zaofan jingshen wansui* (Long Live the Spirit of Revolutionary Rebellions)', *Renmin Ribao (People's Daily)*, 24 August 1966, p. 1. English adopted from John Gittings' translation.

22. Gittings, John. *The Changing Face of China: from Mao to Market*. Oxford: Oxford University Press, 2006, p. 60.

23. Gao Minglu, 'From Elite to Small Man: The Many Faces of a Transitional Avant-Garde in Mainland China', in Gao Minglu (ed.), *Inside Out: New Chinese Art*. London: University of California Press, 1998, p. 164.

25. With the help from Liu Xun, an officer of the Beijing Art Association, the Exhibition was eventually allowed to be shown in Beihai Park from 23 November to 2 December 1979. The second Star Show was open from 20 August to 7 September 1980, and attracted an audience of more than 80,000.

26. Li Xianting. 'An Introduction to the History of Modern Chinese Art', in Jochen Noth, Wolfger Pohlmann and Kai Reschke (eds.), *China Avant-garde*. Oxford: Oxford University Press, 1993, p. 42.

27. During the art phenomenon of the 85 New Wave, in particular the period between 1984 and 1987, there were over 300 art groups across China. Featured by the quest of liberating energy, each was represented by their personal reflections and artistic approaches towards new Chinese art.

28. For further details, see Valerie Doran (ed.), *China's New Art, Post-1989*. Hong Kong: Hanart T. Z. Gallery, 1993.

Interviews with the artists were conducted by Jiang Jiehong in China, from 2000–2007.

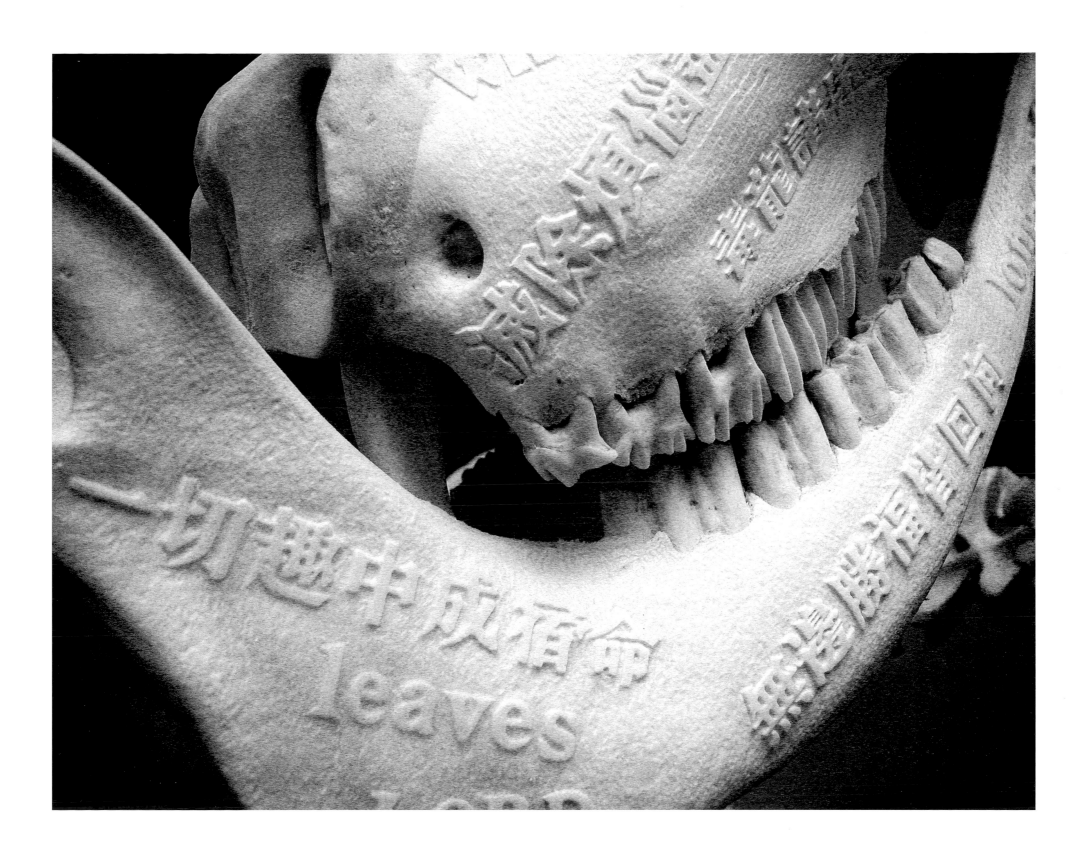

SHEN SHAOMIN
UNKNOWN CREATURE - THREE HEADED MONSTER, 2002
(DETAIL)

SHEN SHAOMIN
UNKNOWN CREATURE - MOSQUITO, 2002
bone, meal, glue,
92 x 34 x 42cm (36 1/4 x 13 1/2 x 16 1/2 in)

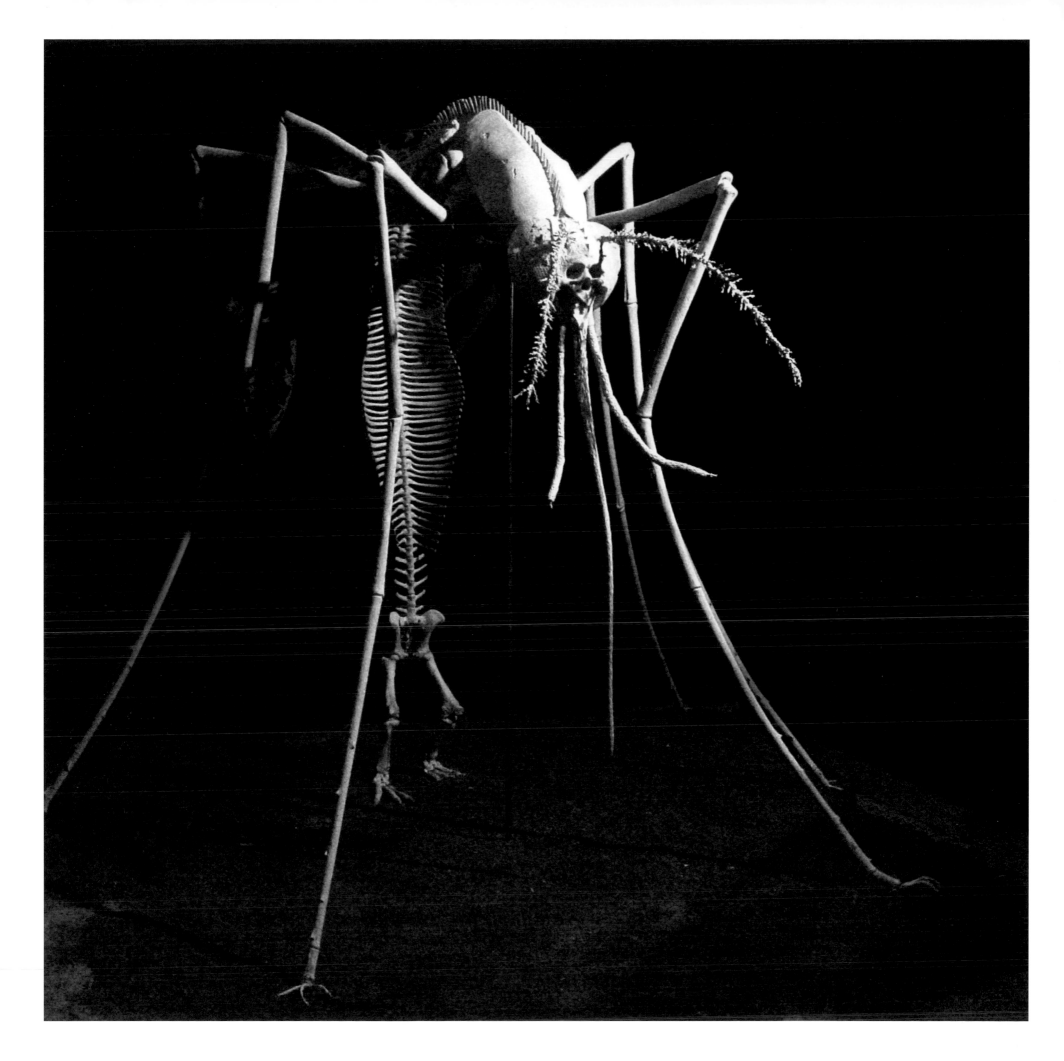

革命在继续

Le Voyage
vers l'Ouest

《新西遊

記圖》他郷山人批

二仟年元月於日内瓦

爲七十得子而作

QIU JIE
PÈLERINAGE VERS L'OUEST, 2000
lead on paper,
224 x 336cm (88 1/4 x 132 1/2 in)

LI SONGSONG
GIFT, 2003
oil on canvas,
180 x 300cm (71 x 118in)

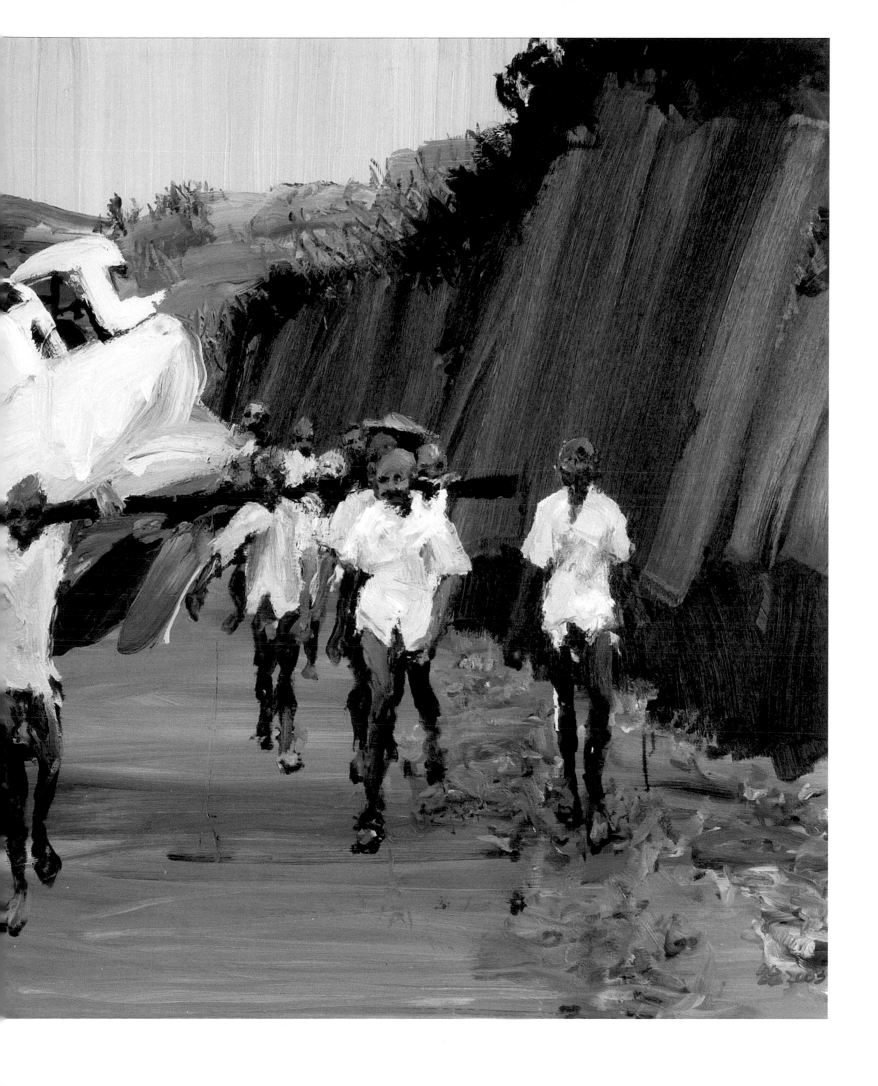

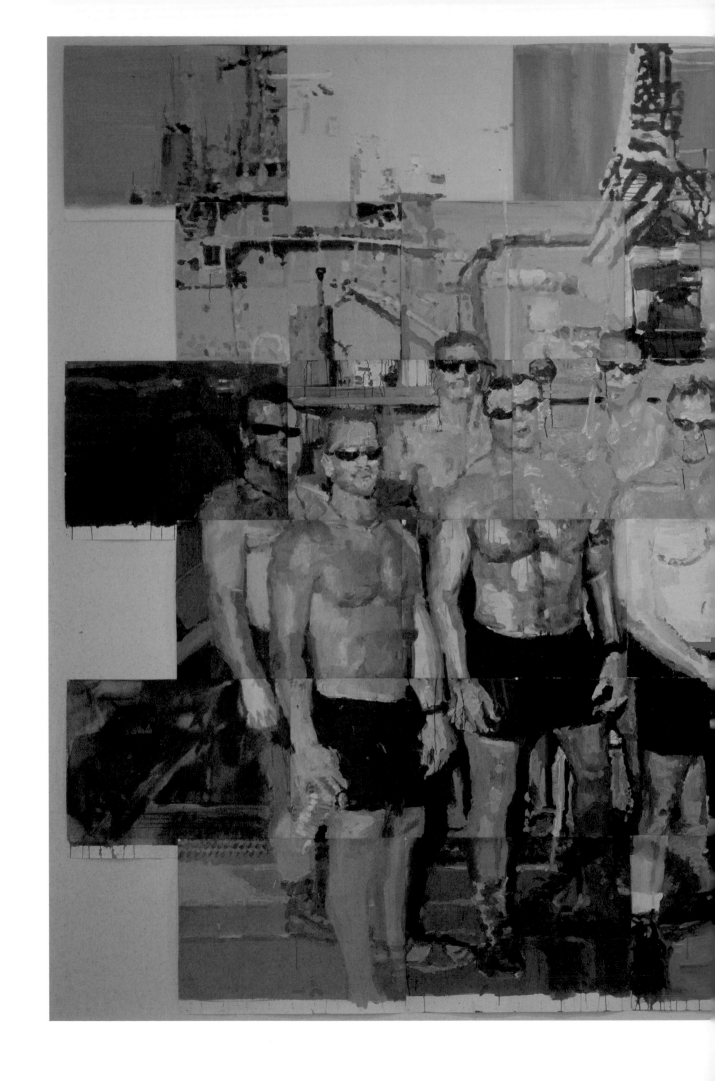

LI SONGSONG
IN GOD WE TRUST, 2006
acrylic on board,
430 x 610cm (169$^{1/2}$ x 240in)

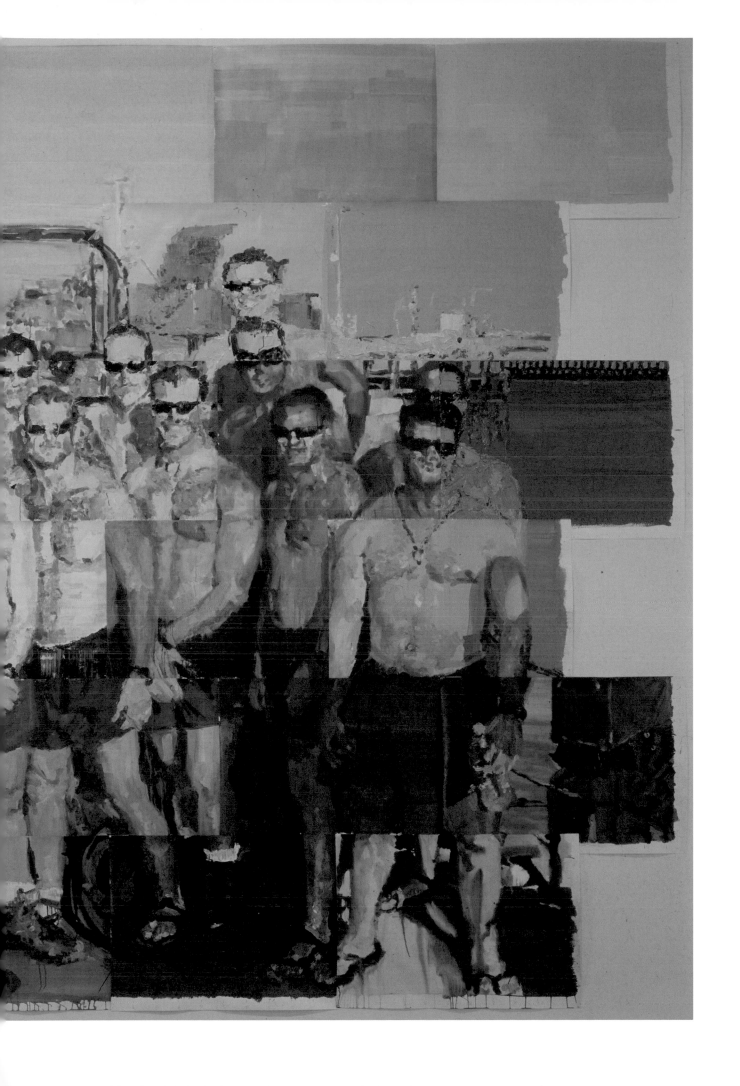

LI SONGSONG
NATIONAL GEOGRAPHIC, 2006
oil on canvas,
360 x 240cm (142 x 81 1/2 in)

LI YAN
ACCIDENT NO.5, EXHIBITION VIEW, 2007
acrylic on canvas

LI YAN
ACCIDENT NO.6.1, 2007
acrylic on canvas,
72 x 72cm (28 1/4 x 28 1/4 in)

ZHANG HUAN
SEEDS OF HAMBURG, 2007
incense ash, charcoal and resin on canvas,
250 x 400cm (98 1/2 x 157 1/2 in)

ZHANG HUAN
SEEDS OF HAMBURG
(DETAIL)

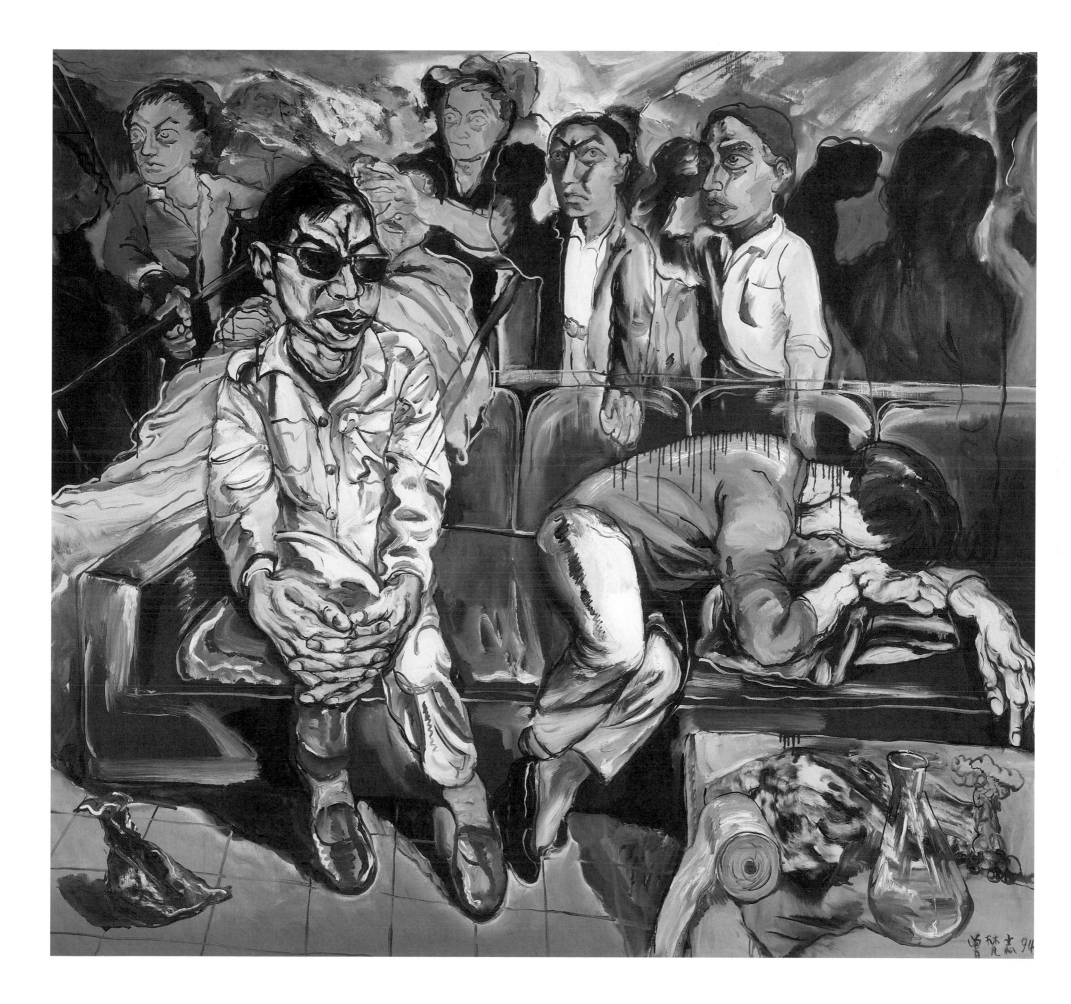

ZENG FANZHI
THIS LAND IS SO RICH IN BEAUTY 2, 2006
oil on canvas,
215 x 330cm (84 3/4 x 130in)

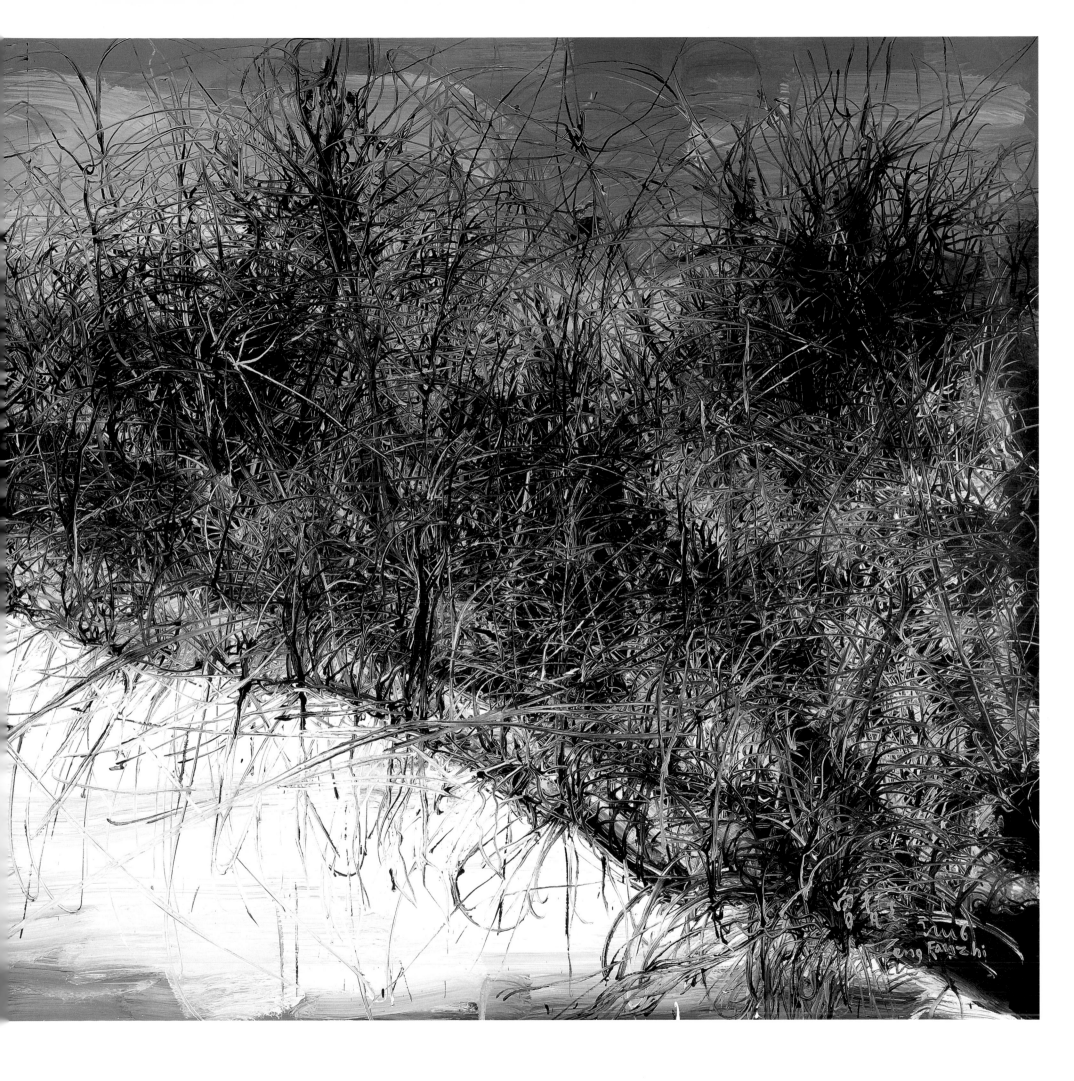

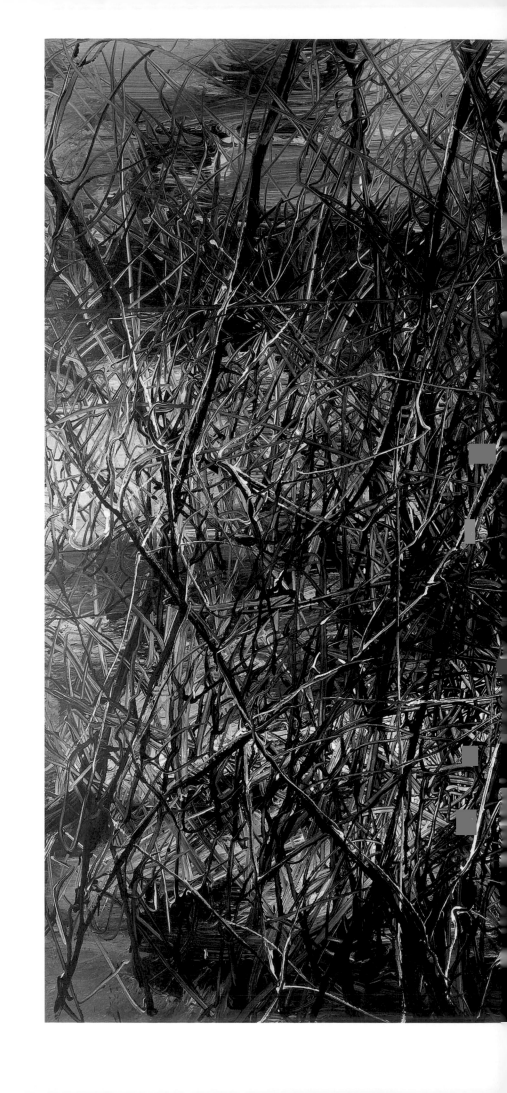

ZENG FANZHI
LITTLE BOY, 2006
oil on canvas,
180 x 280cm (71 x 110in)

144

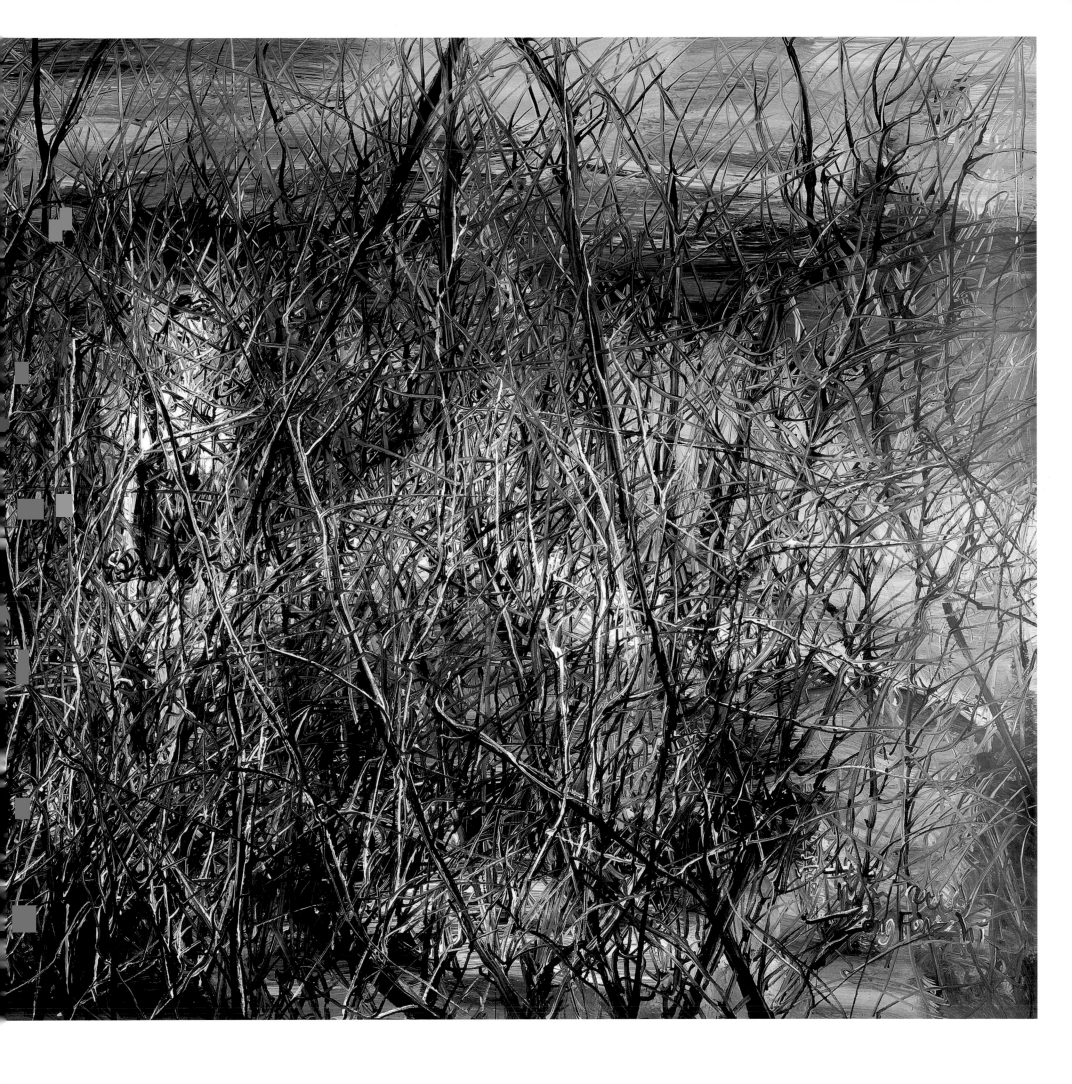

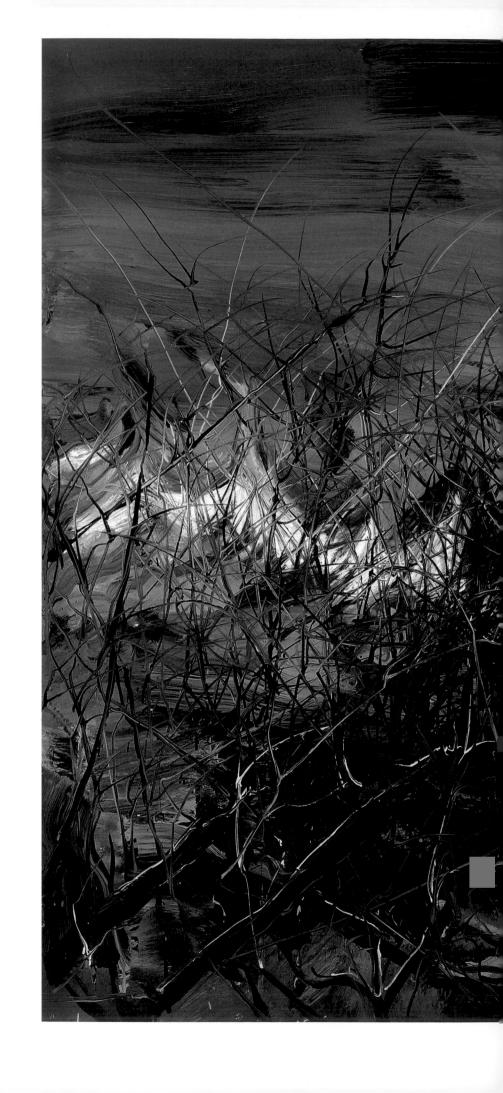

ZENG FANZHI
HUANG JIGUANG, 2006
oil on canvas,
215 x 330cm (84 3/4 x 130in)

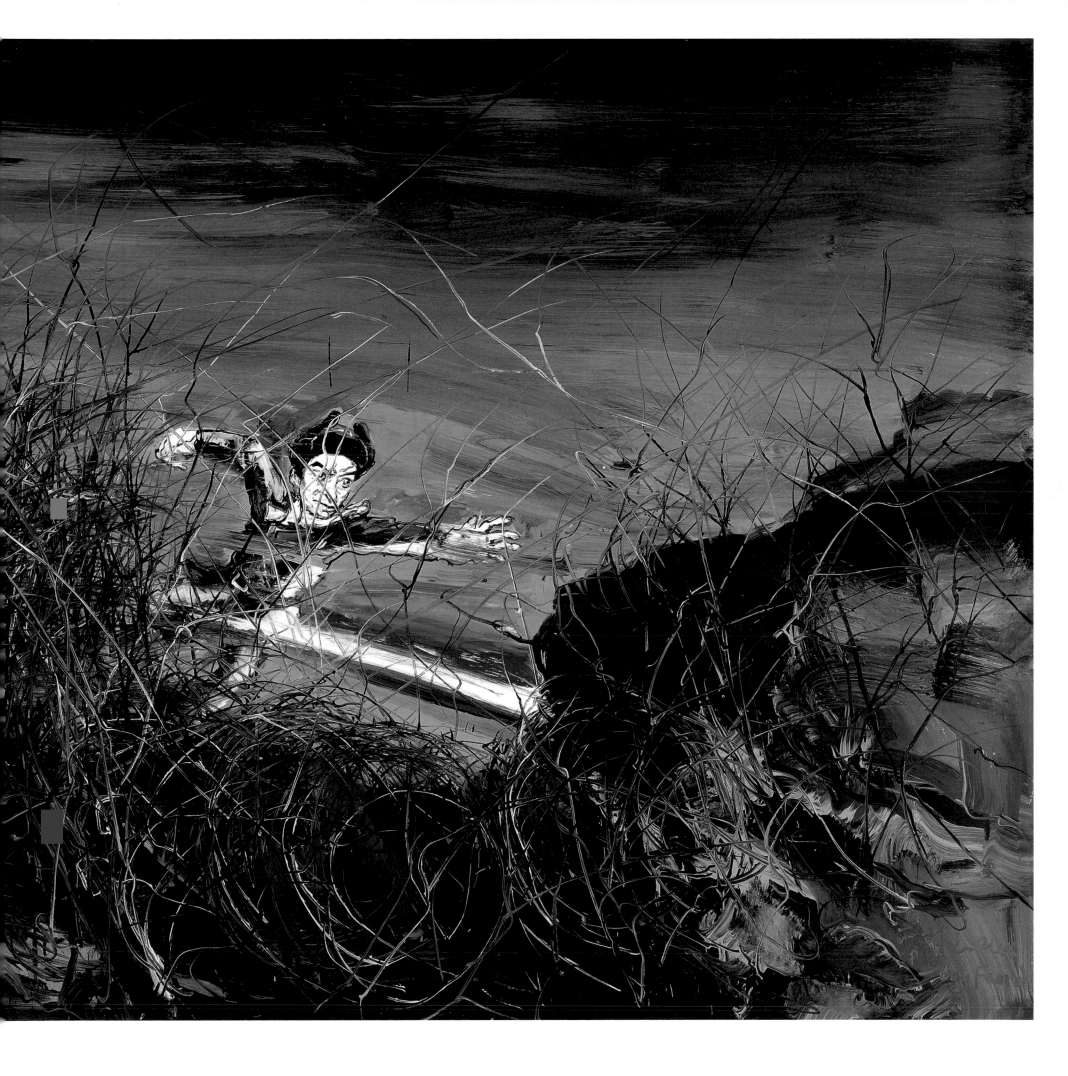

SHI JINSONG
NA ZHA'S WALKER, 2005
stainless steel,
54 x 59 x 66cm (21¼ x 23¼ x 26in)

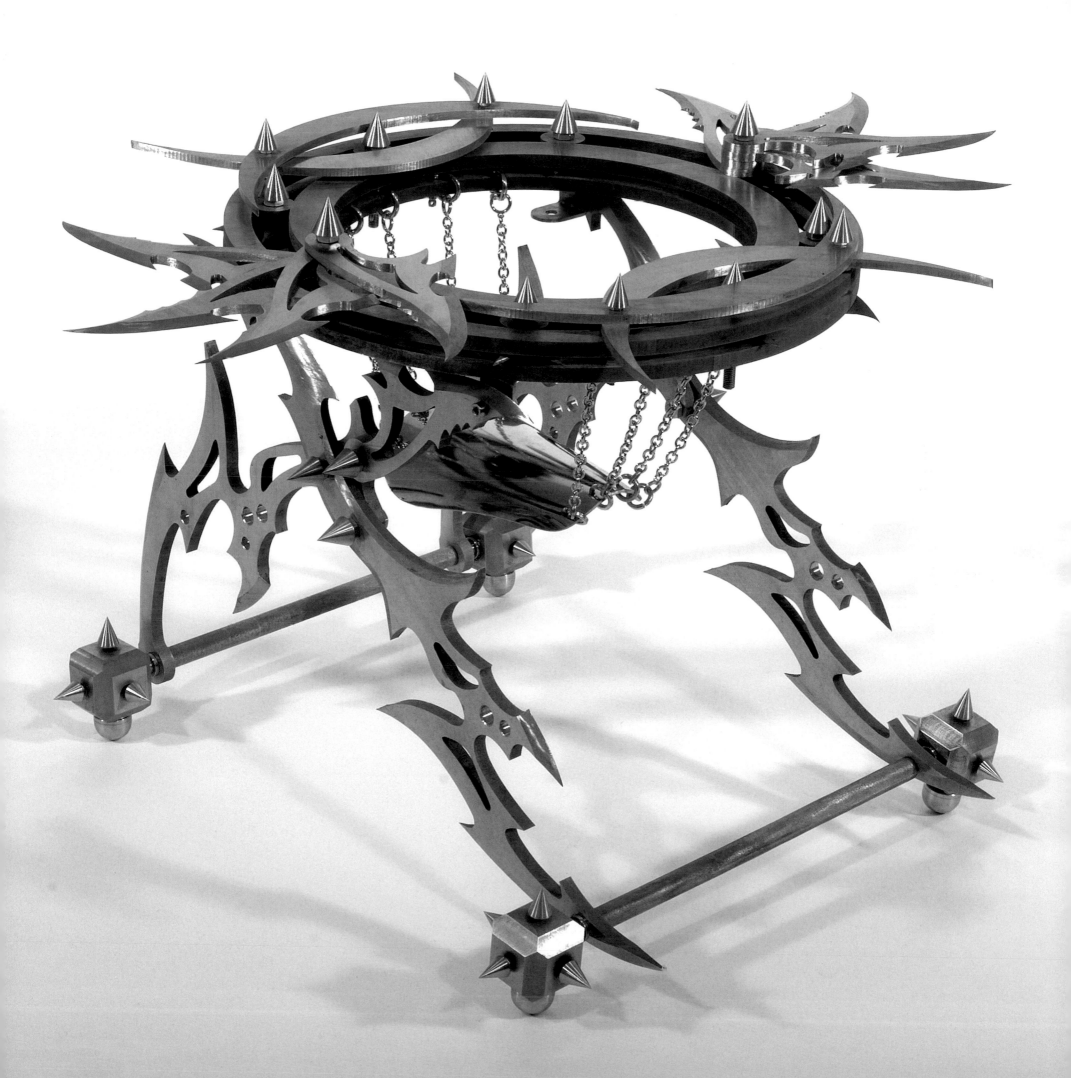

ZHENG GUOGU
WATERFALL, 2003
collaborative work with the yang jiang group inc. chen zaiyan, and sun qinglin
wax, paper, metal armature
210 x 140 x 140cm (82¹/² x 55 x 55in)

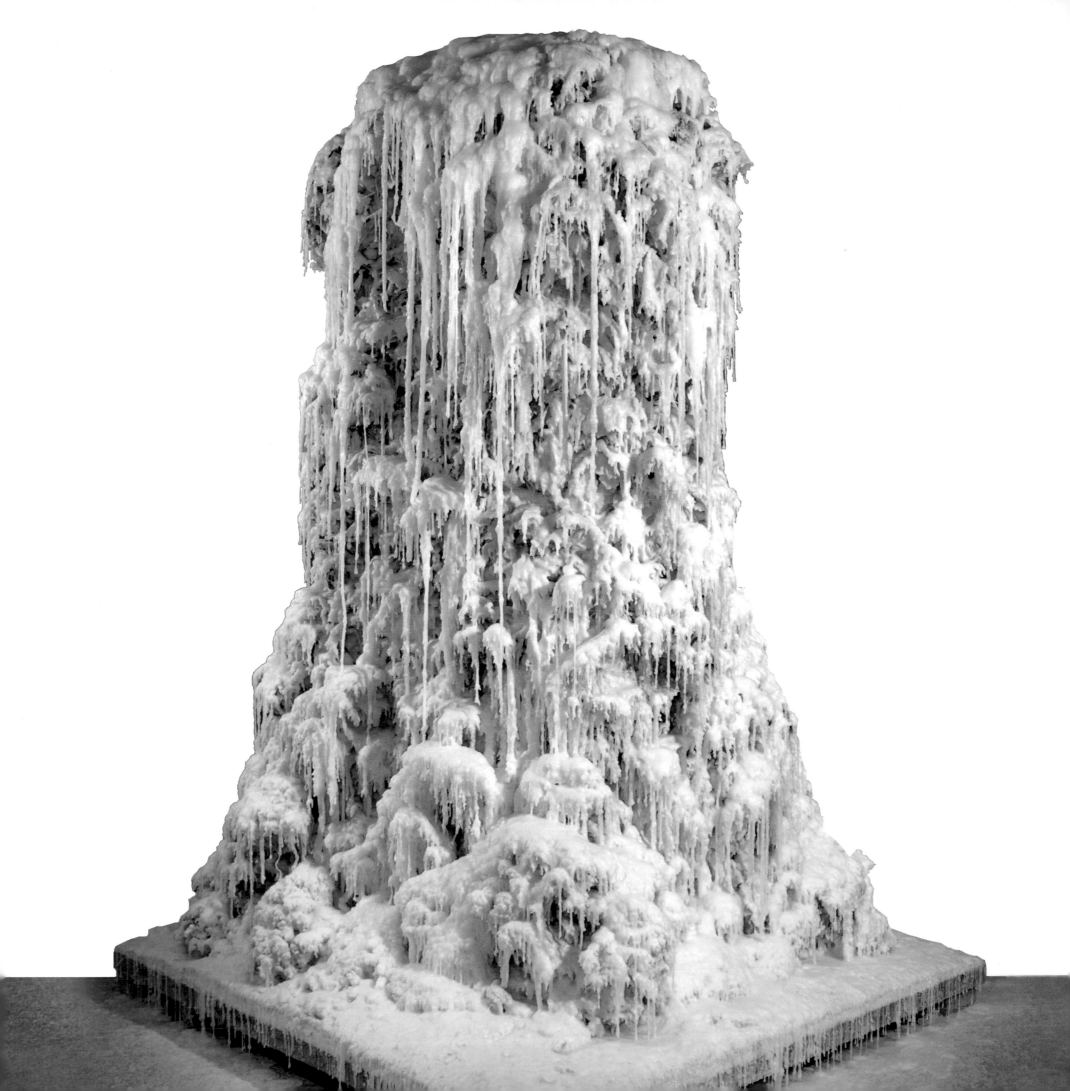

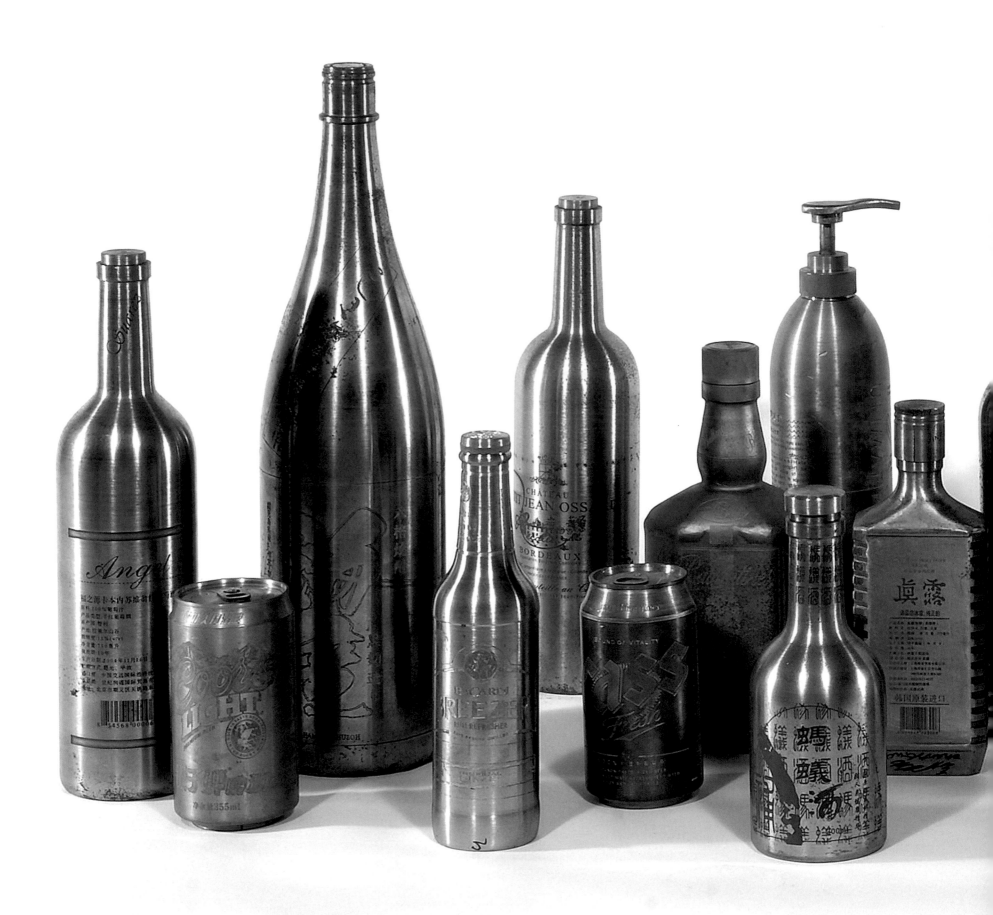

ZHENG GUOGU
YEAR TWO THOUSAND, ANOTHER TWO THOUSAND YEARS TO RUST, 1999-2006
set of 23 hand made and etched life size wine and beer bottles

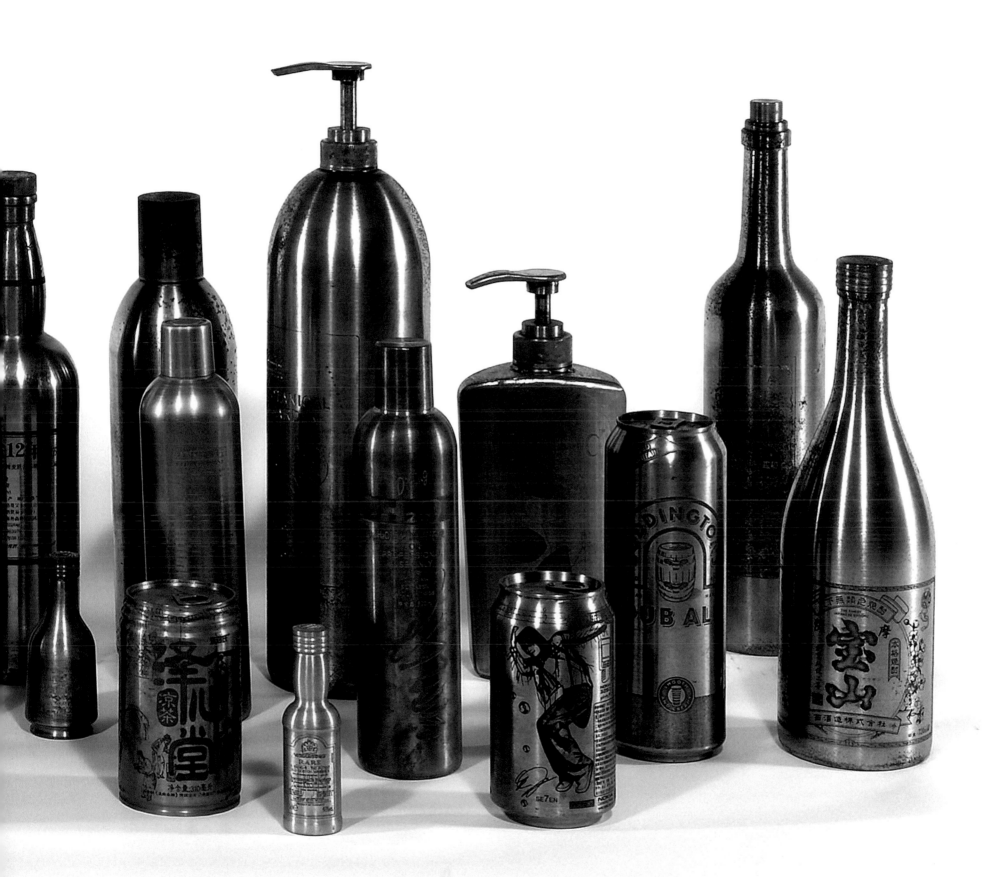

ZHAN WANG
ORNAMENTAL ROCK NO.71, 2006
polished stainless steel,
170.2 x 157.5 x 106.7cm (67 x 62 x 42in)

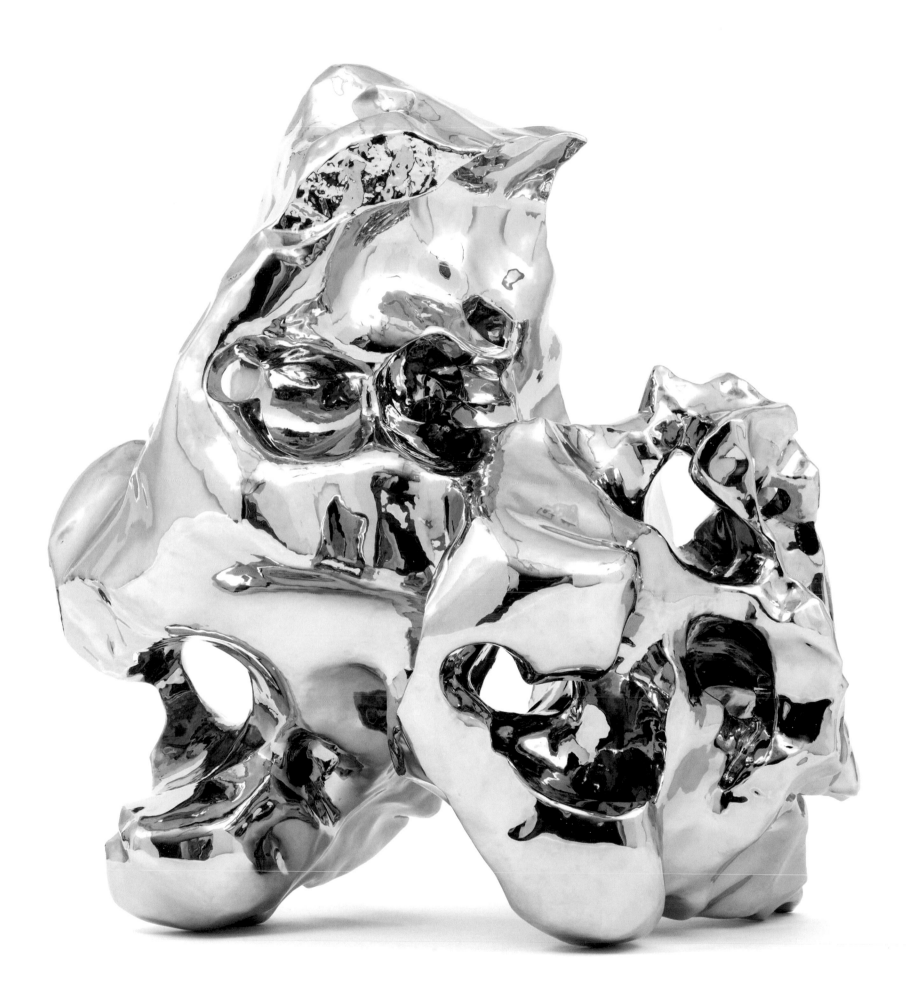

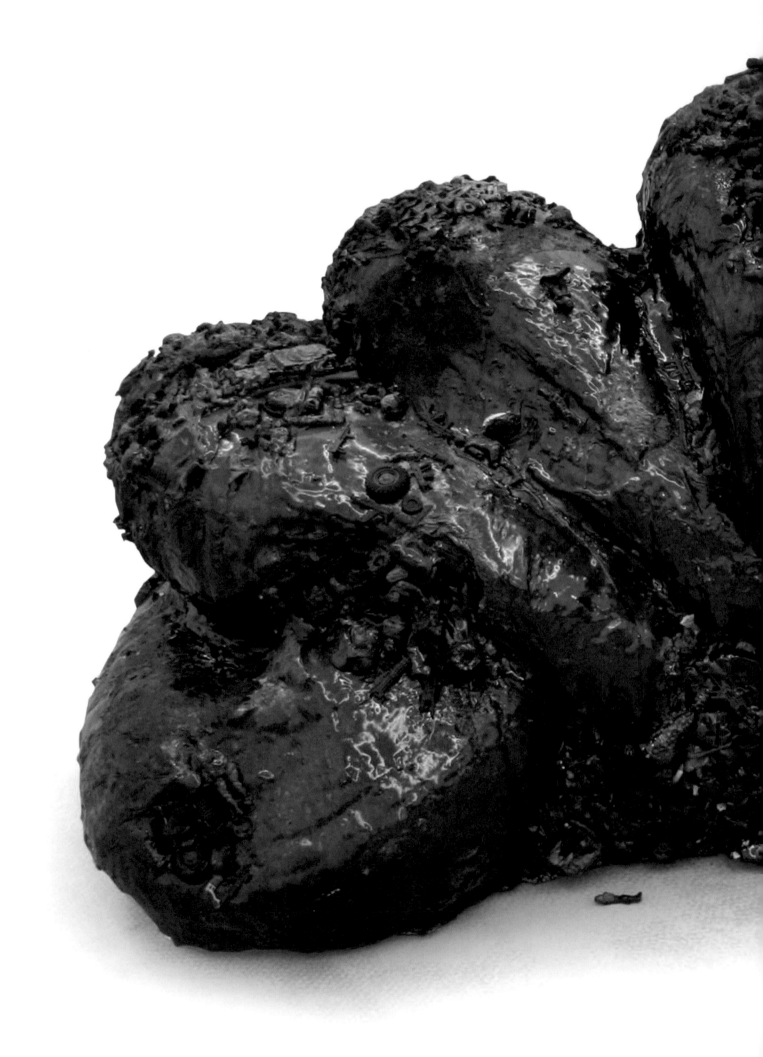

LIU WEI
INDIGESTION II, 2004-2005
mixed media,
200 x 120 x 100cm (78 3/4 x 47 1/4 x 39 1/2 in)

156

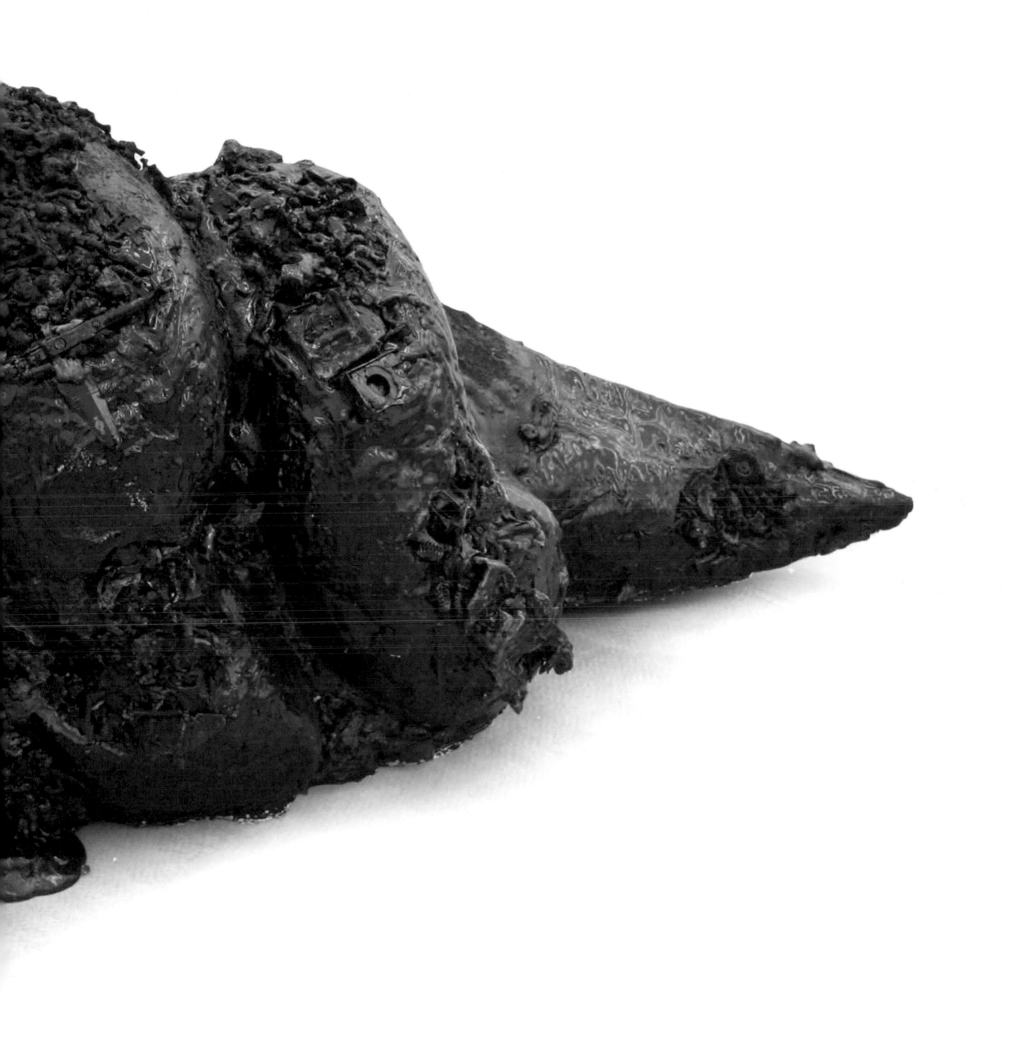

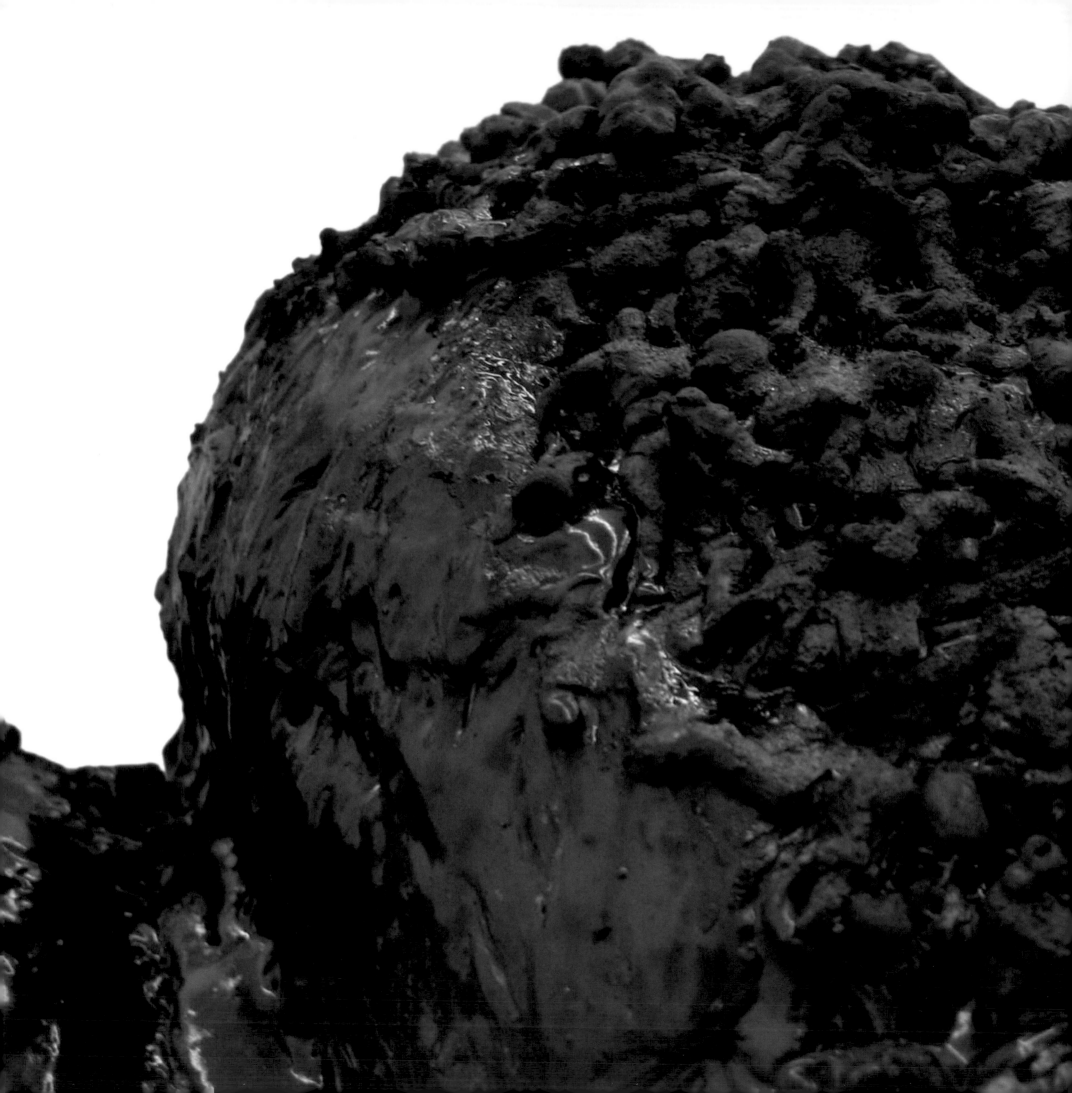

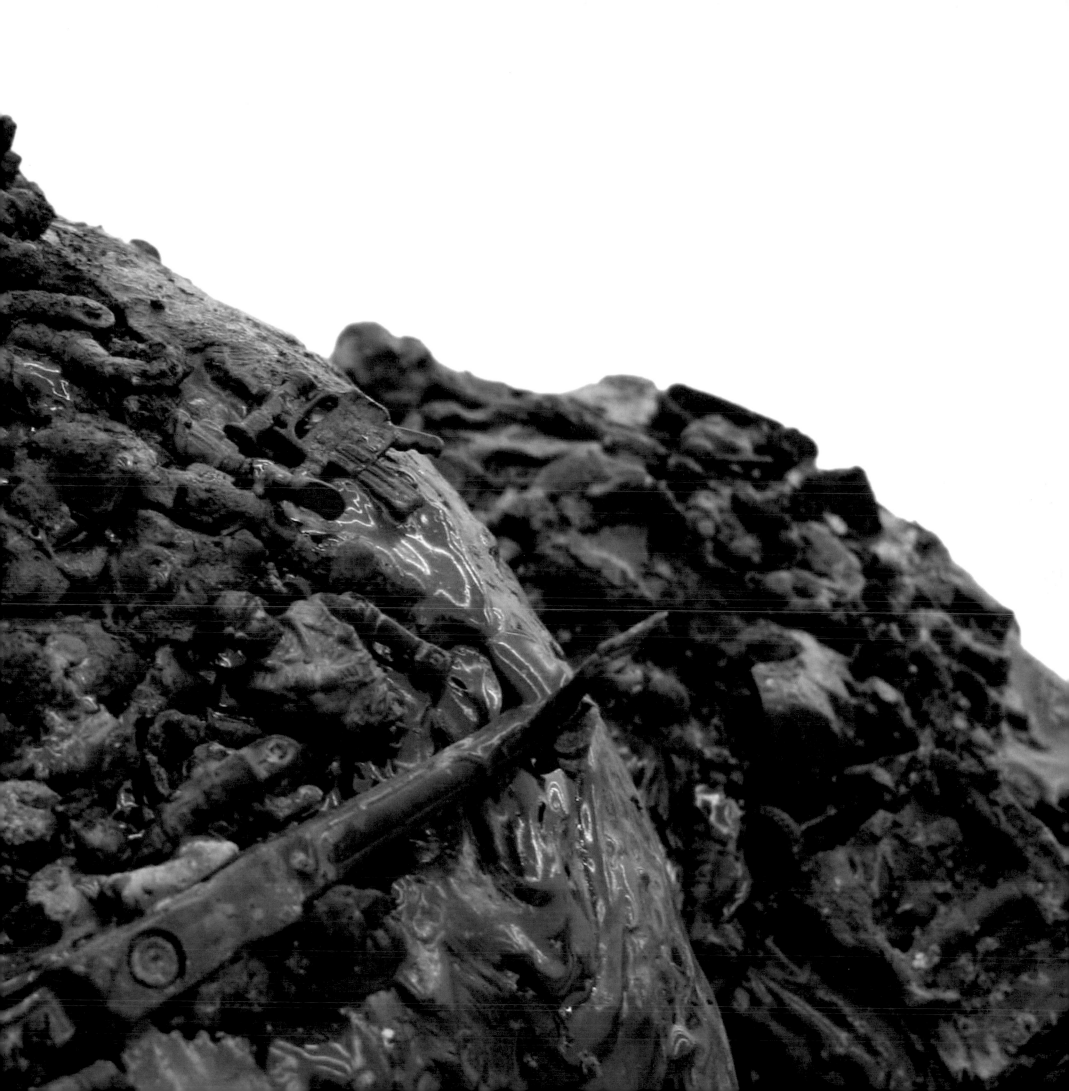

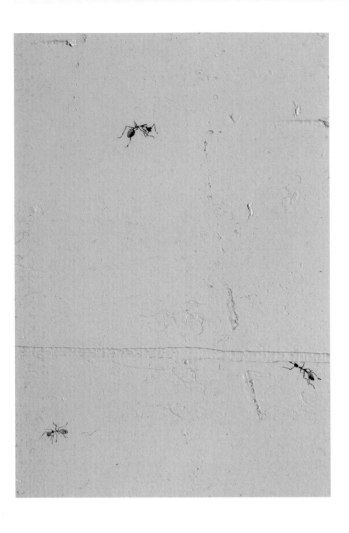

ZHANG HUAN
INSECT PAINTING NO.2, 2007
oil on canvas,
250 x 360cm (98 1/2 x 142in)

INSECT PAINTING NO.2
(DETAIL)

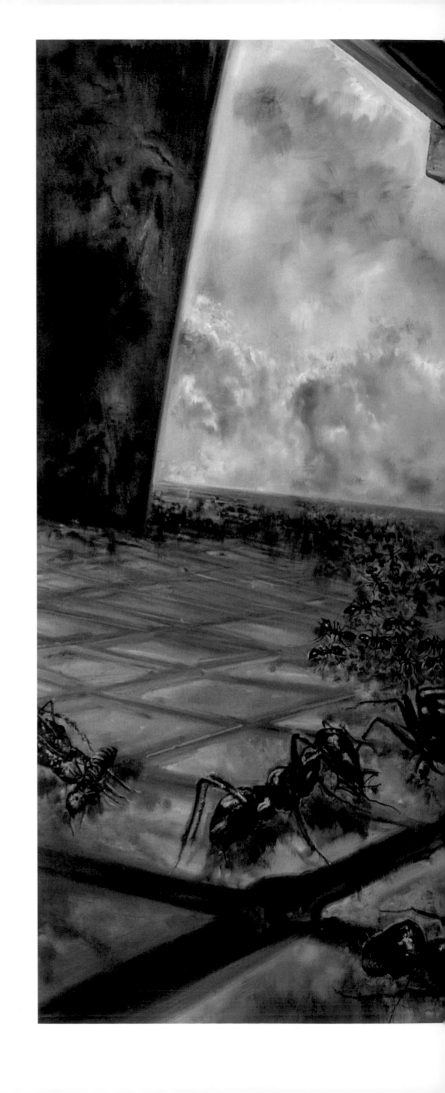

ZHANG XIAOTAO
ANTS MOVING THINGS NO.3, 2006
oil on canvas,
200 x 300cm (78 3/4 x 118in)

162

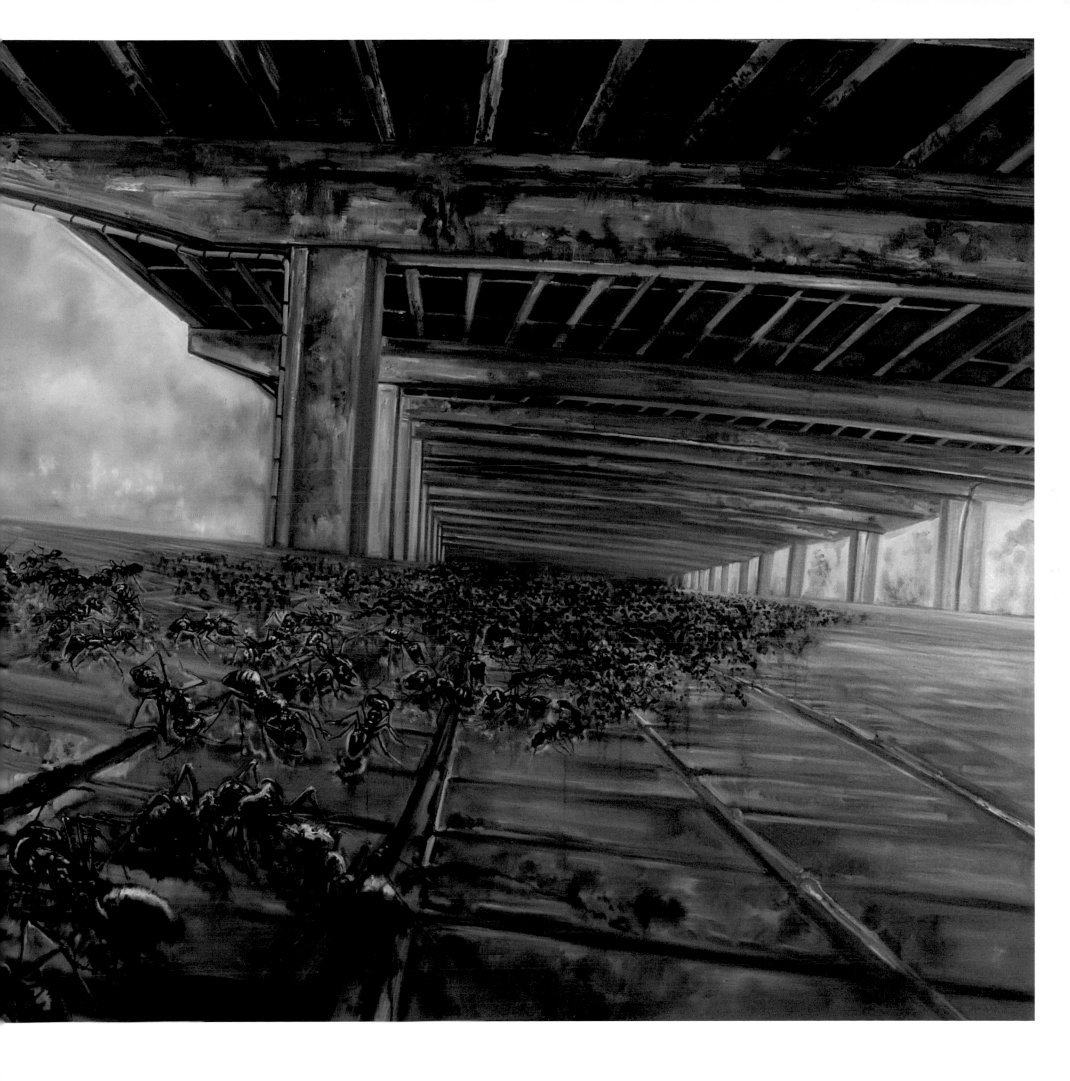

ZHANG XIAOTAO
TRAVEL, 2006
oil on canvas,
300 x 200cm (118 x 78 3/4 in)

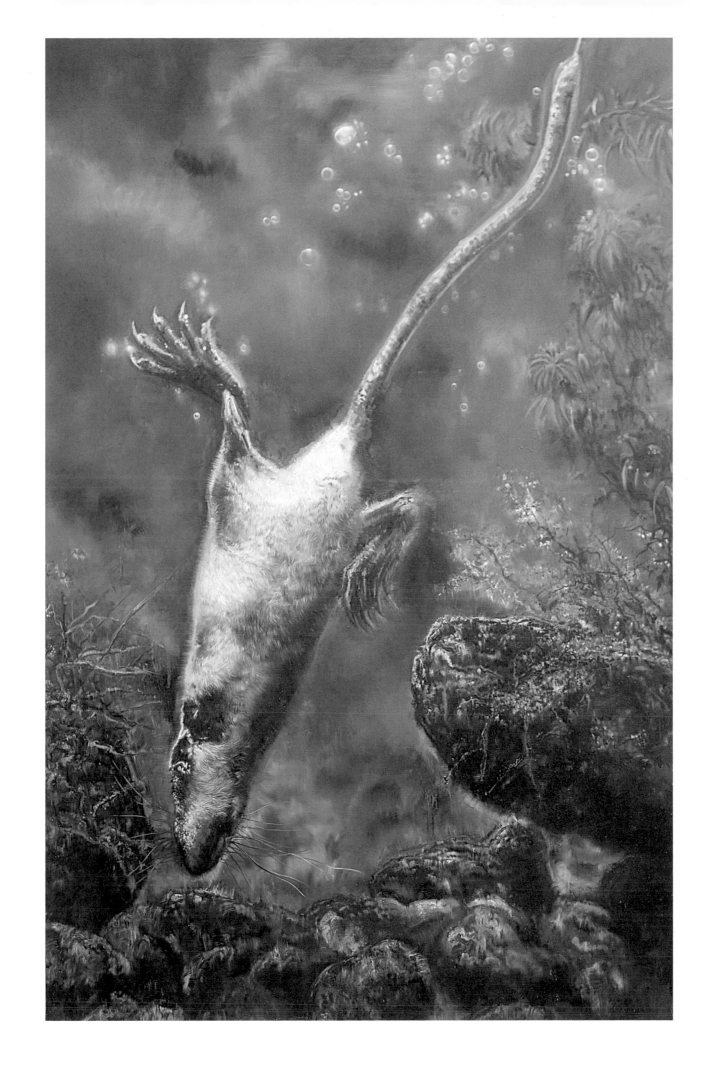

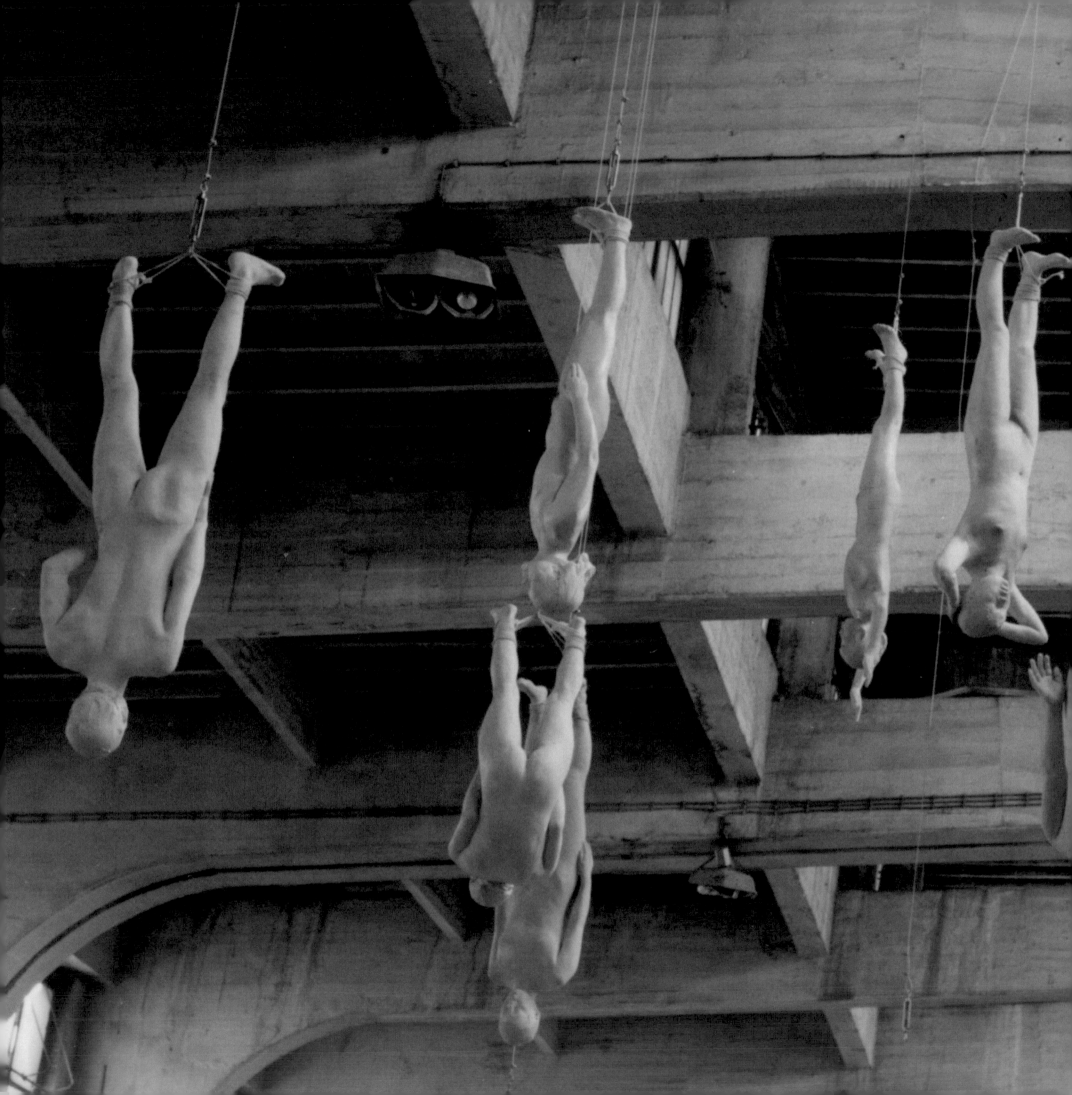

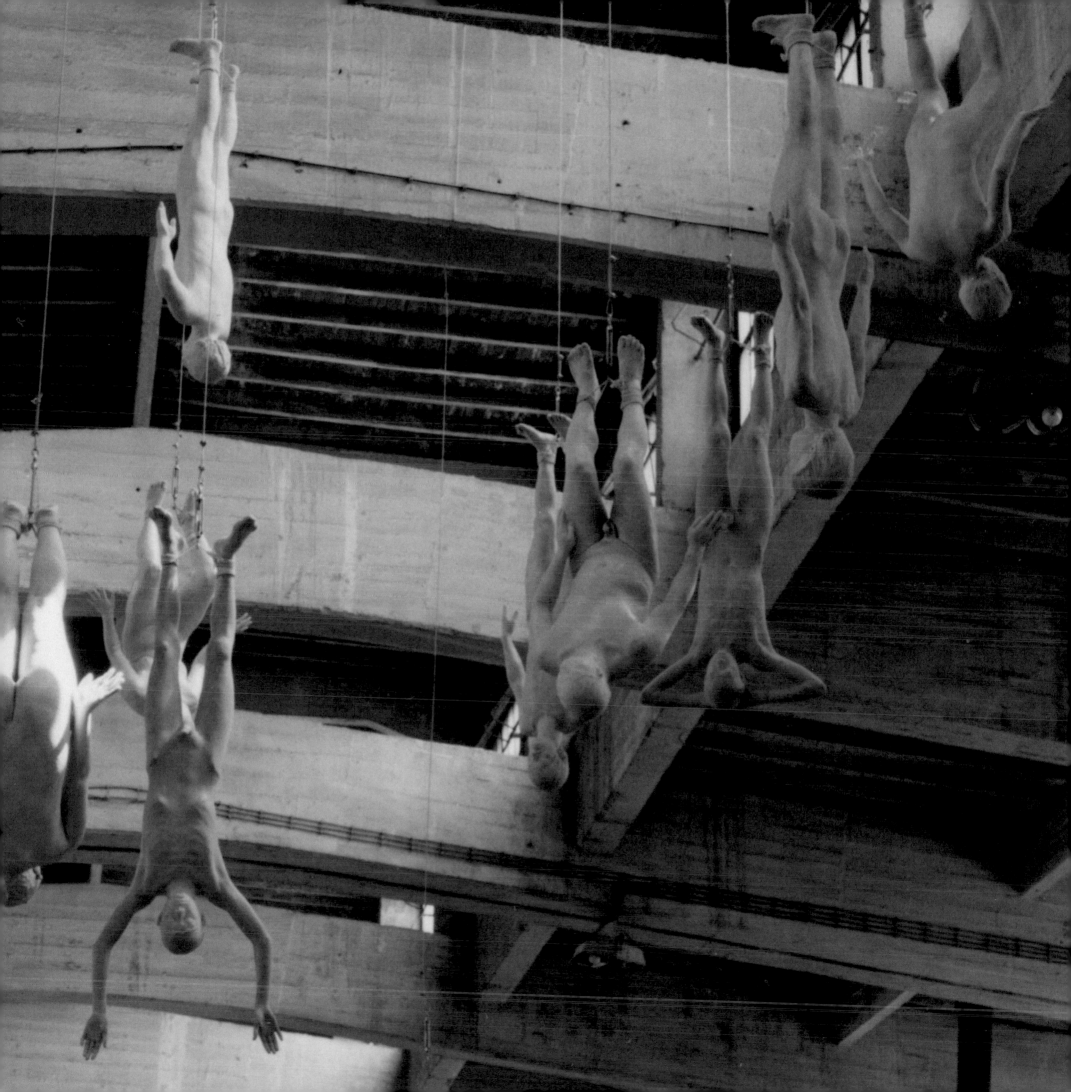

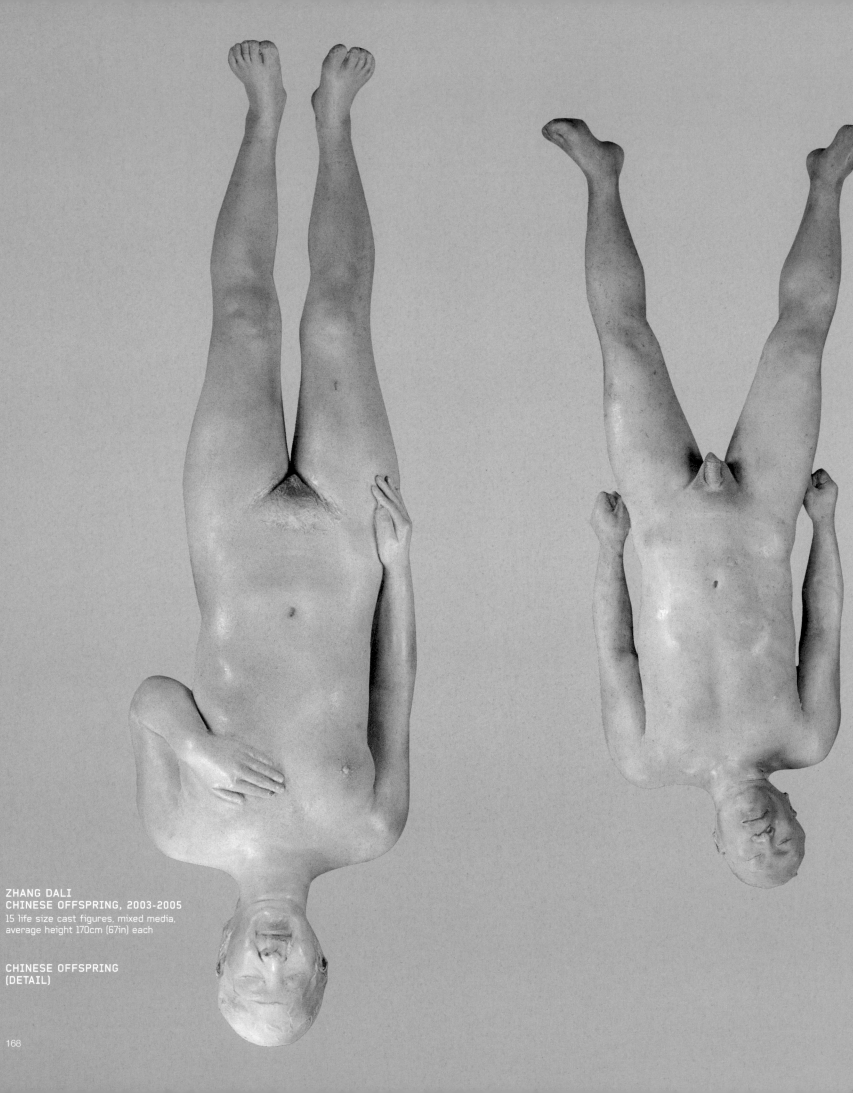

ZHANG DALI
CHINESE OFFSPRING, 2003-2005
15 life size cast figures, mixed media,
average height 170cm (67in) each

CHINESE OFFSPRING
(DETAIL)

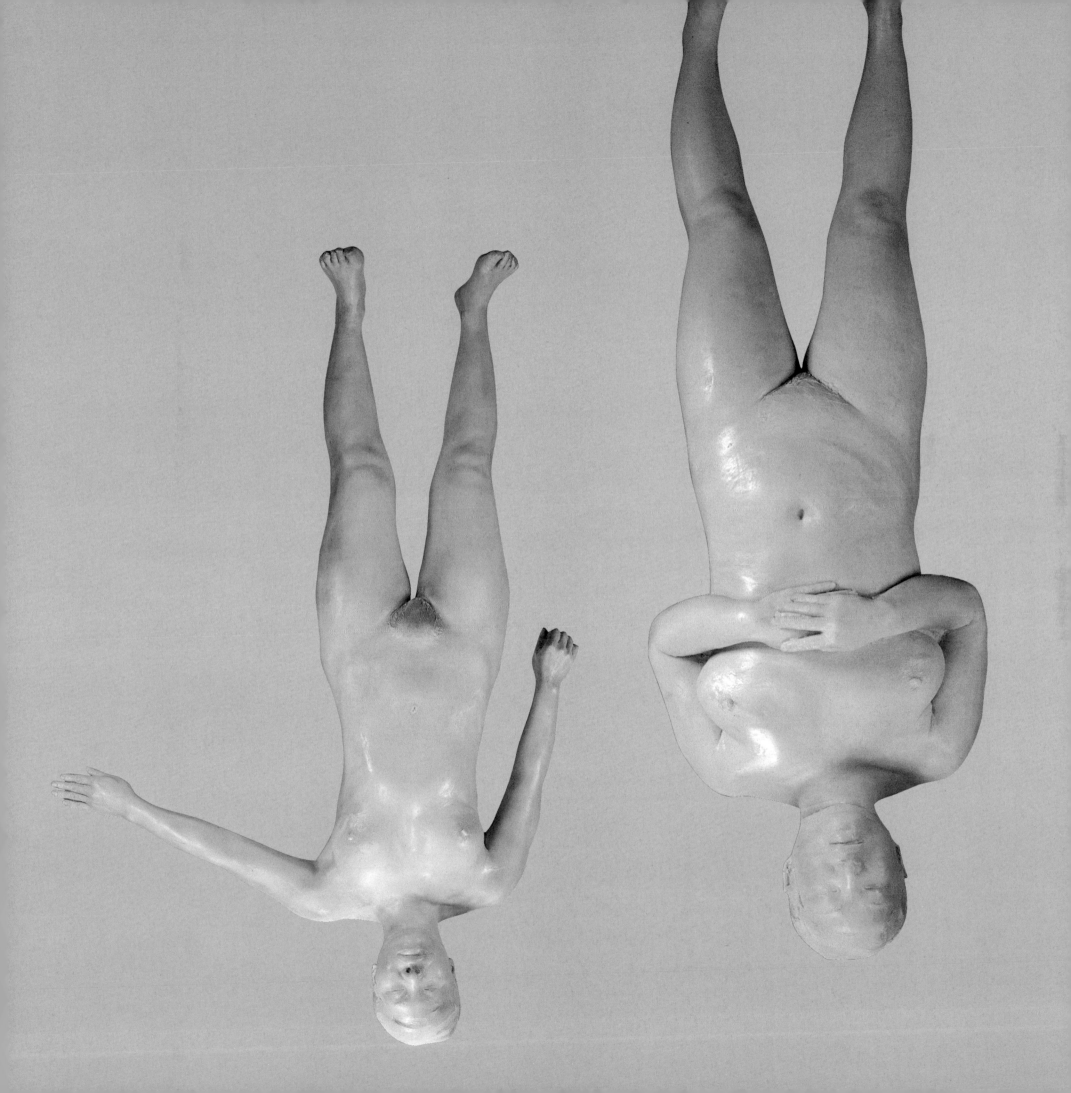

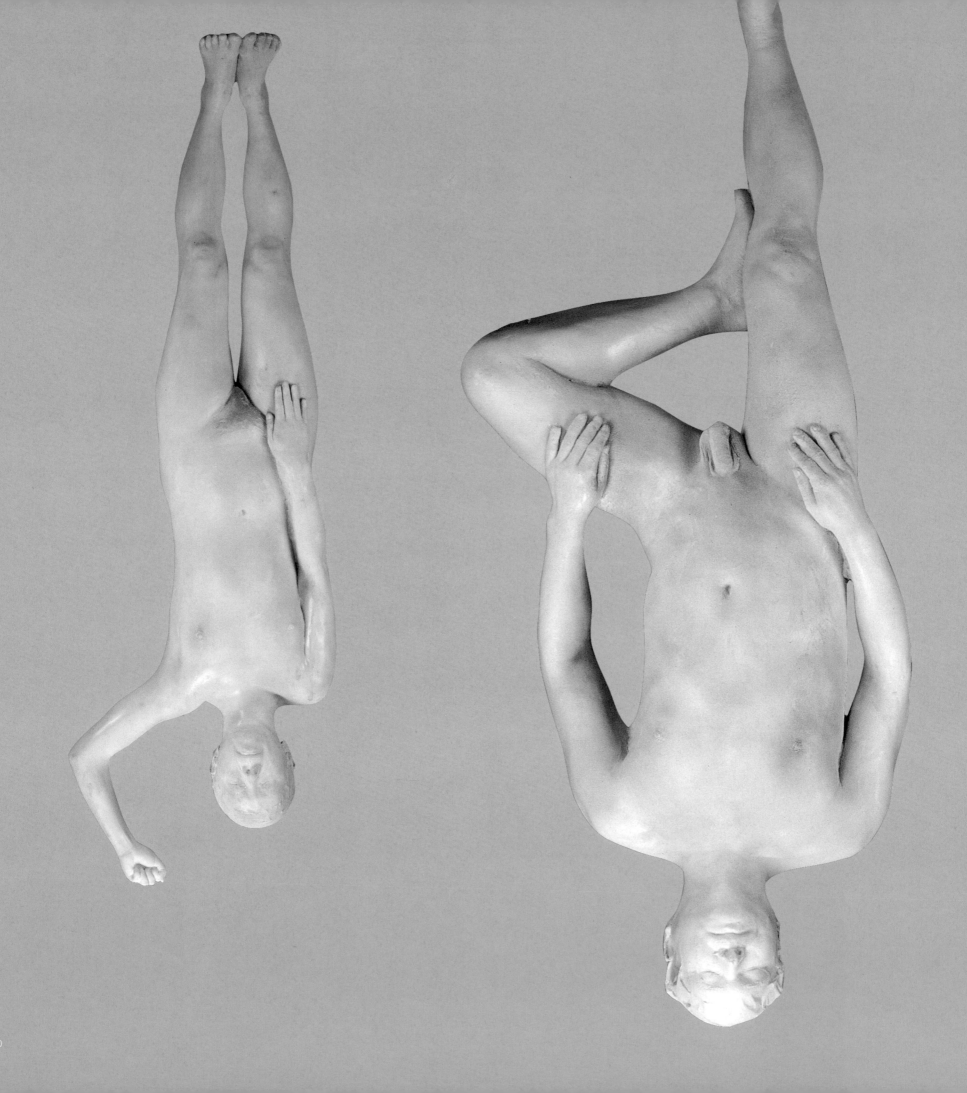

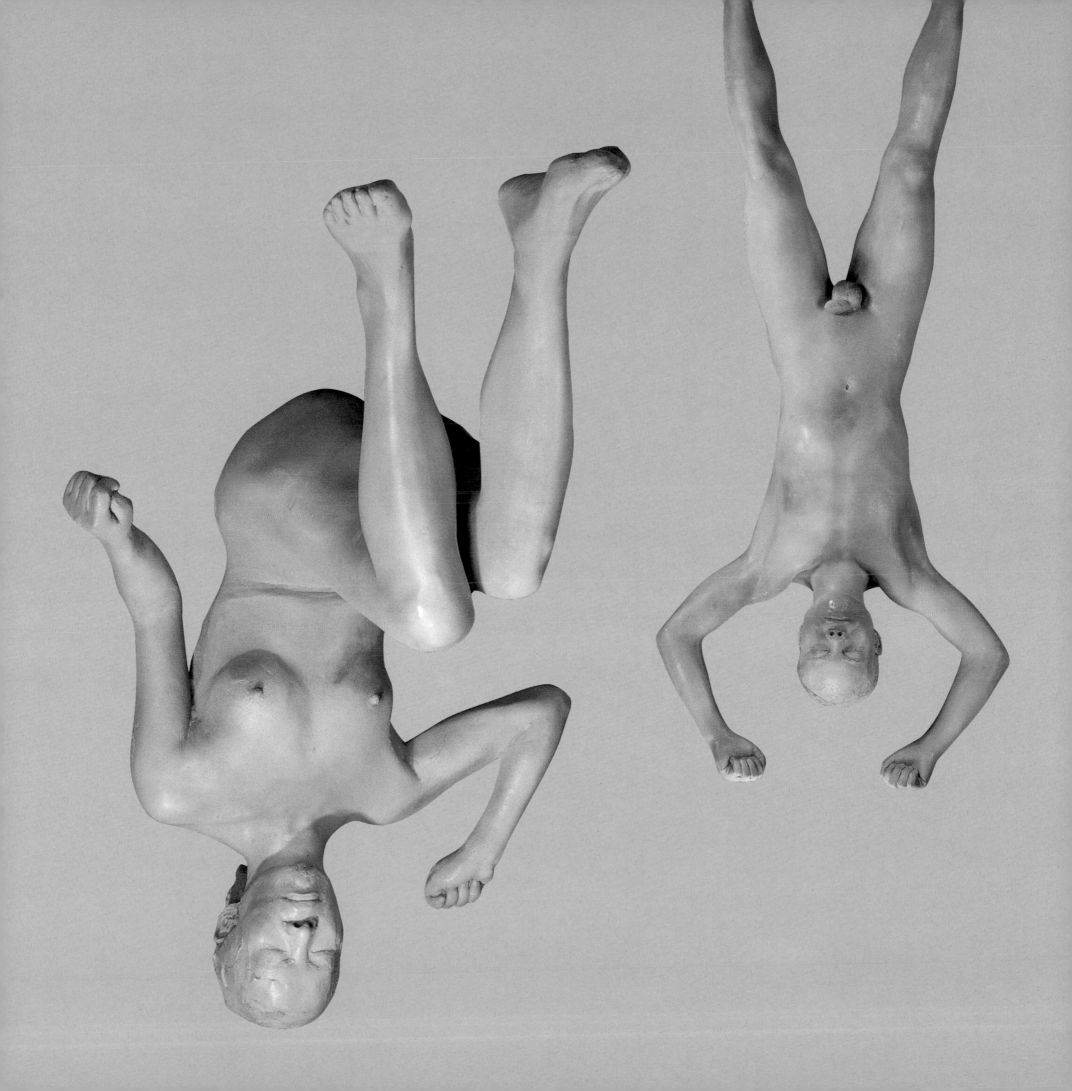

YIN ZHAOHUI
UNTITLED (FACE), 2007
oil on canvas,
200 x 200cm (78 3/4 x 78 3/4 in)

YIN ZHAOHUI
UNTITLED (FINGERS), 2007
oil on canvas,
200 x 300cm (78 3/4 x 118in)

SUN YUAN & PENG YU
OLD PERSONS HOME, 2007
13 life-sized sculptures and 13 dynamoelectric wheelchairs,
dimensions variable

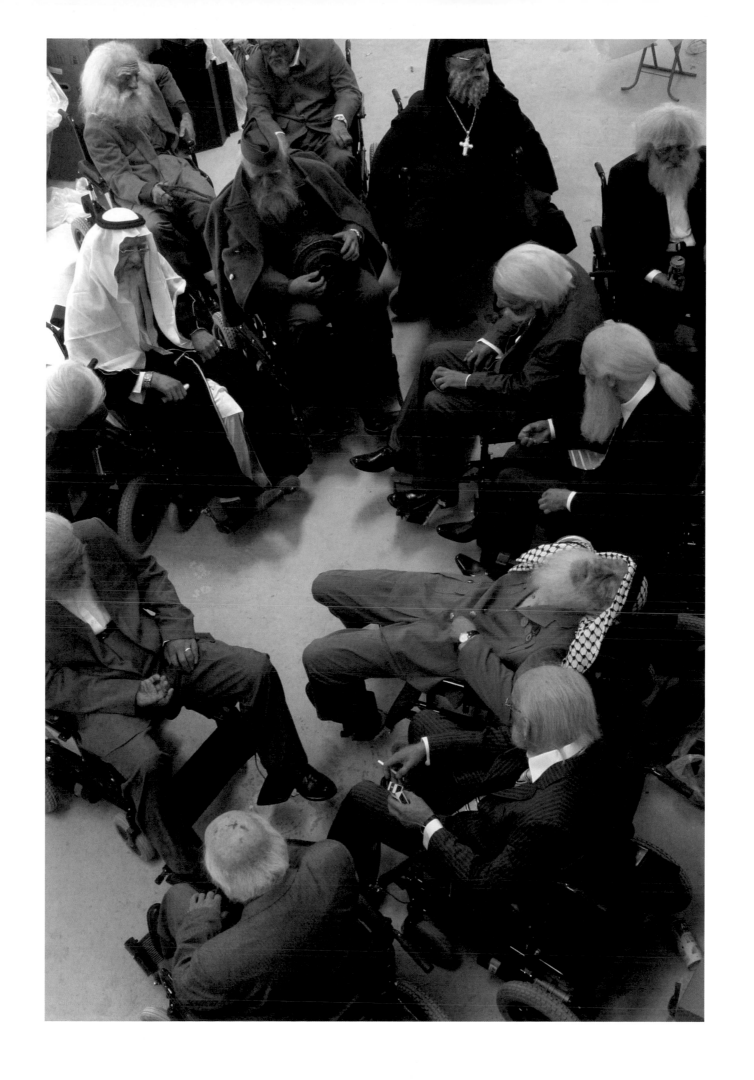

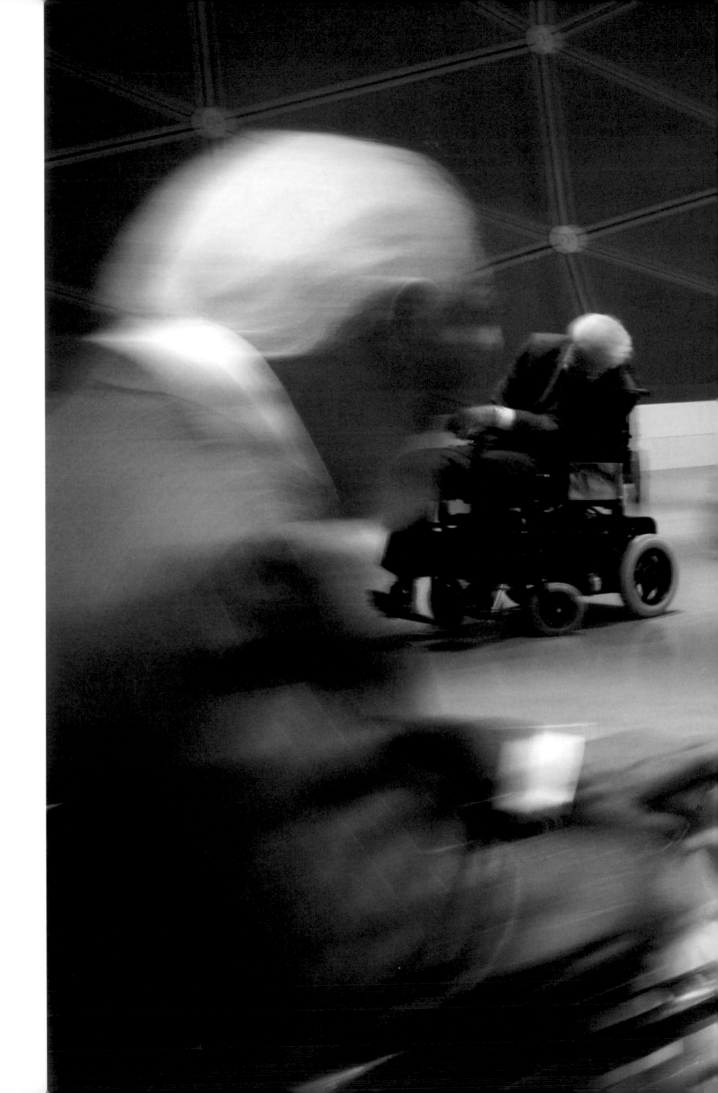

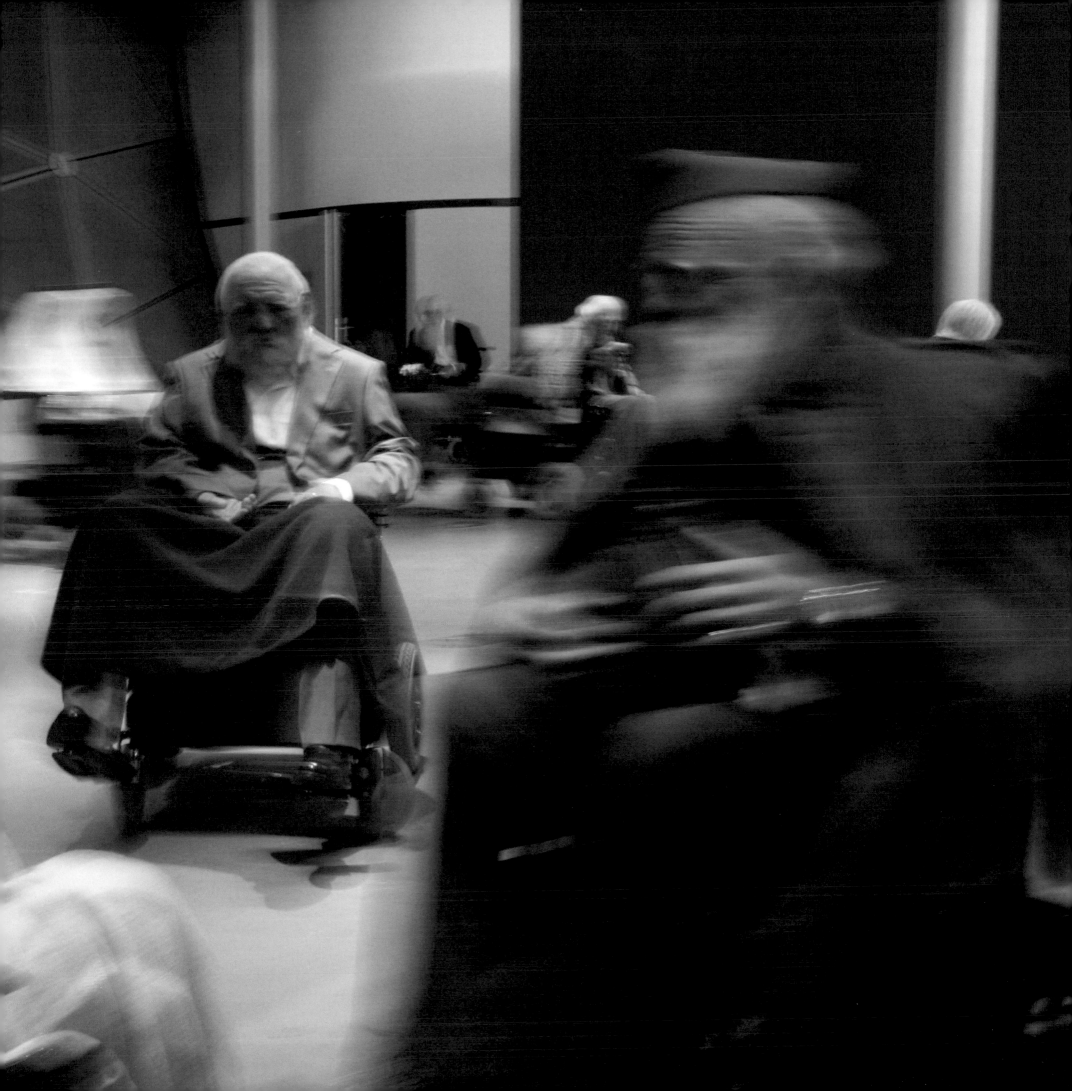

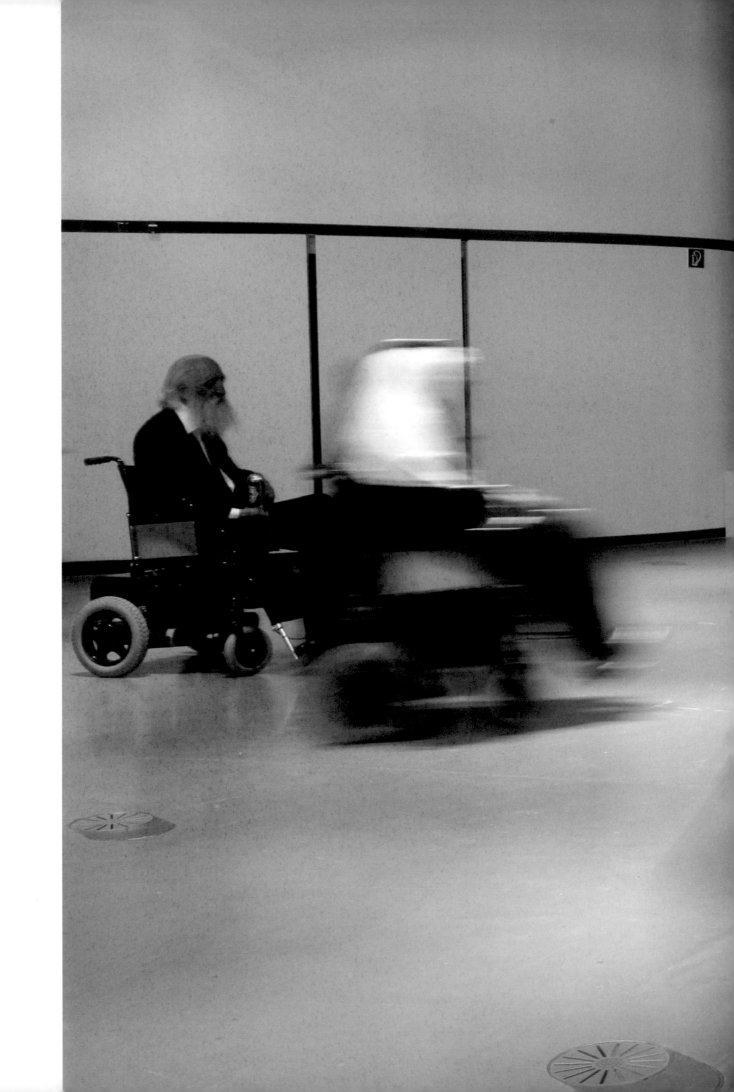

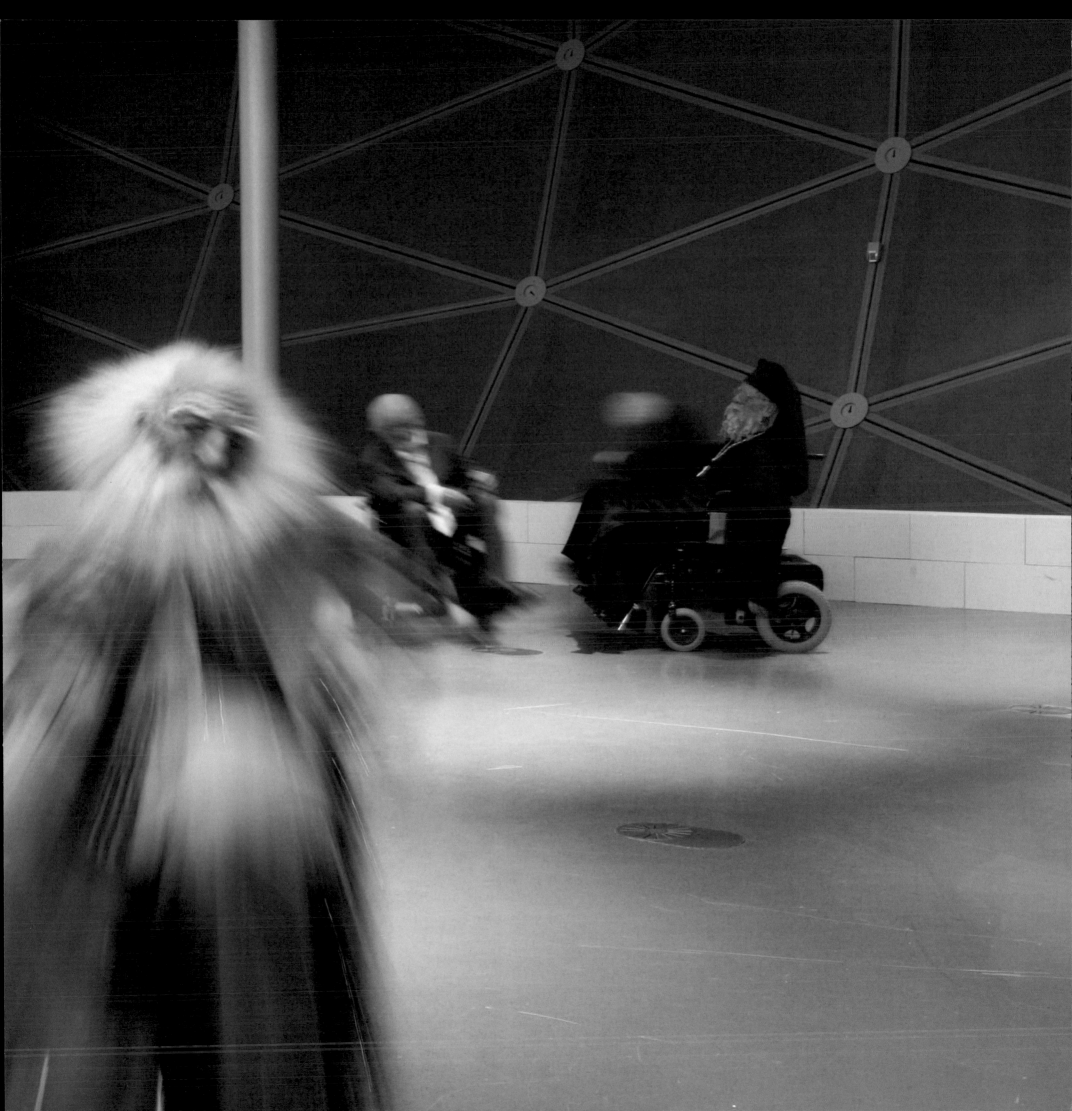

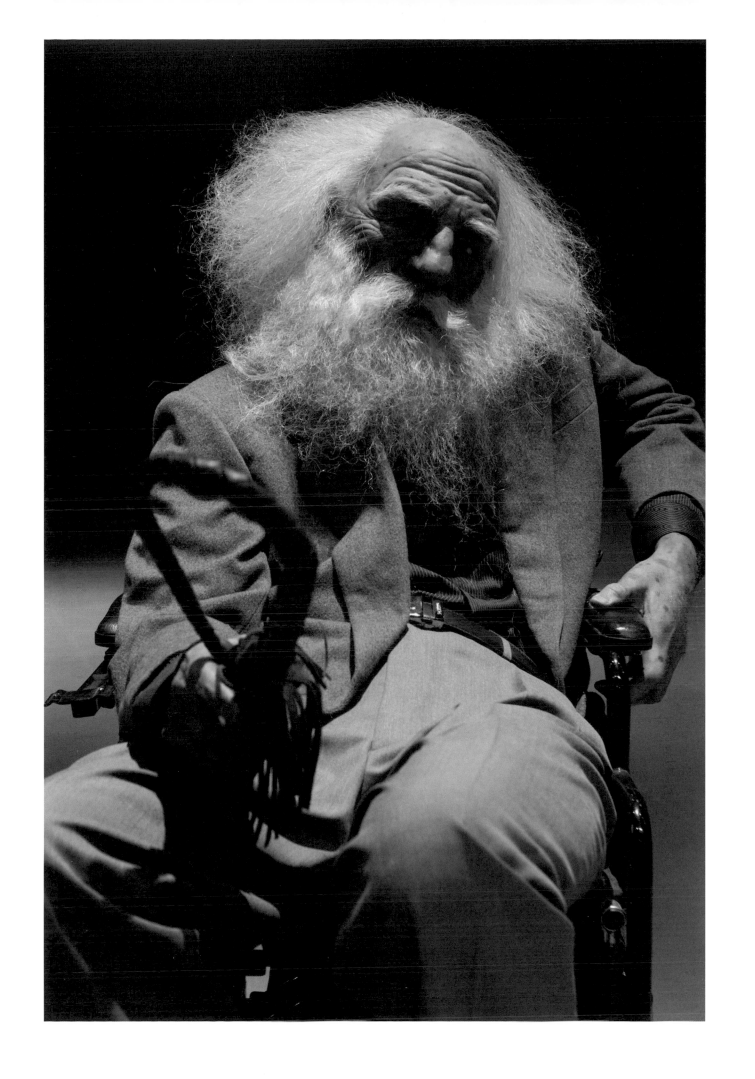

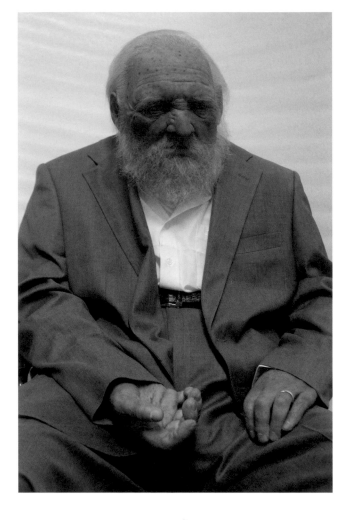
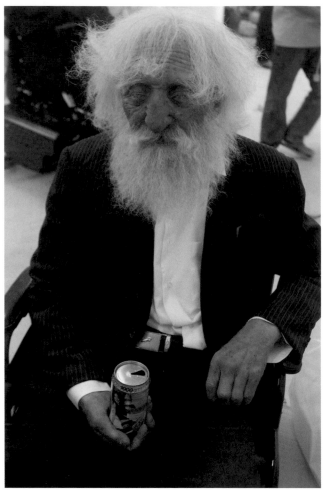
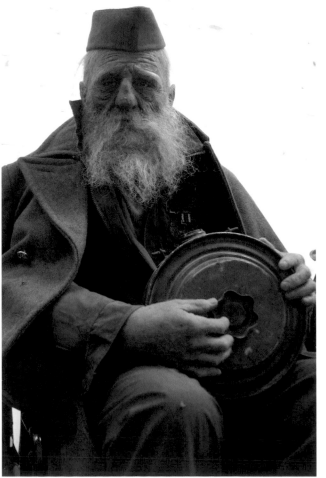
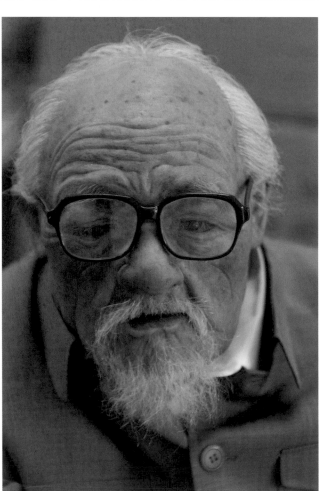

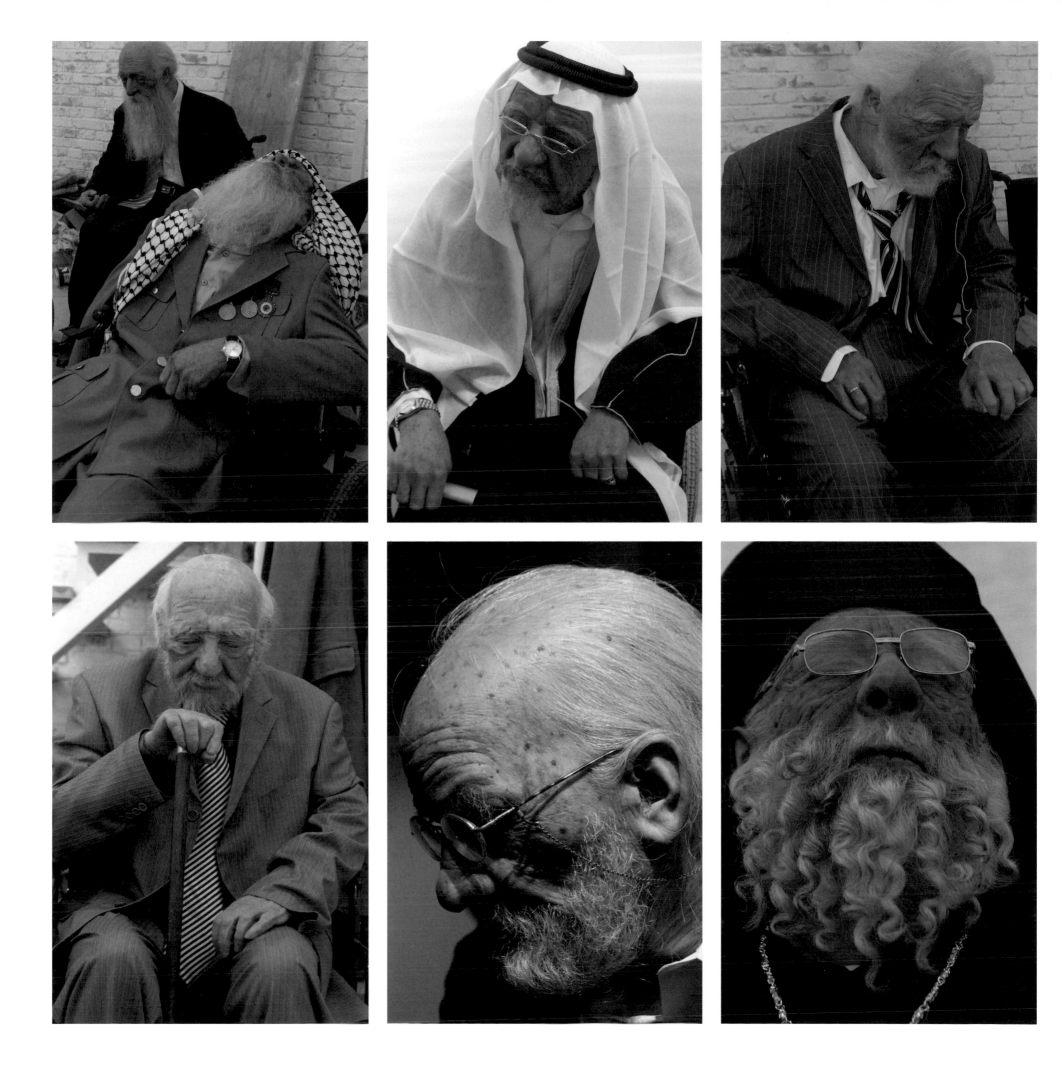

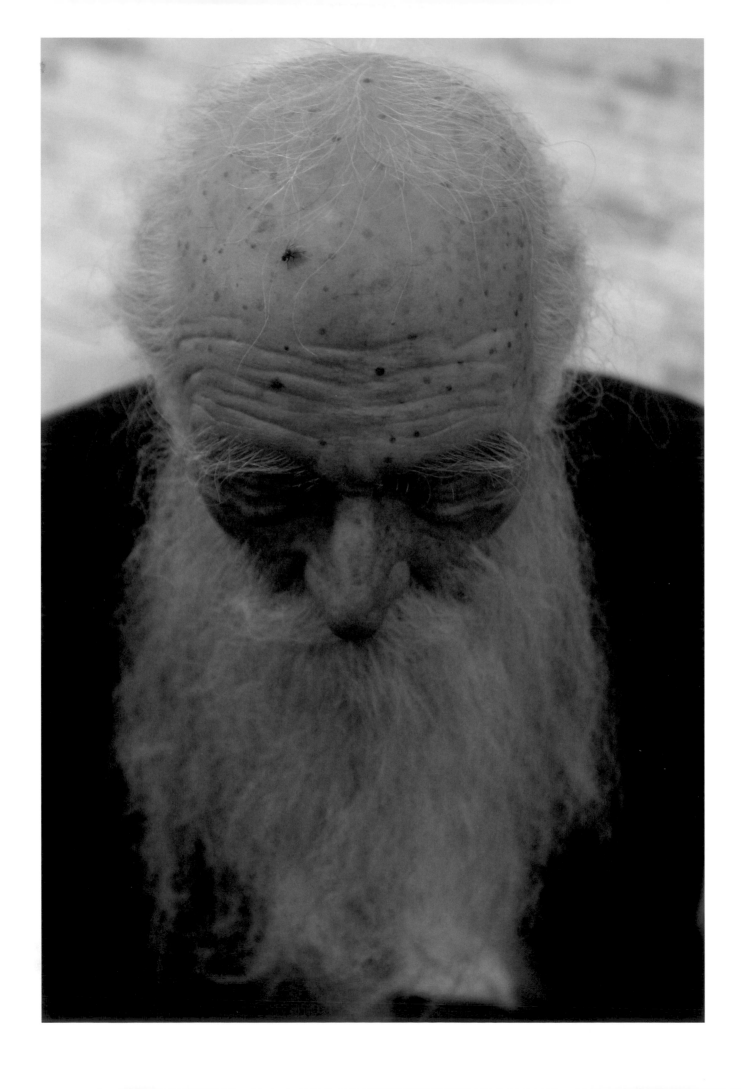

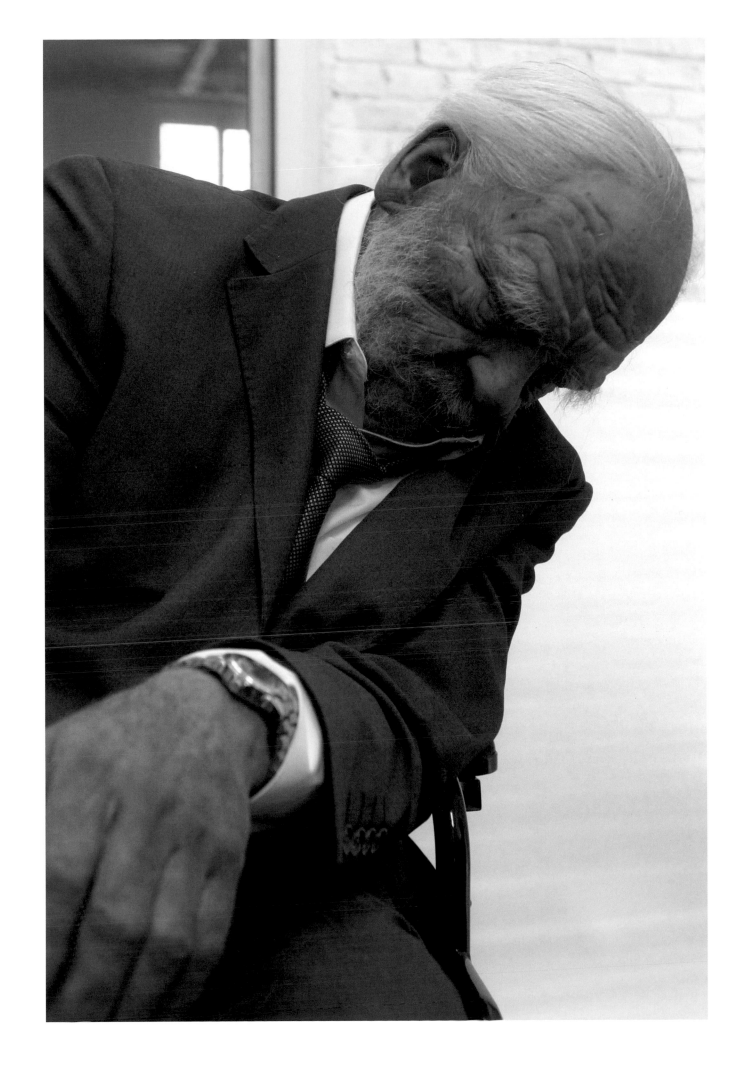

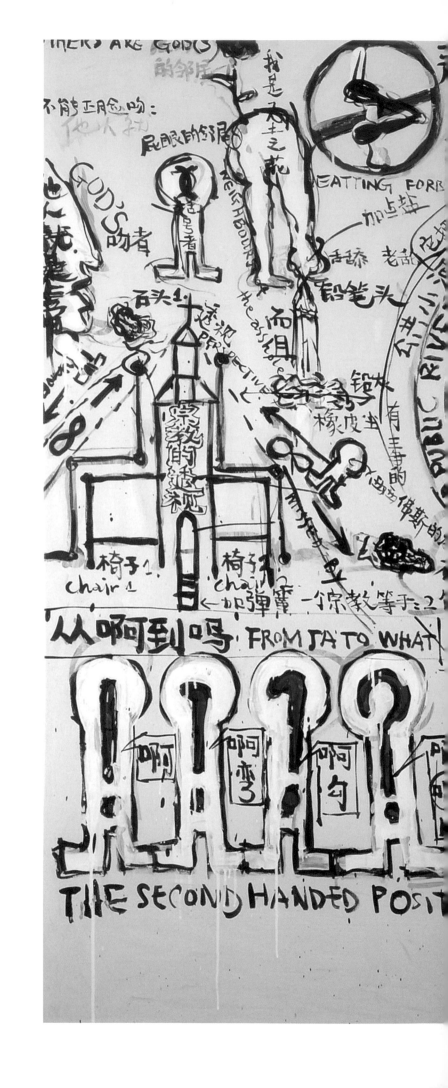

WU SHANZHUAN
TODAY NO WATER - CHAPTER 29, 2007
acrylic and oil based marker on canvas,
200 x 300cm (78 3/4 x 118in)

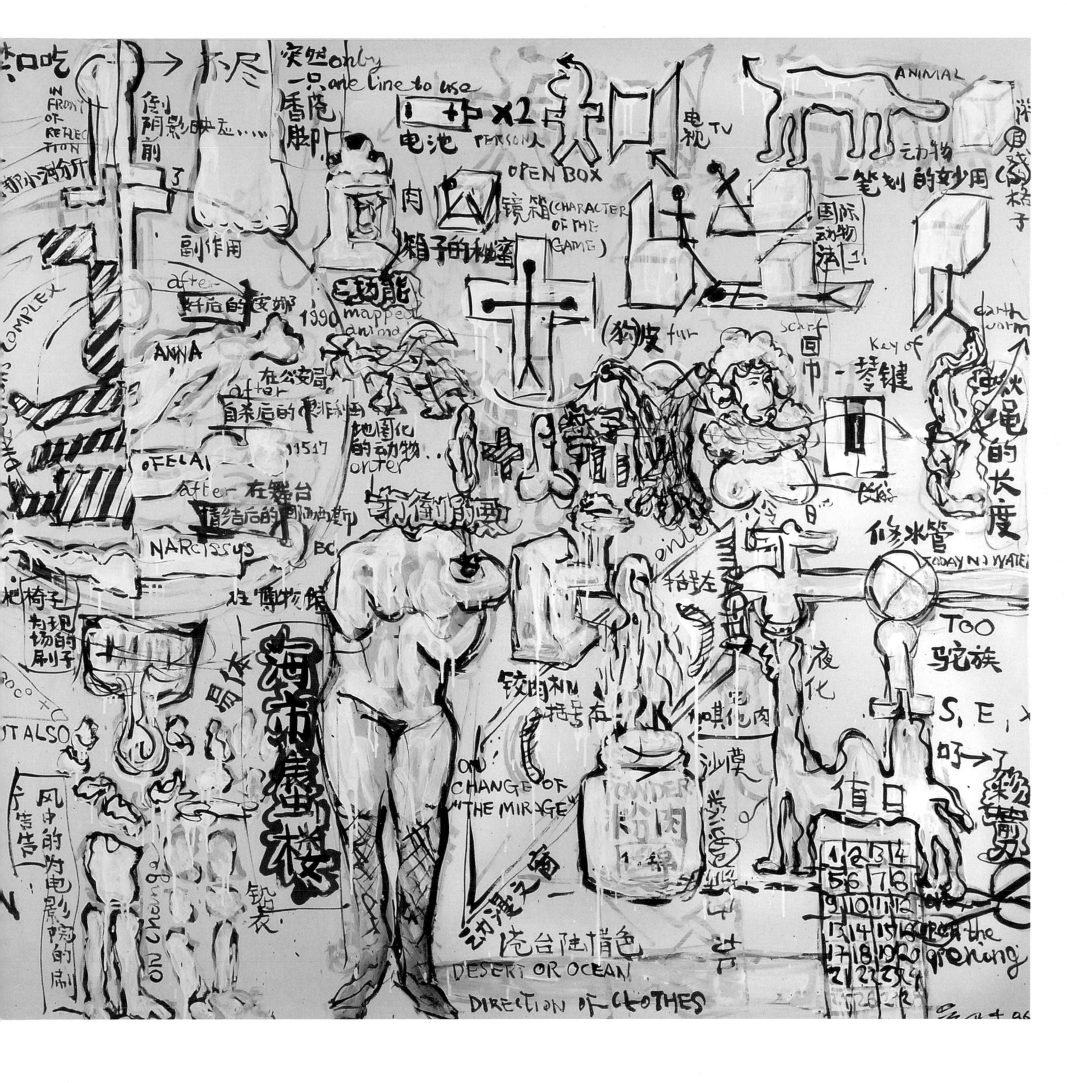

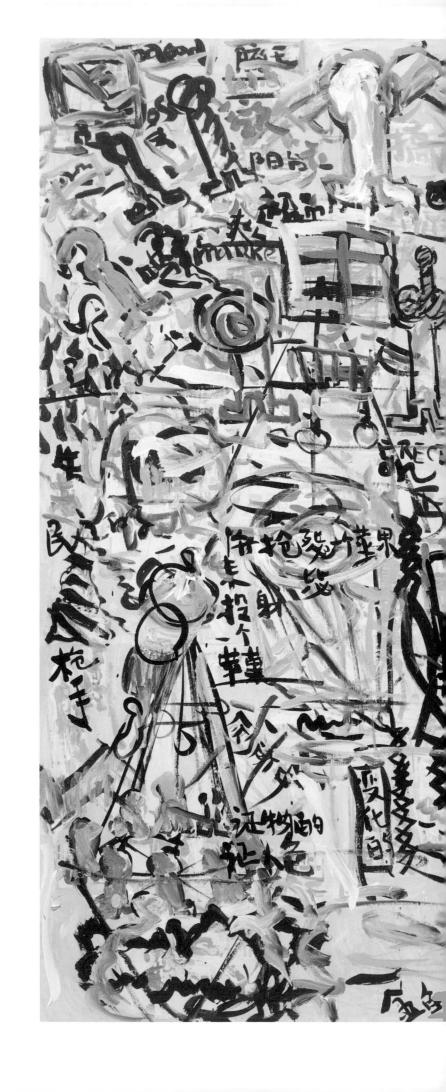

WU SHANZHUAN
TODAY NO WATER - CHAPTER 30, 2007
acrylic and oil based marker on canvas,
200 x 300cm (78 1/2 x 118in)

190

WU SHANZHUAN
NEW ARTWORK NO.1, 2008
acrylic and oil based marker on canvas,
200 x 300cm (78 1/2 x 118in)

WU SHANZHUAN
NEW ARTWORK NO.3, 2008
acrylic and oil based marker on canvas,
200 x 300cm (78 1/2 x 118in)

194

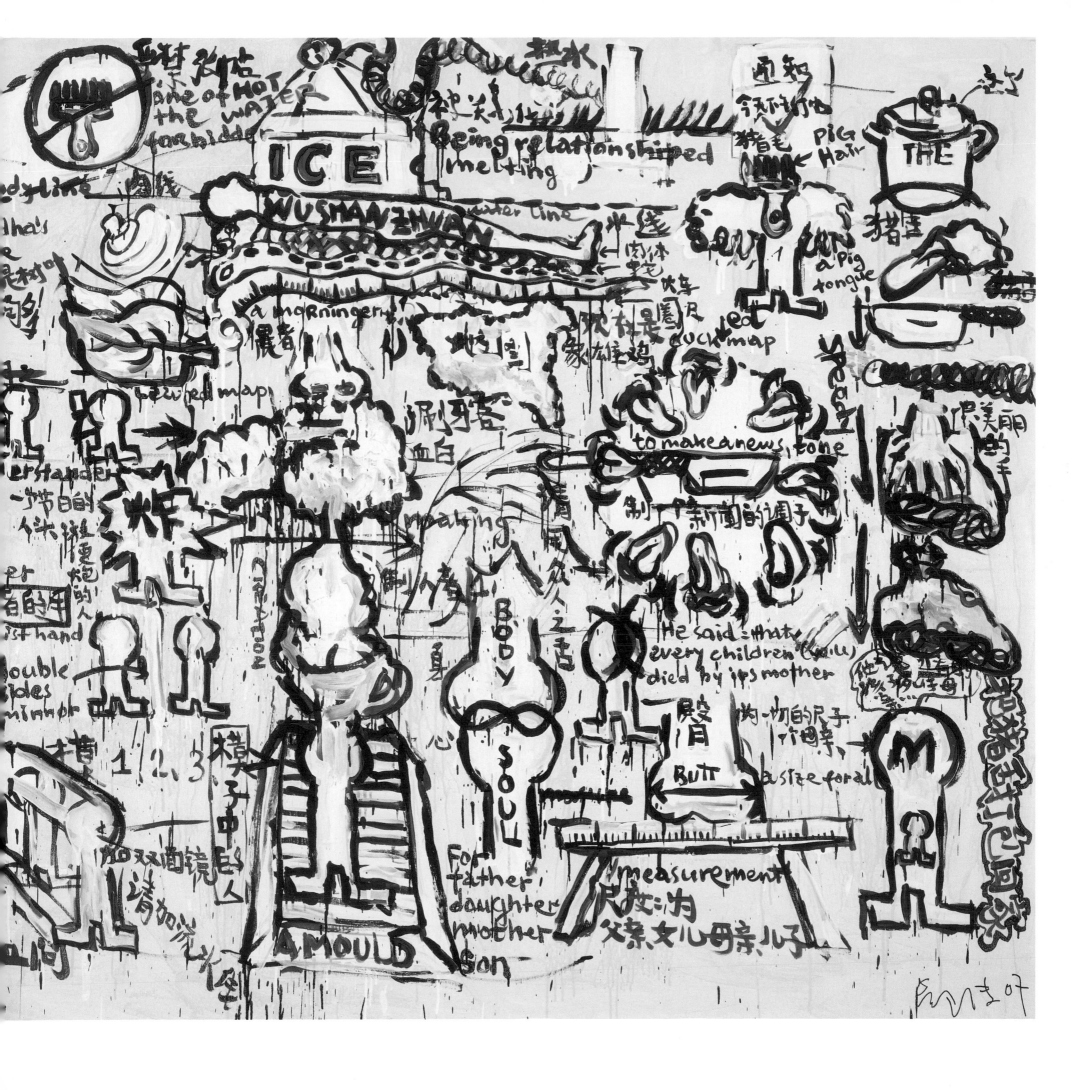

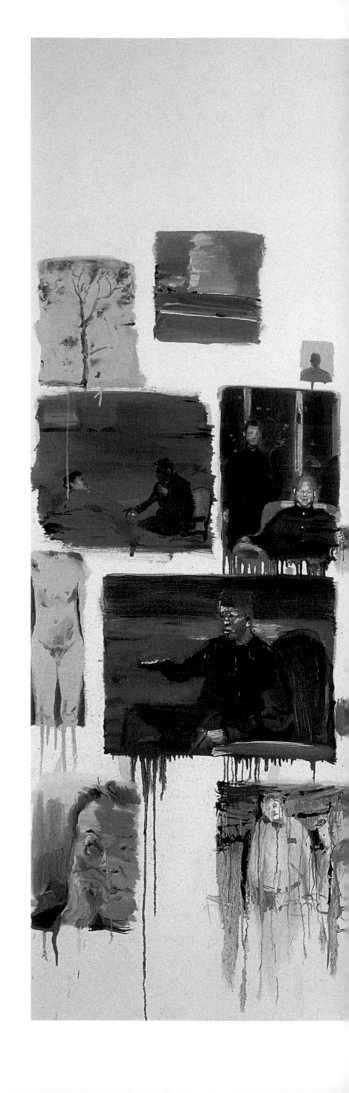

ZHANG YUAN
9 O'CLOCK, 2007
oil on canvas,
210 x 295cm (82 3/4 x 116in)

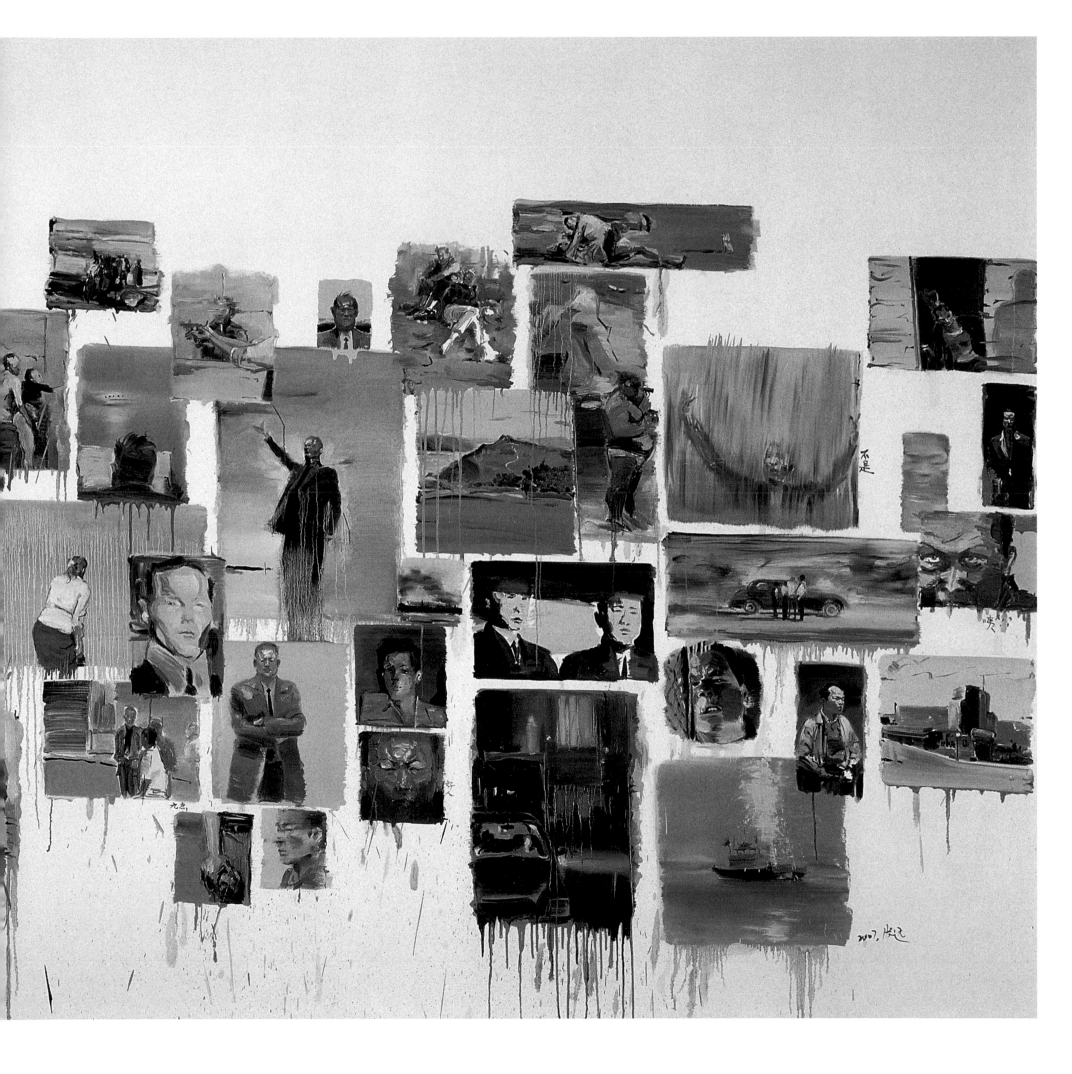

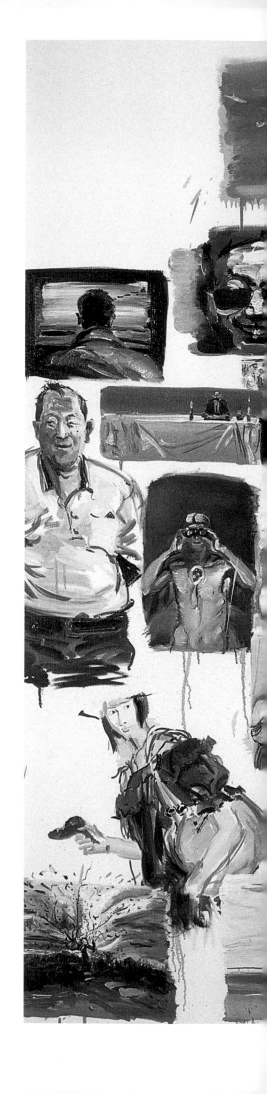

ZHANG YUAN
BRILLIANCE, 2007
oil on canvas,
210 x 280cm (82 3/4 x 110 1/4 in)

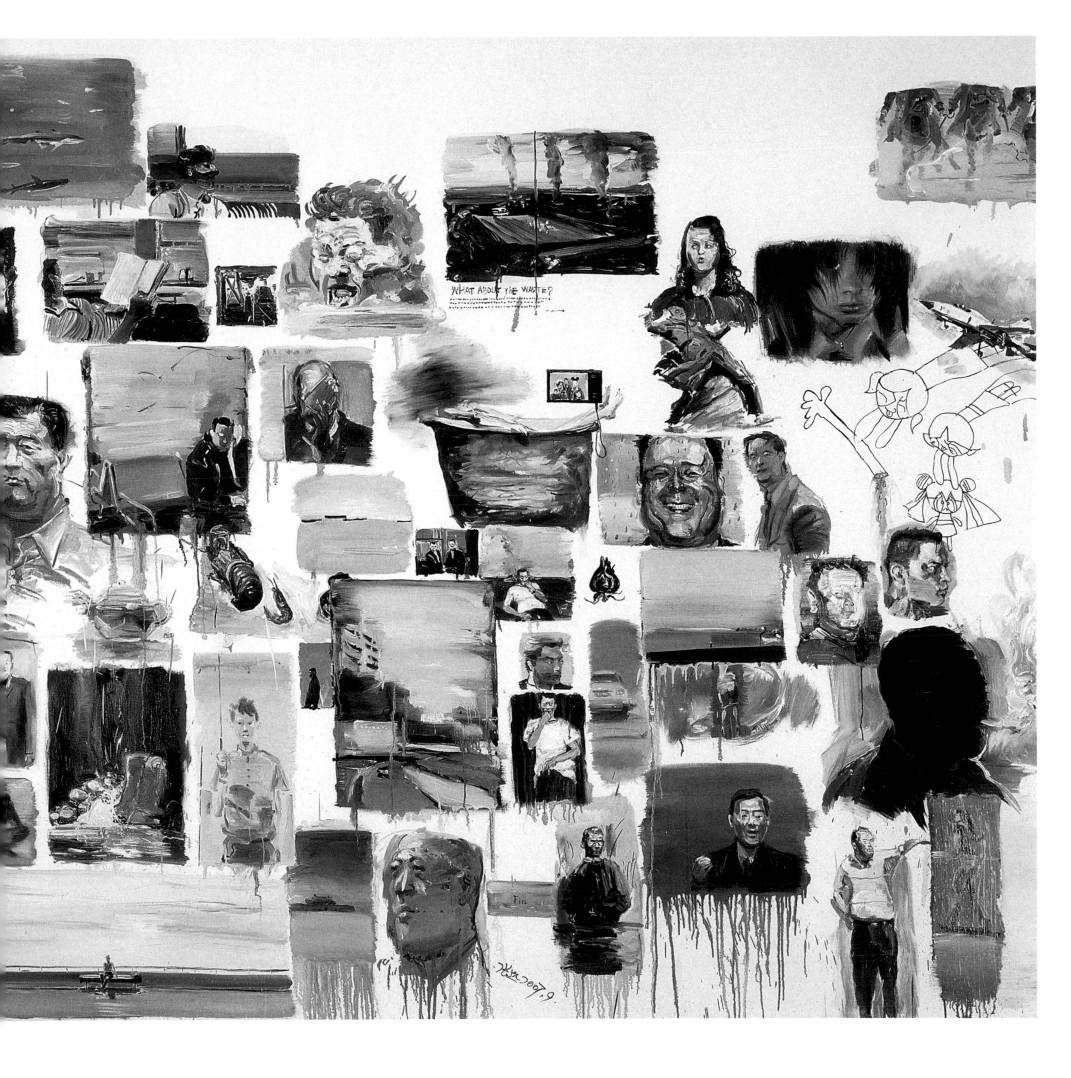

ZHANG YUAN
FOG'S COLOUR, 2007
oil on canvas,
210 x 280cm (82 3/4 x 110 1/4 in)

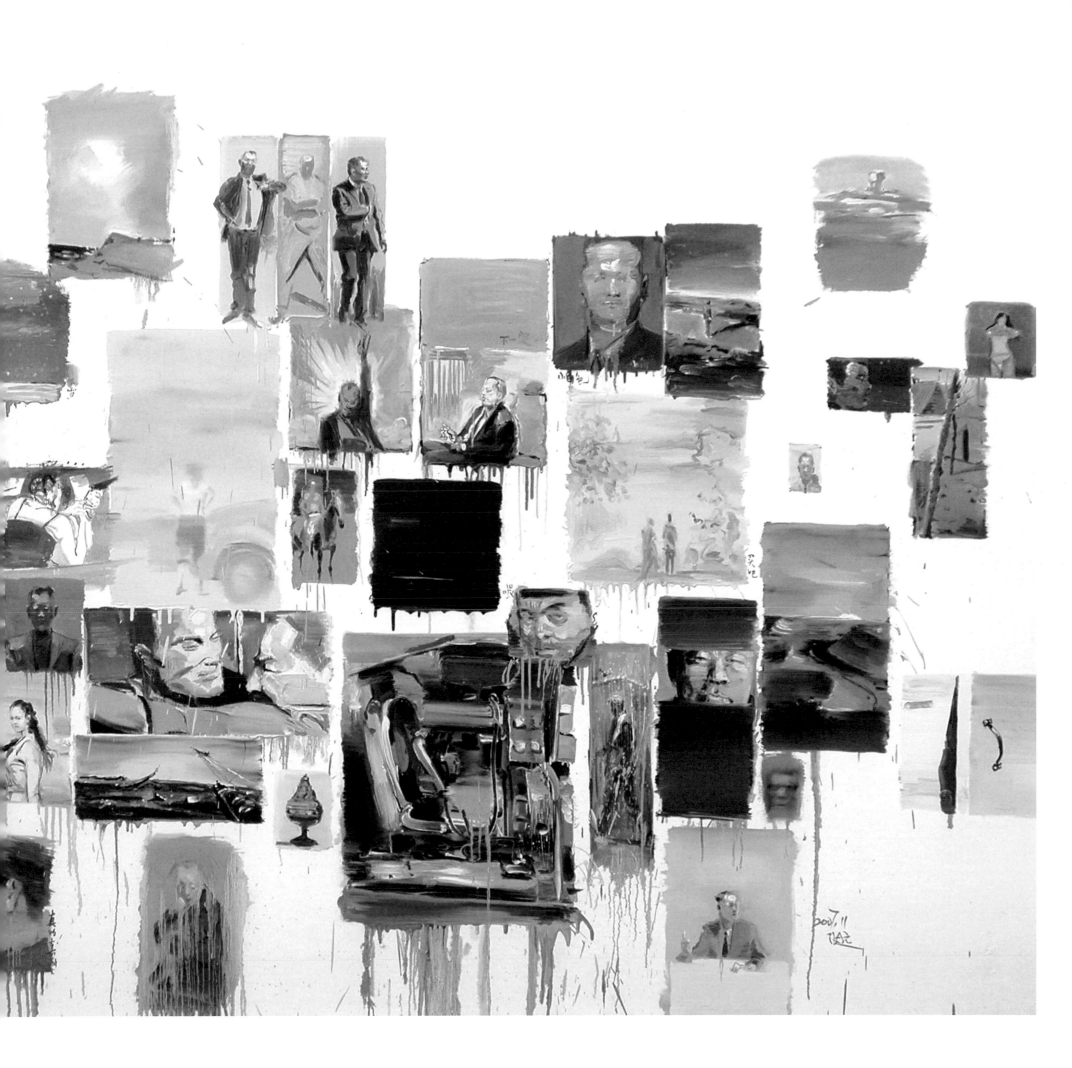

FENG ZHENGJIE
CHINESE PORTRAIT L SERIES NO.11, 2006
oil on canvas,
210 x 300cm (82 3/4 x 118in)

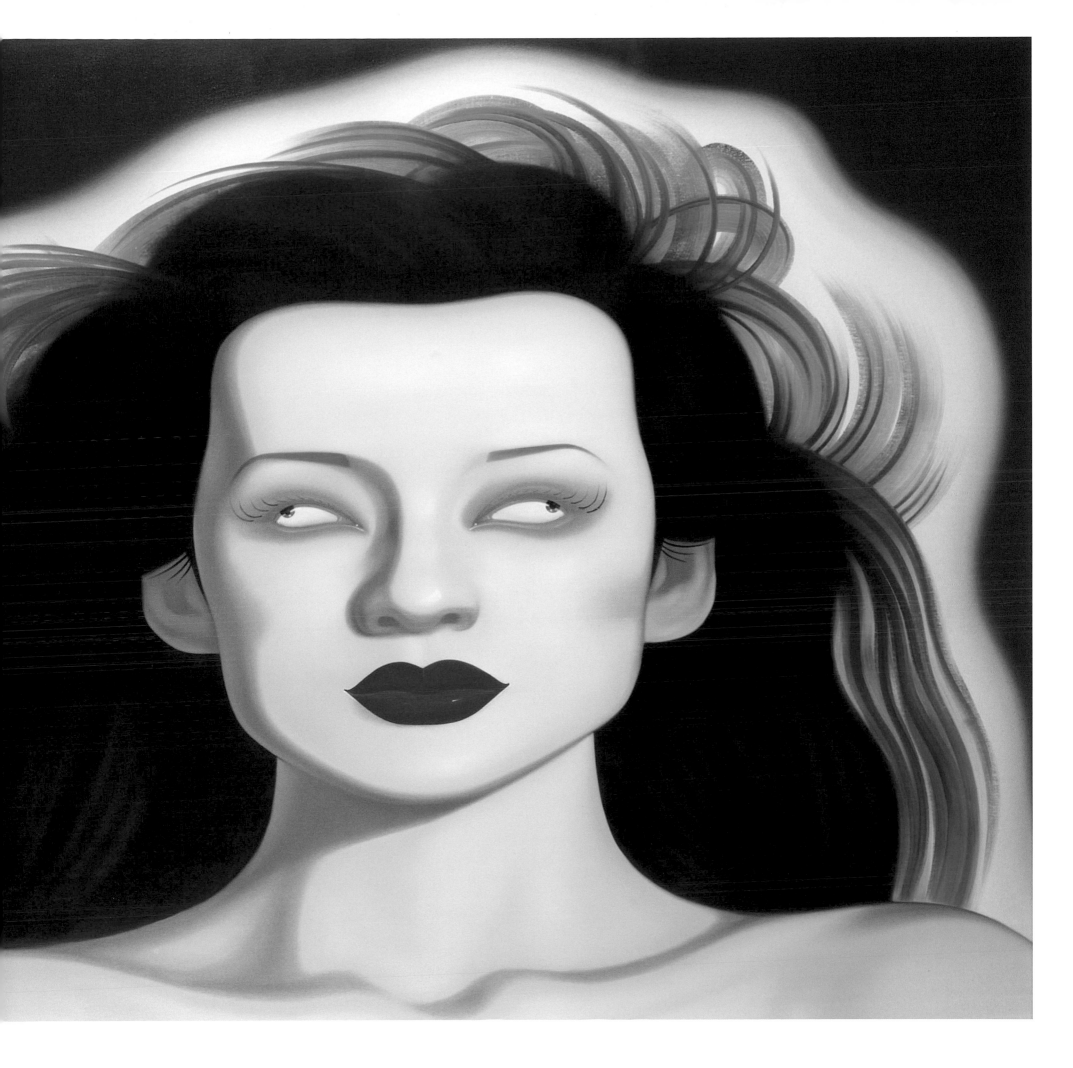

FENG ZHENGJIE
CHINESE PORTRAIT P SERIES NO.1, 2006
oil on canvas,
300 x 400cm (118 x 157$^{1/2}$ in)

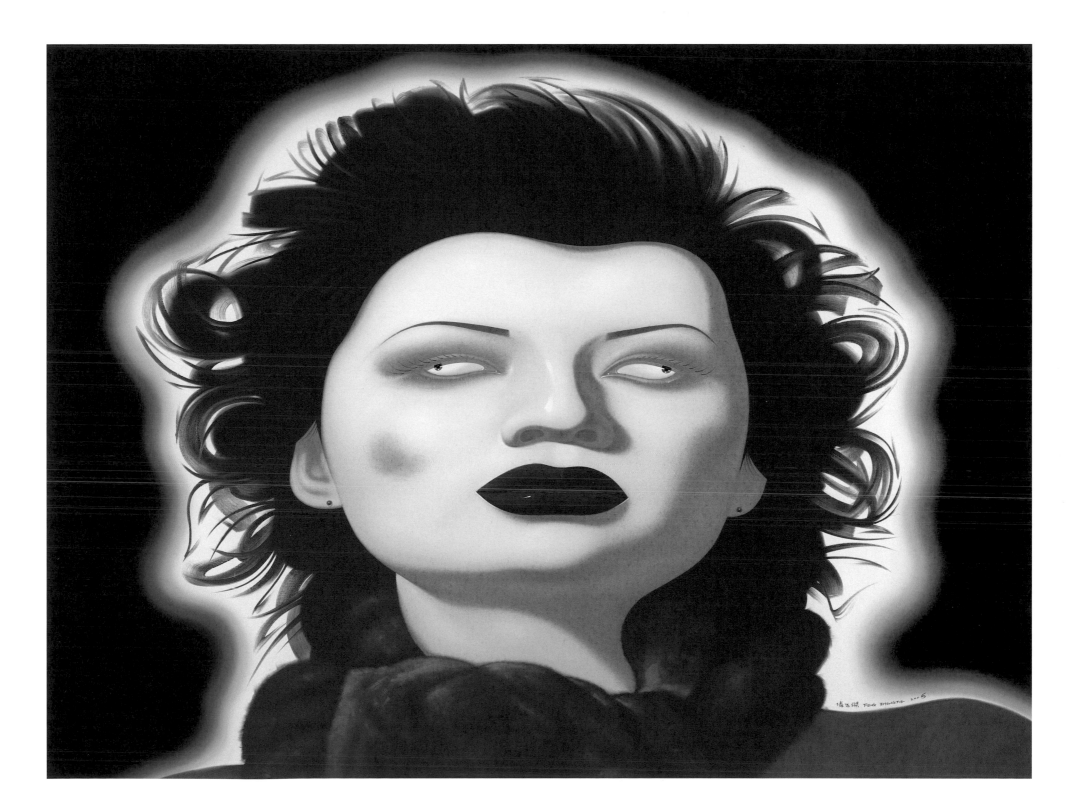

FENG ZHENGJIE
CHINESE PORTRAIT P SERIES NO.2, 2006
oil on canvas,
300 x 400cm (118 x 157$^{1/2}$ in)

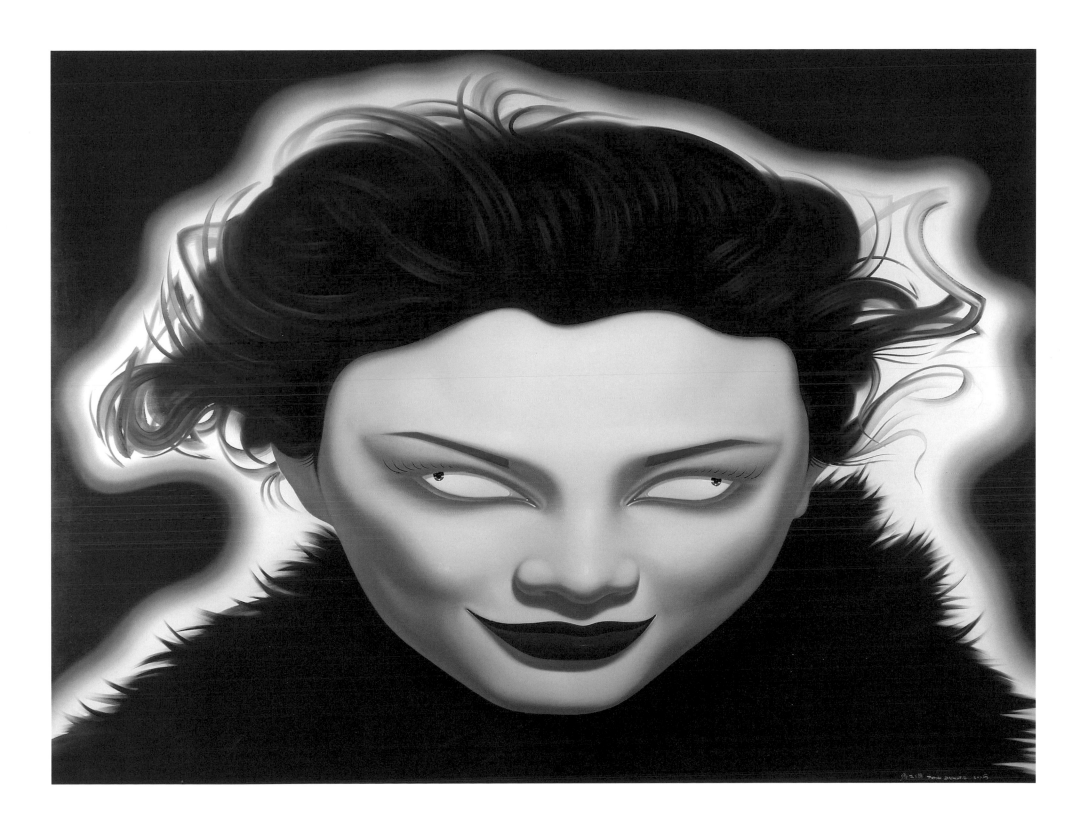

FENG ZHENGJIE
CHINESE PORTRAIT L SERIES NO.10, 2006
oil on canvas,
210 x 300cm (82 3/4 x 118in)

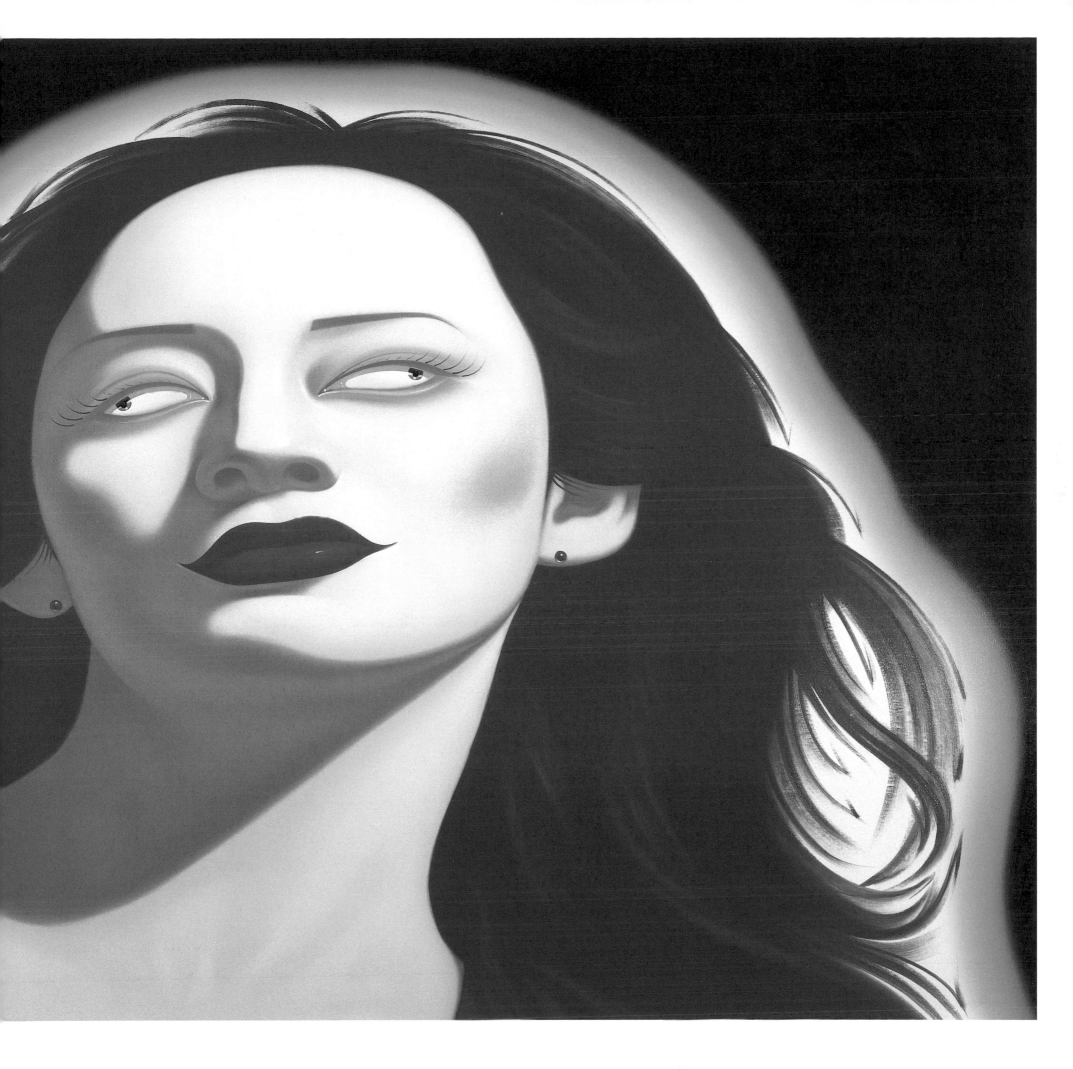

ZHANG PENG
YI FAN NO.1, 2006
photograph,
120 x 120cm (47 1/4 x 47 1/4 in)

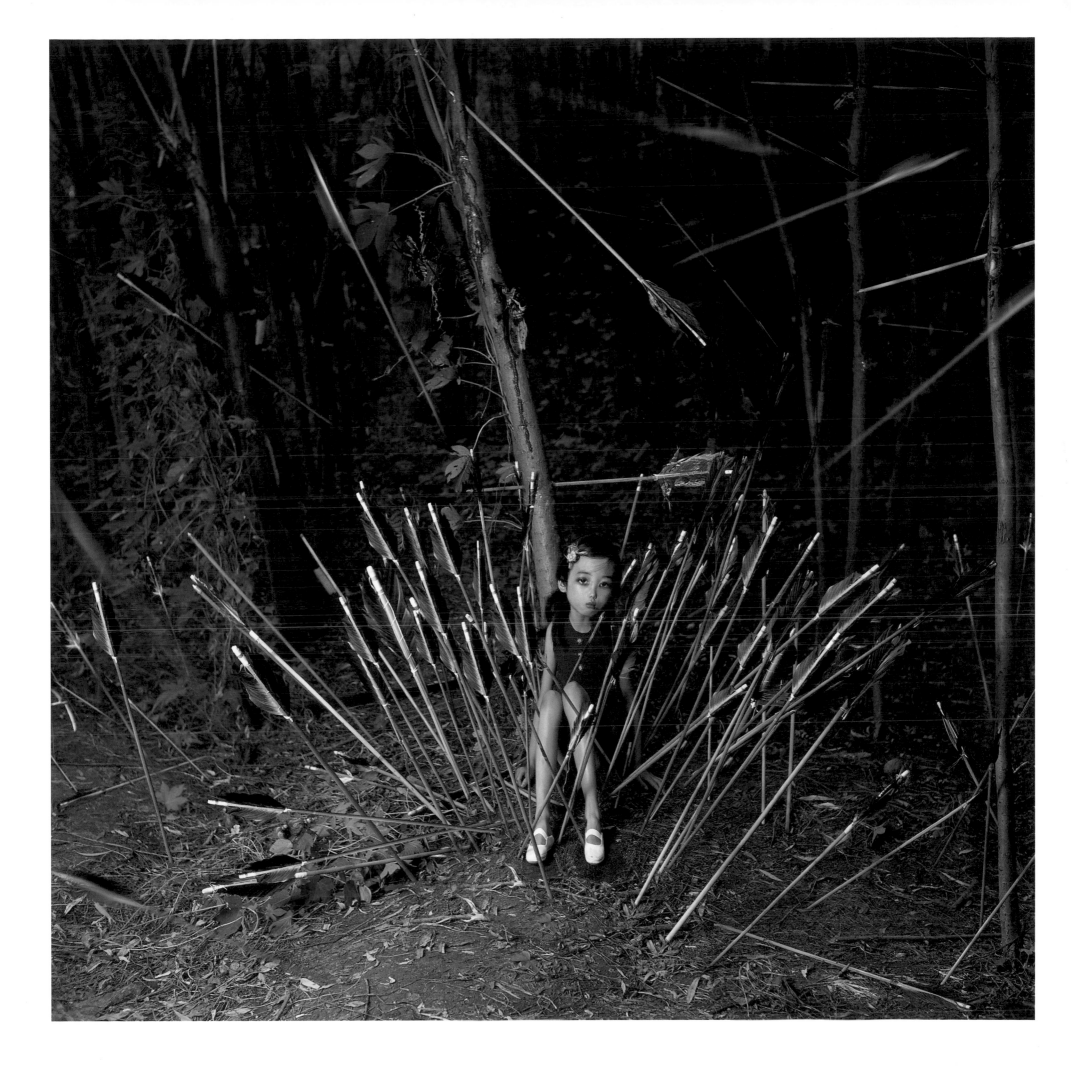

ZHANG PENG
YI FAN NO.2, 2006
photograph,
120 x 120cm (47 1/4 x 47 1/4 in)

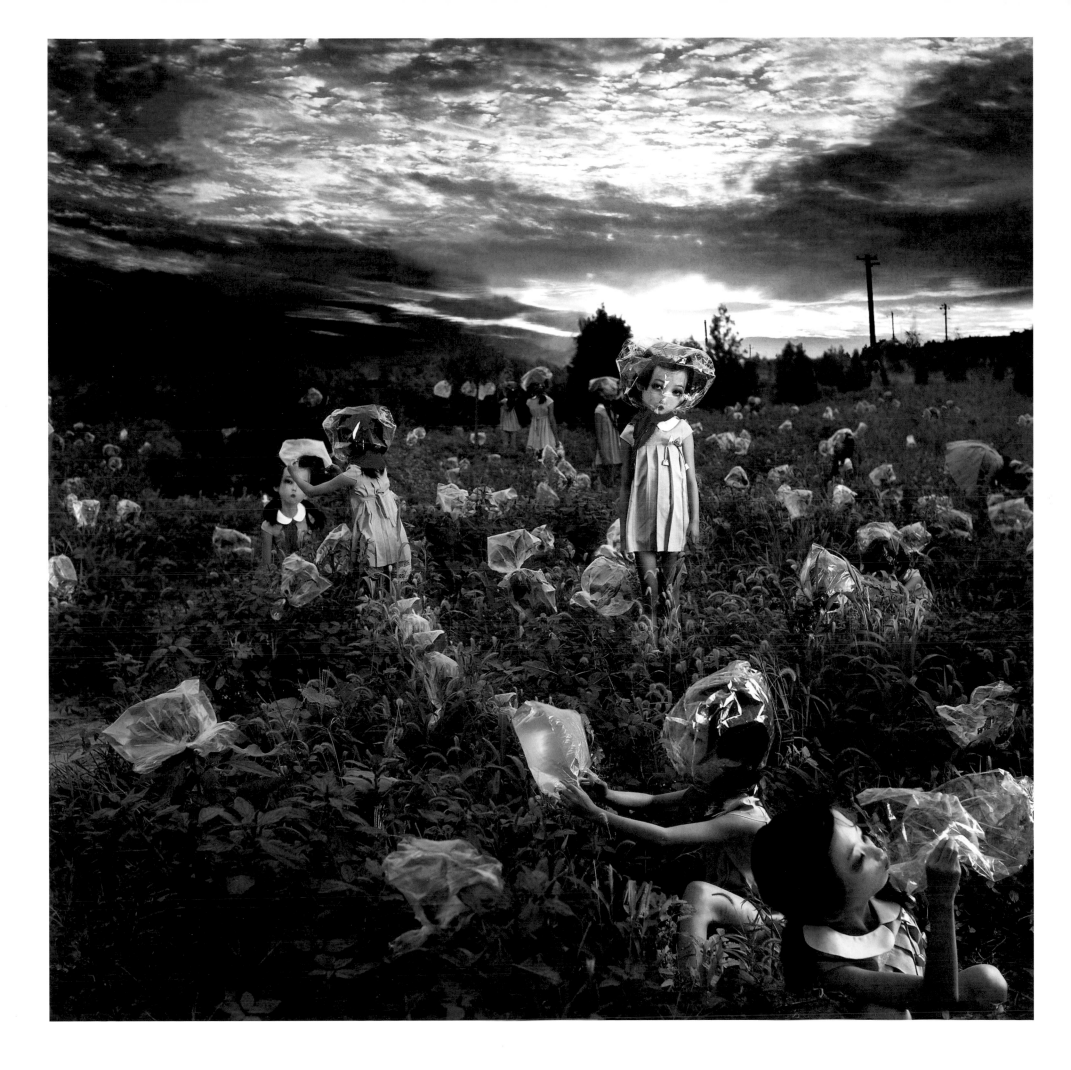

ZHANG PENG
GUI FEI, 2007
photograph,
193 x 150cm (76 x 59in)

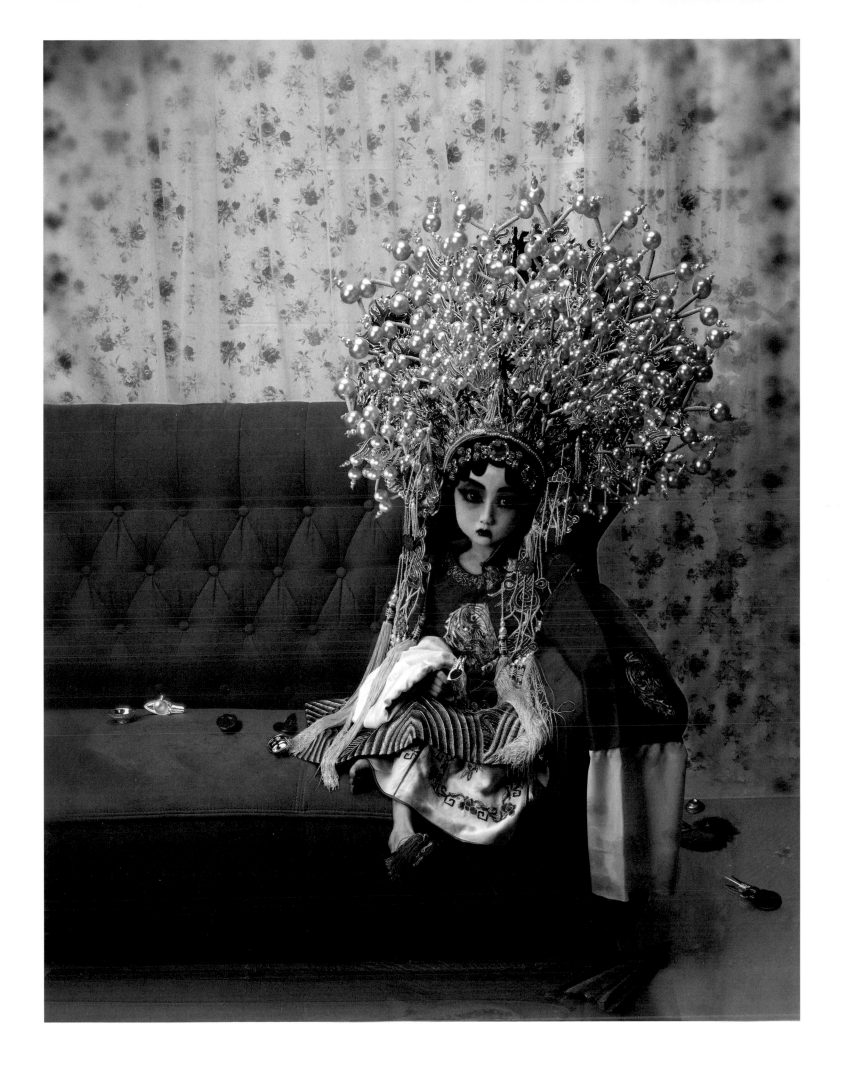

ZHANG HAIYING
ANTI-VICE CAMPAIGN SERIES – 005, 2007
oil on canvas,
200 x 300cm (78 3/4 x 118in)

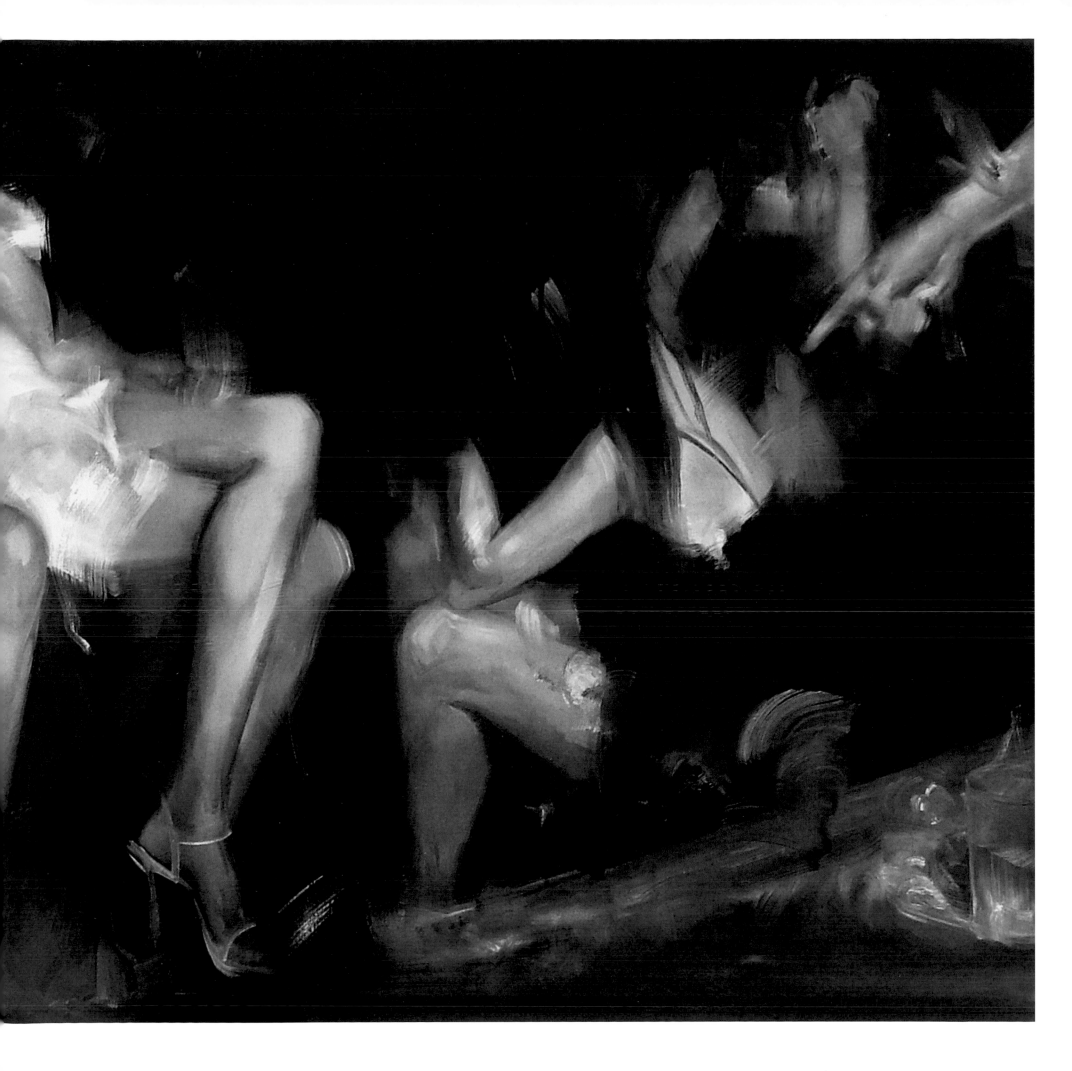

ZHANG HAIYING
ANTI-VICE CAMPAIGN SERIES – 001, 2005
oil on canvas,
300 x 400cm (118 x 157 1/2 in)

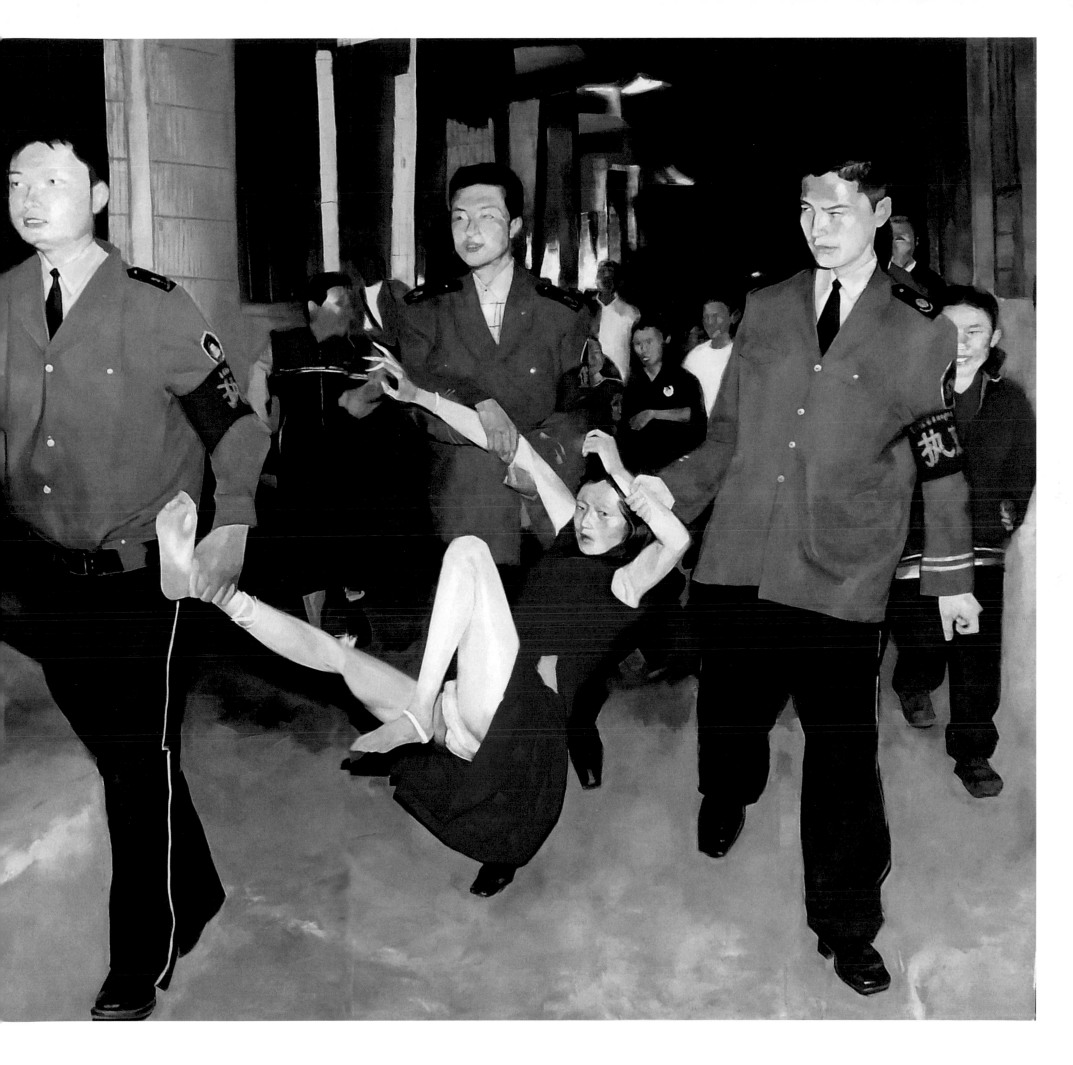

ZHANG HAIYING
ANTI-VICE CAMPAIGN SERIES – 002, 2005
oil on canvas,
200 x 300cm (78 3/4 x 118in)

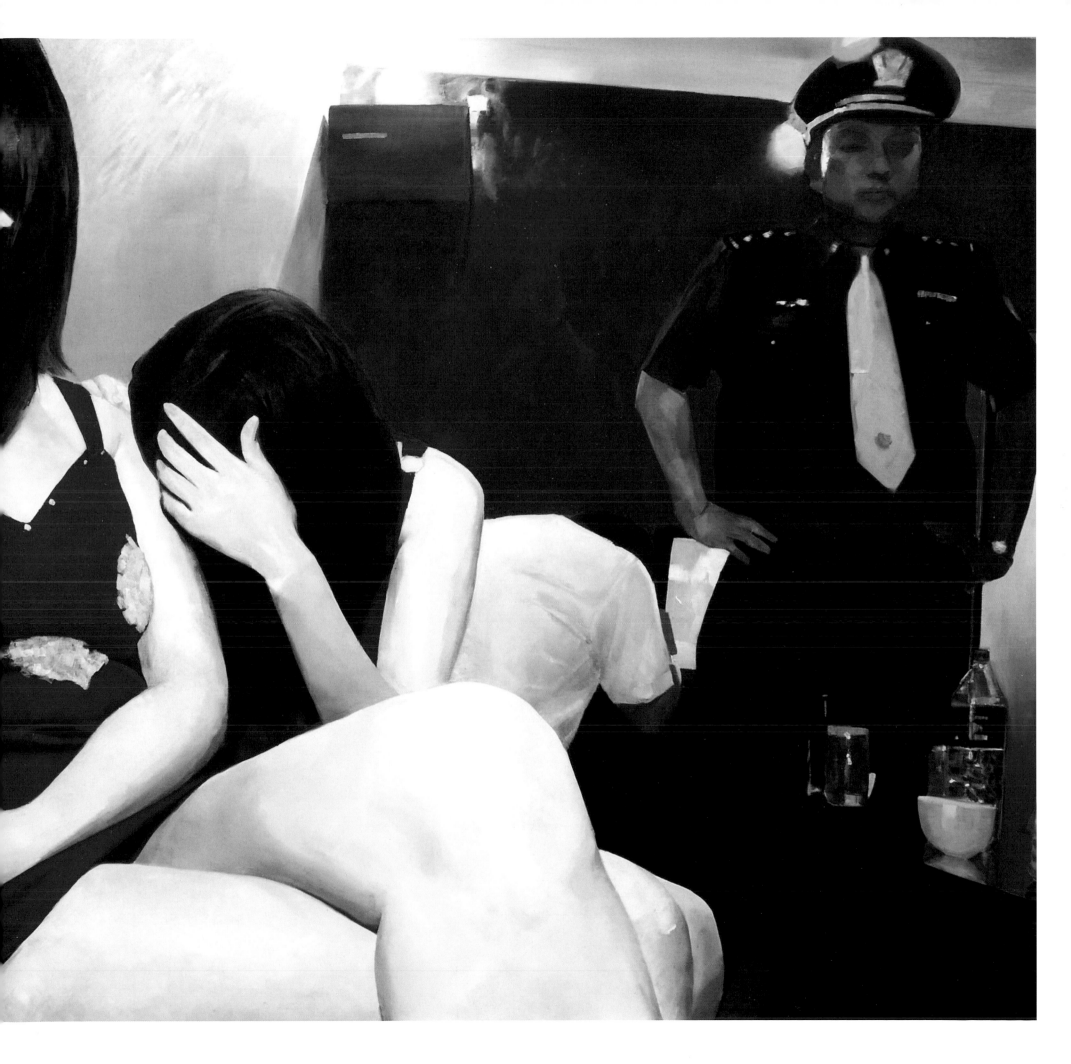

ZHANG XIAOGANG
MY DREAM: LITTLE GENERAL, 2005
oil on canvas,
200 x 160cm (78 3/4 x 63in)

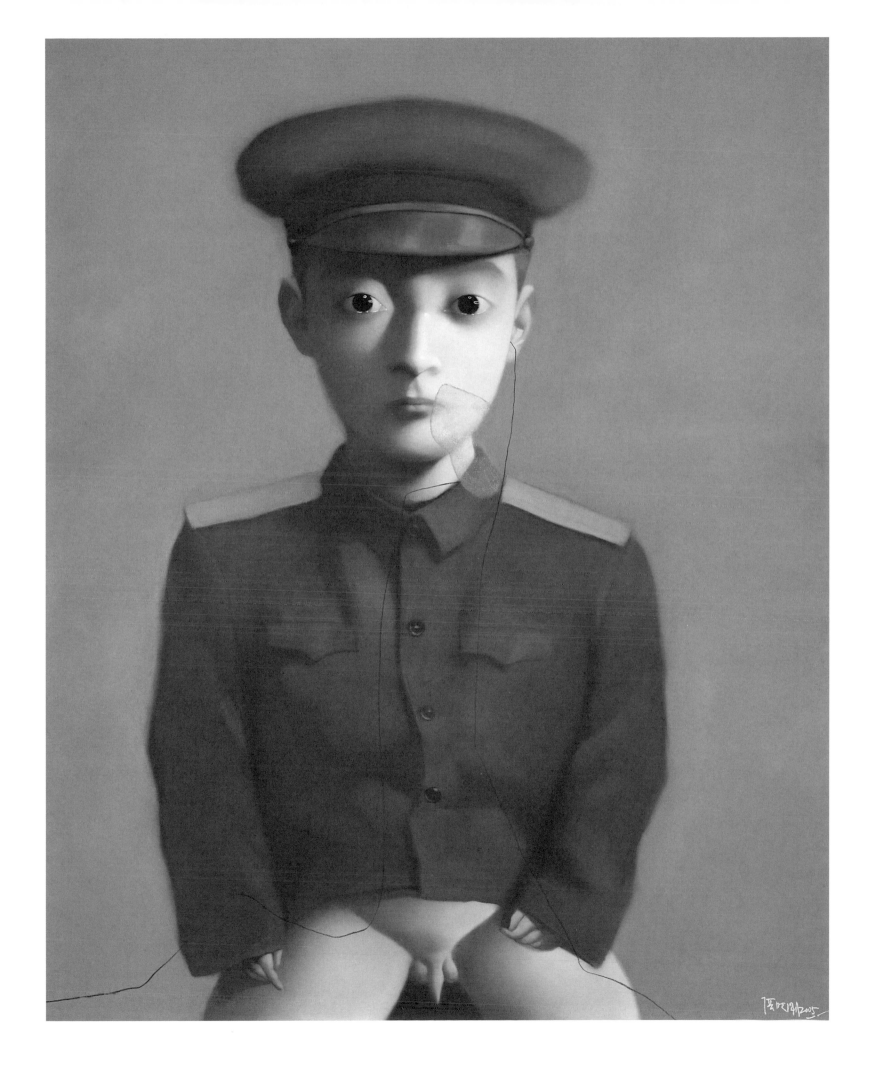

ZHANG XIAOGANG
BLOODLINE, 2005
oil on canvas,
200 x 260cm (78 3/4 x 102 1/2 in)

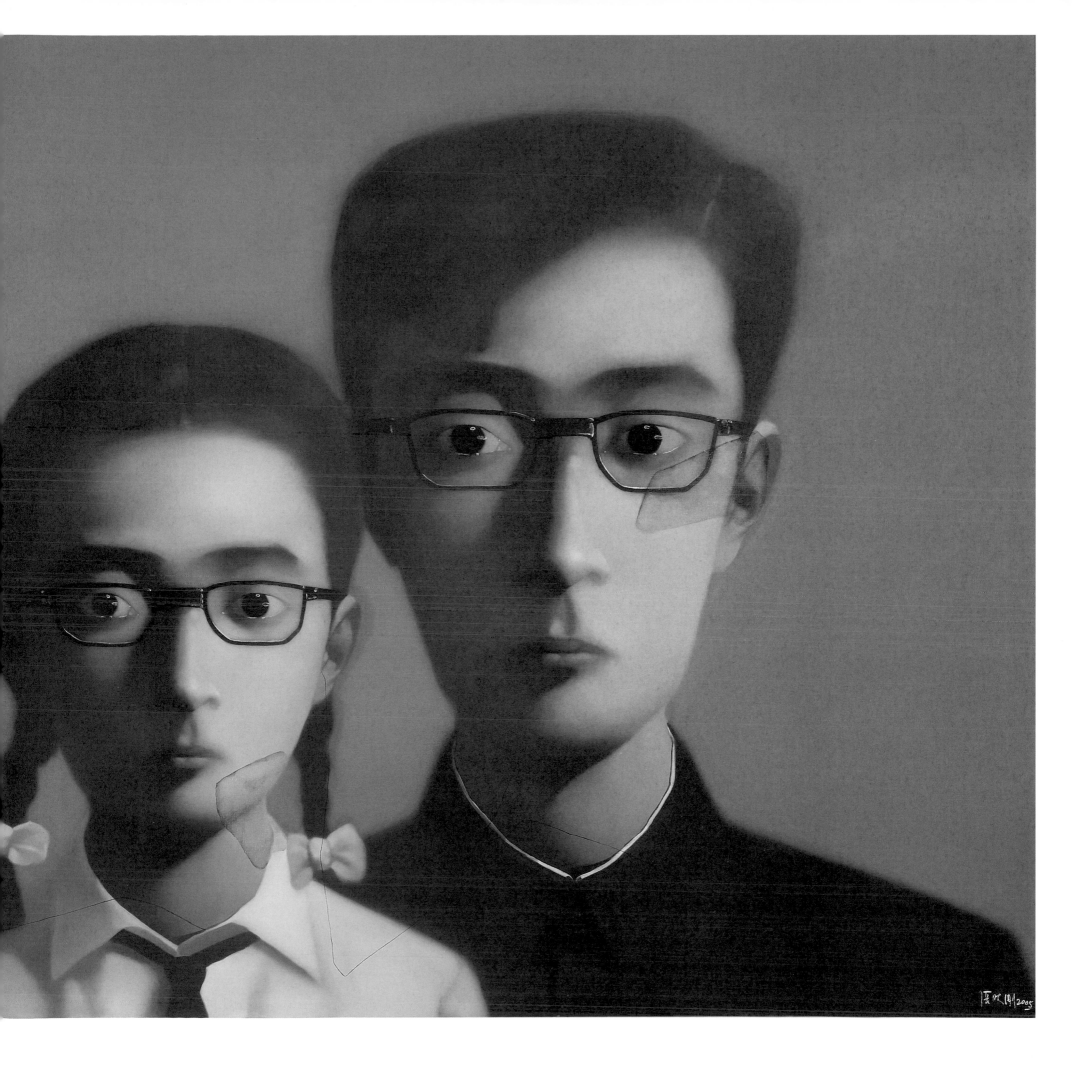

ZHANG XIAOGANG
UNTITLED, 2006
oil on canvas,
200 x 260cm (78 3/4 x 102 1/2 in)

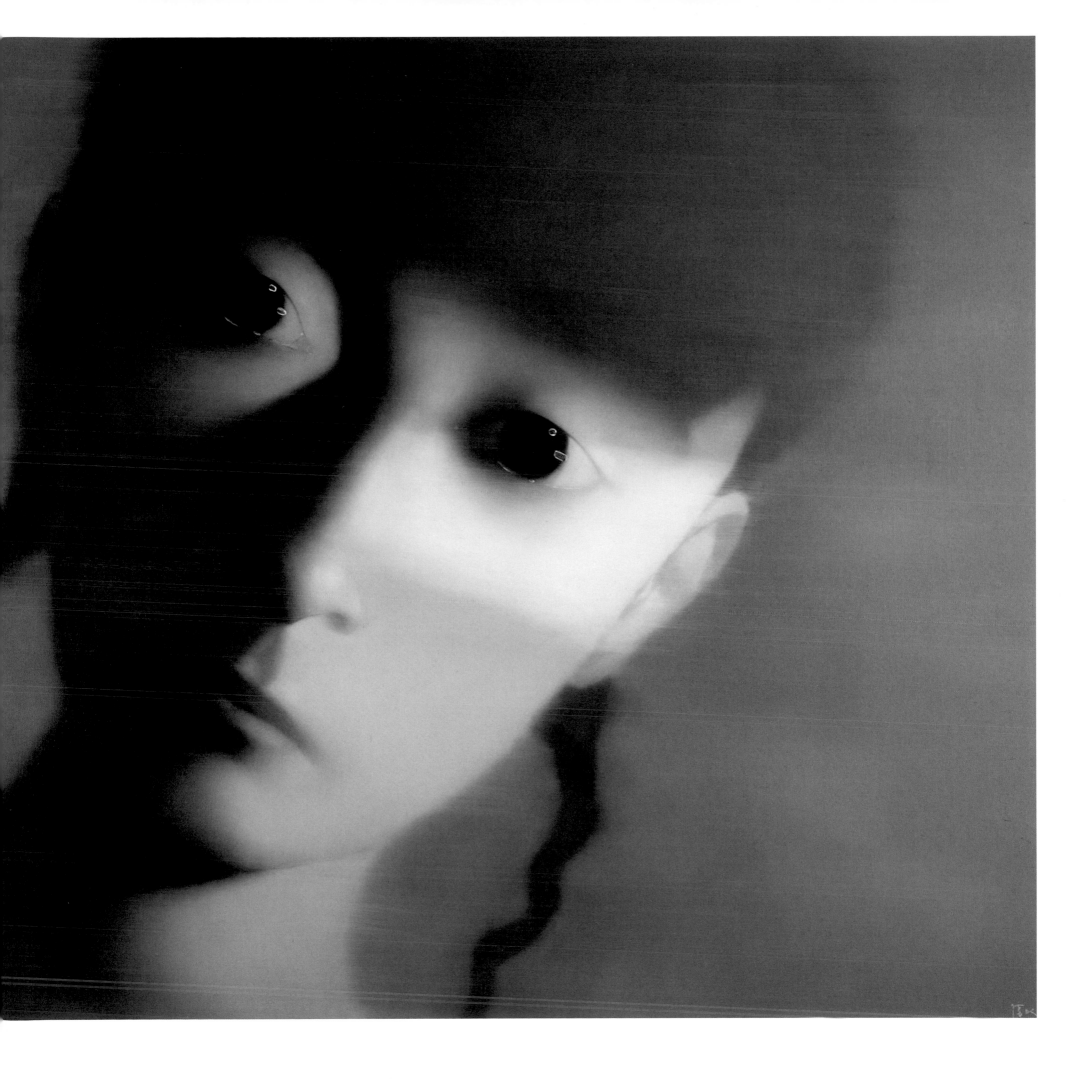

ZHANG XIAOGANG
UNTITLED, 2006
oil on canvas,
200 x 260cm (78 3/4 x 102 1/2 in)

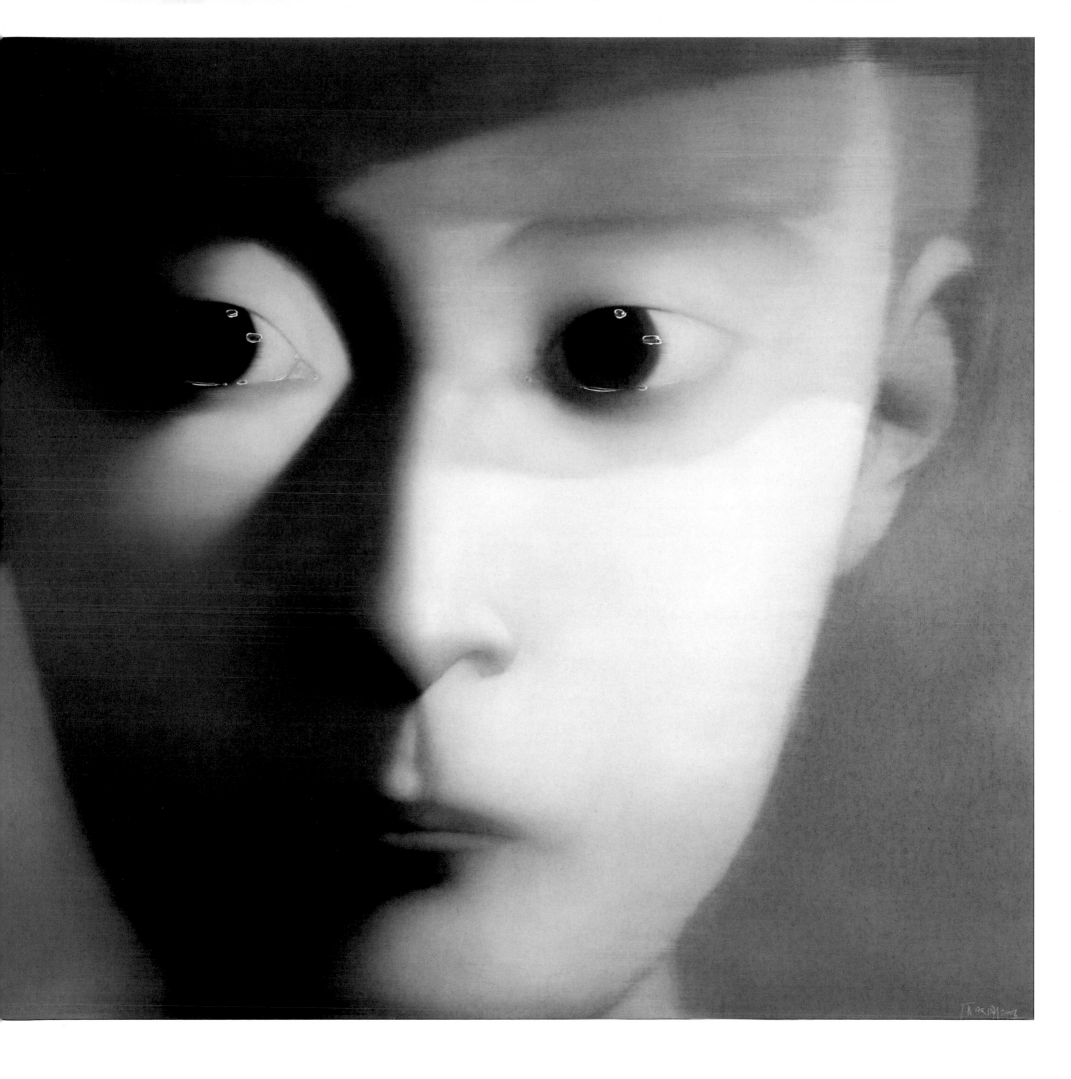

ZHANG XIAOGANG
UNTITLED, 2006
oil on canvas,
200 x 260cm (78 3/4 x 102 1/2 in)

ZHANG XIAOGANG
COMRADE, 2005
oil on canvas,
130 x 220cm (51 x 86 1/2 in) (Diptych)

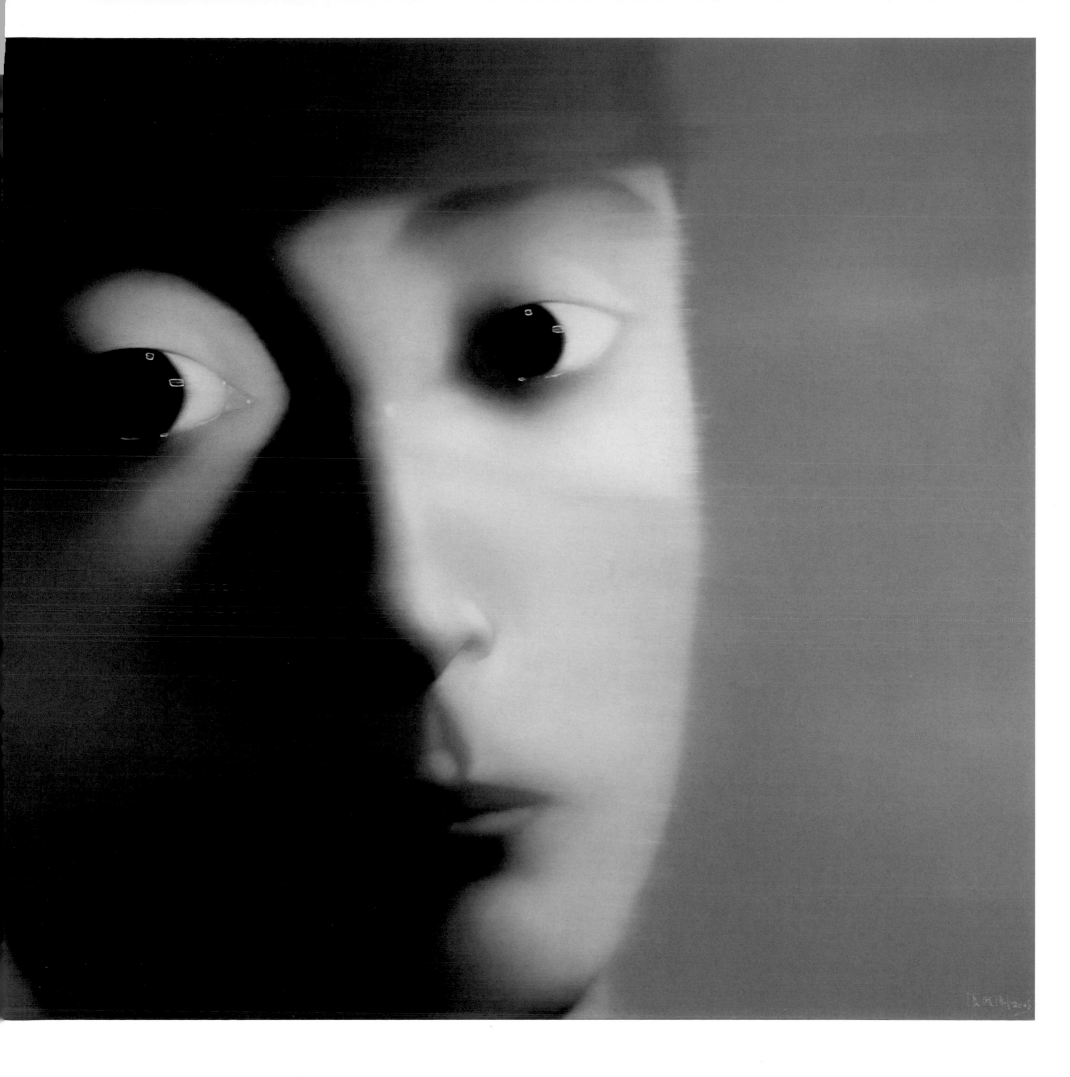

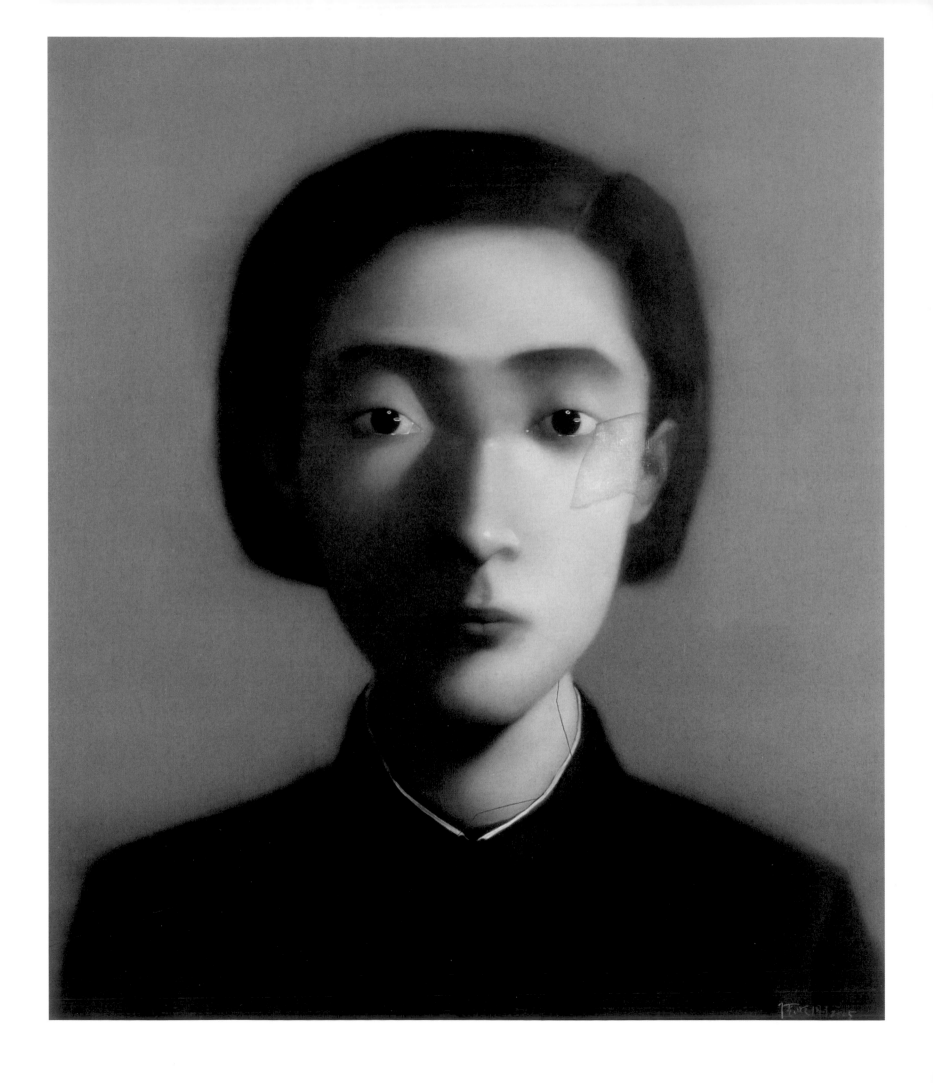

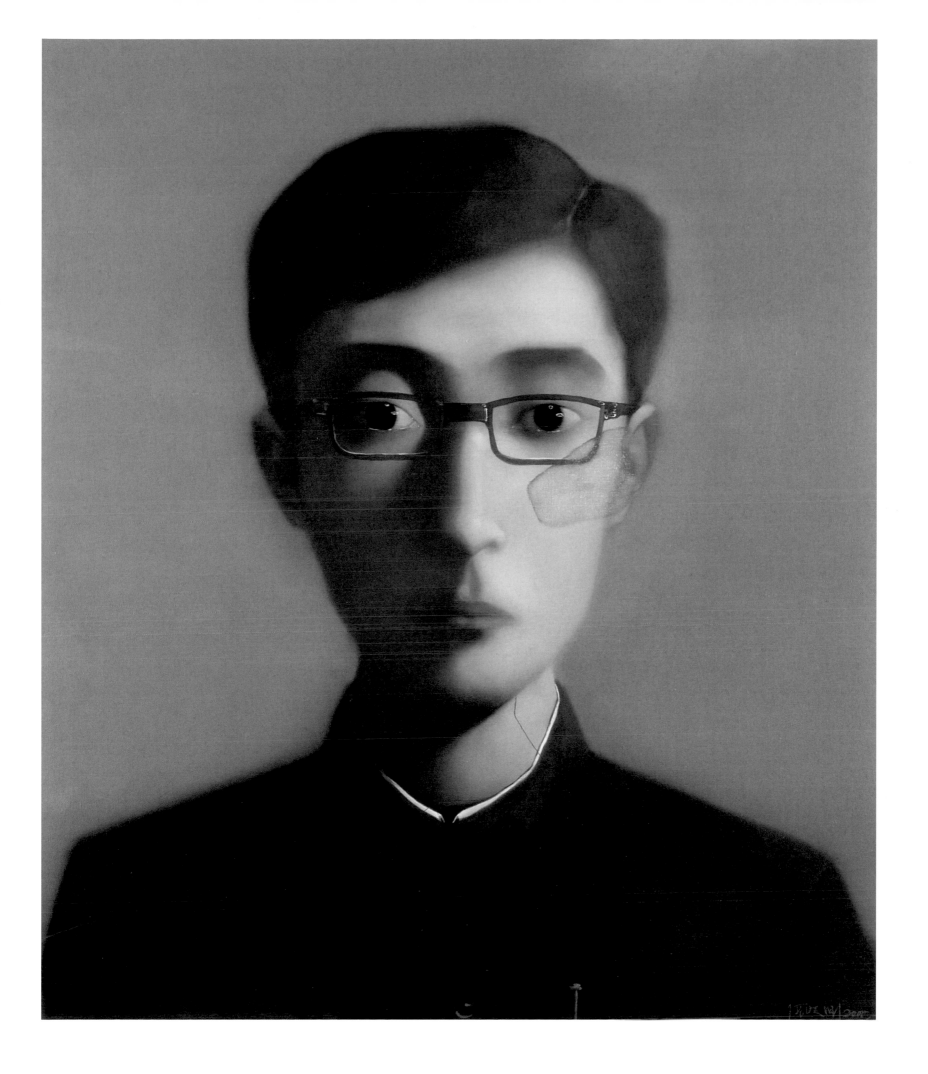

ZENG FANZHI
WE N.2, 2002
oil on canvas,
250 x 250cm (98$^{1/2}$ x 98$^{1/2}$in)

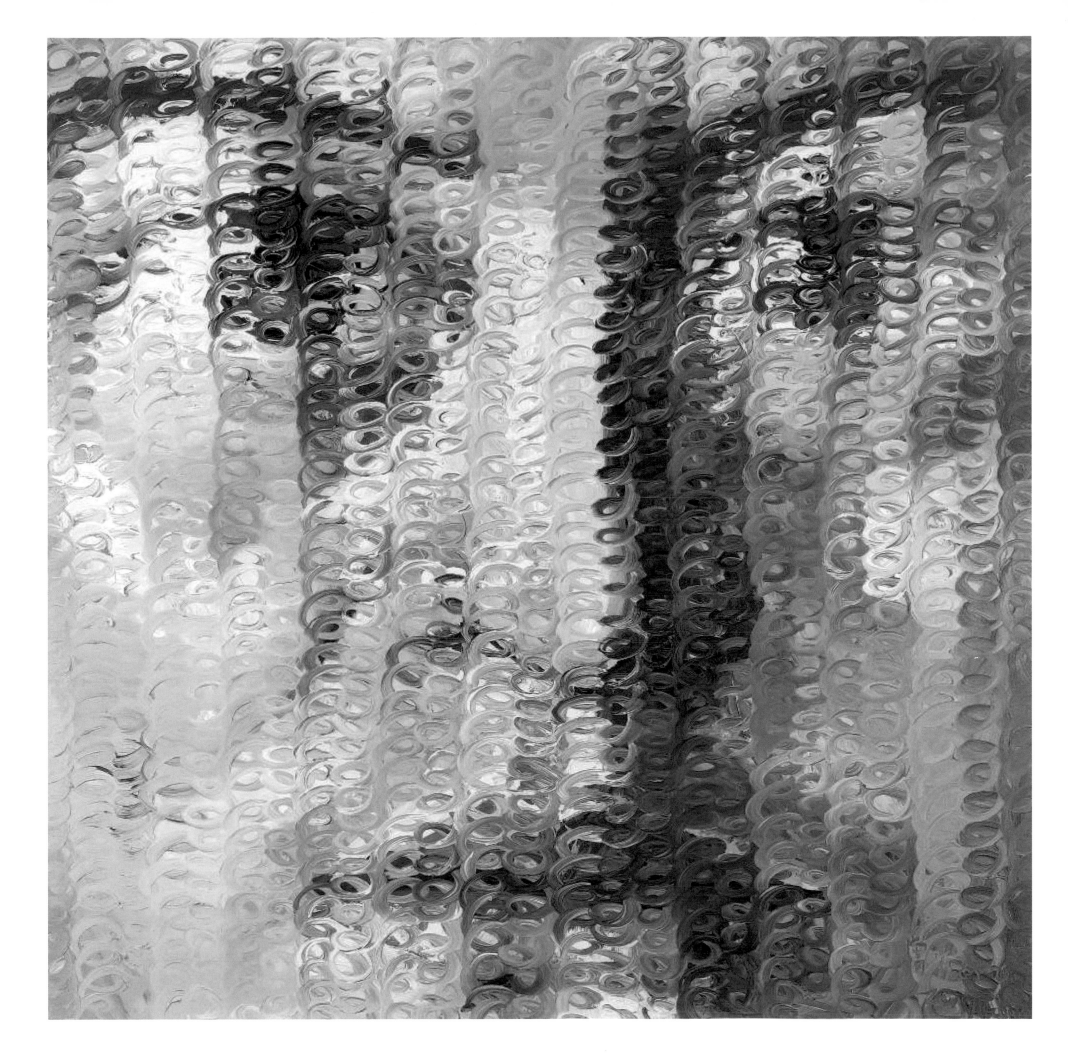

ZHANG HUAN
YOUNG MOTHER, 2007
incense ash on linen
250 x 400cm (98 1/2 x 157 1/2 in)

XIANG JING
YOUR BODY, 2005
colour paint on reinforced fiberglass,
267.5 x 158.5 x 148.6cm (105 1/4 x 62 1/2 x 58 1/2 in)

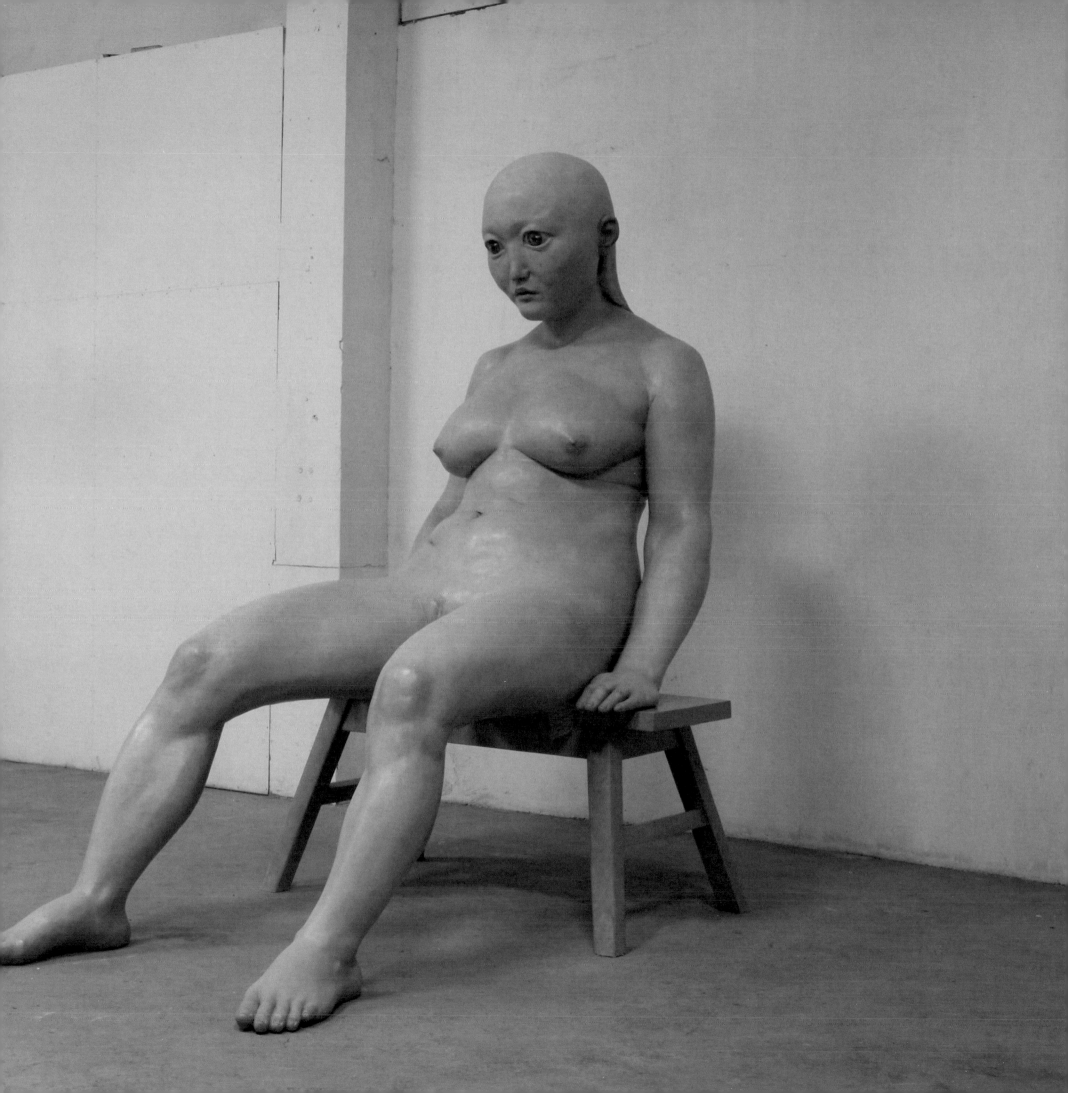

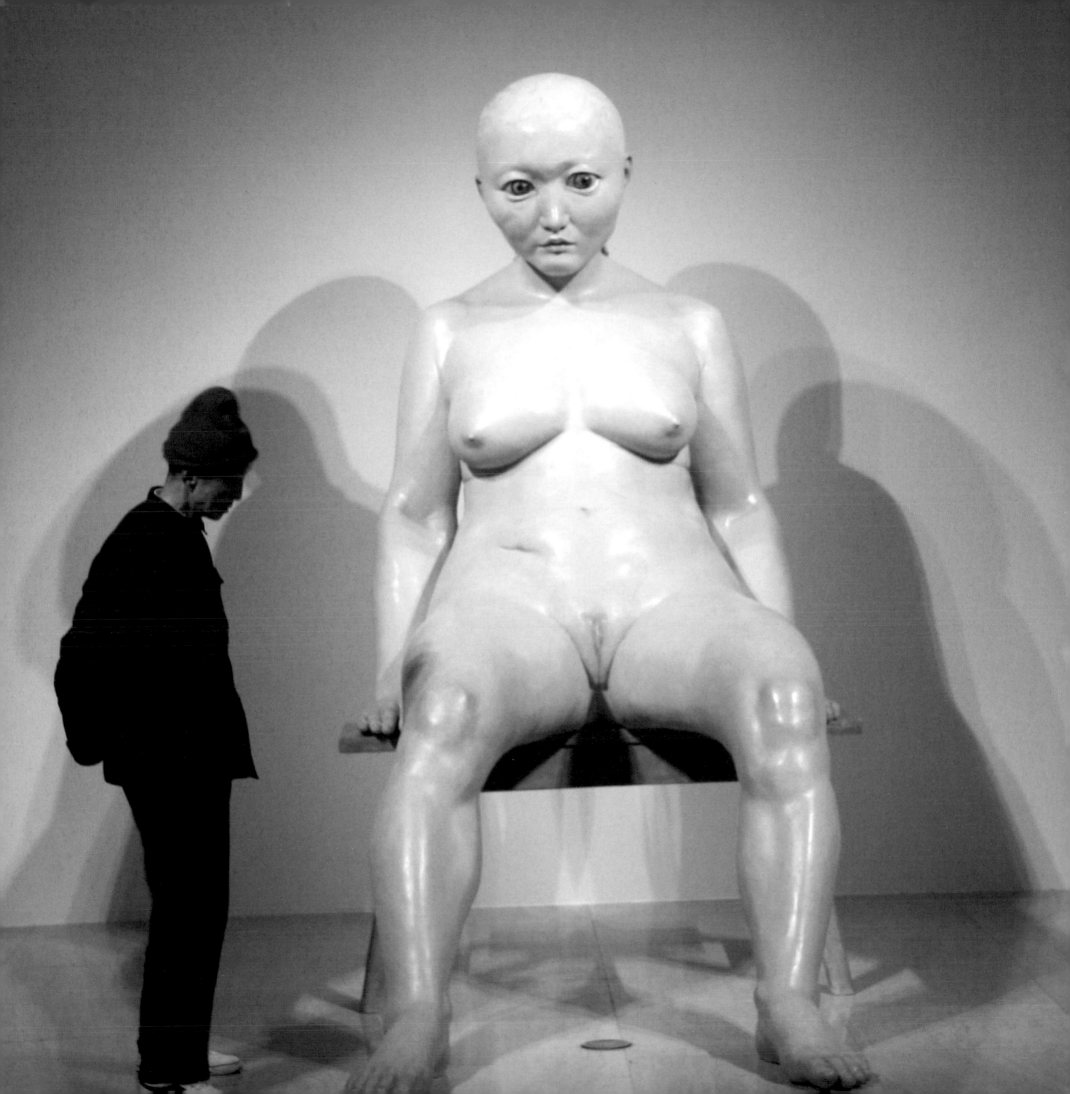

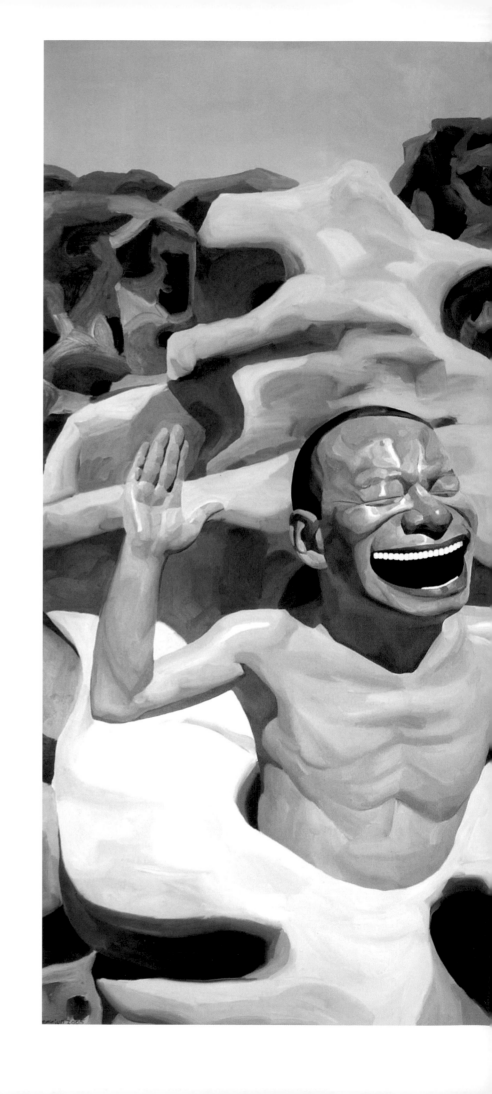

YUE MINJUN
BACKYARD GARDEN, 2005
oil on canvas,
280 x 400cm (110 1/4 x 157 1/2 in)

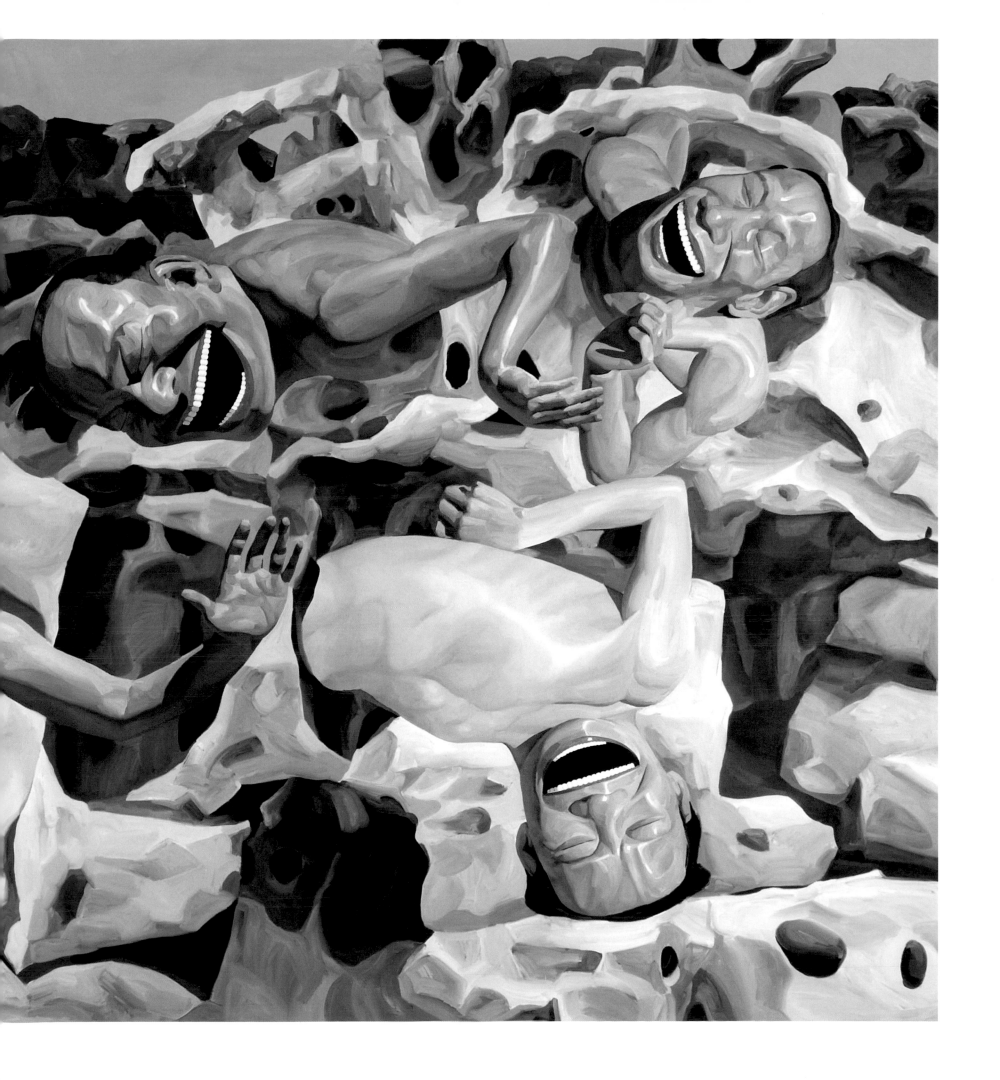

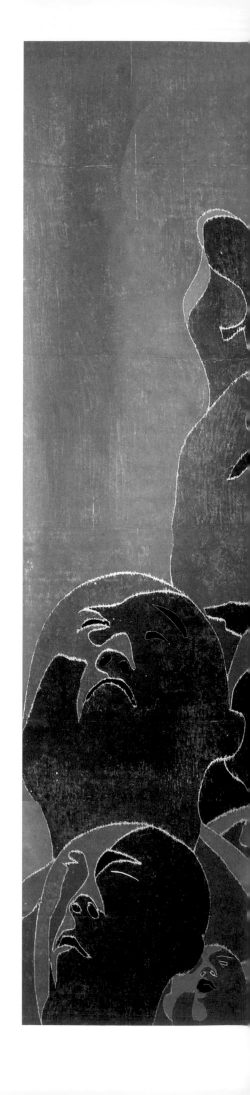

FANG LIJUN
1999.6.1, 1999
woodblock prints and ink on 5 paper and fabric scrolls with wooden dowels,
490.9 x 606.2cm (193 1/2 x 239in)

FANG LIJUN
2003.3.1, 2003
woodblock prints and ink on 8 paper and fabric scrolls with wooden dowels,
400 x 852cm (157 1/2 x 335 3/4 in)

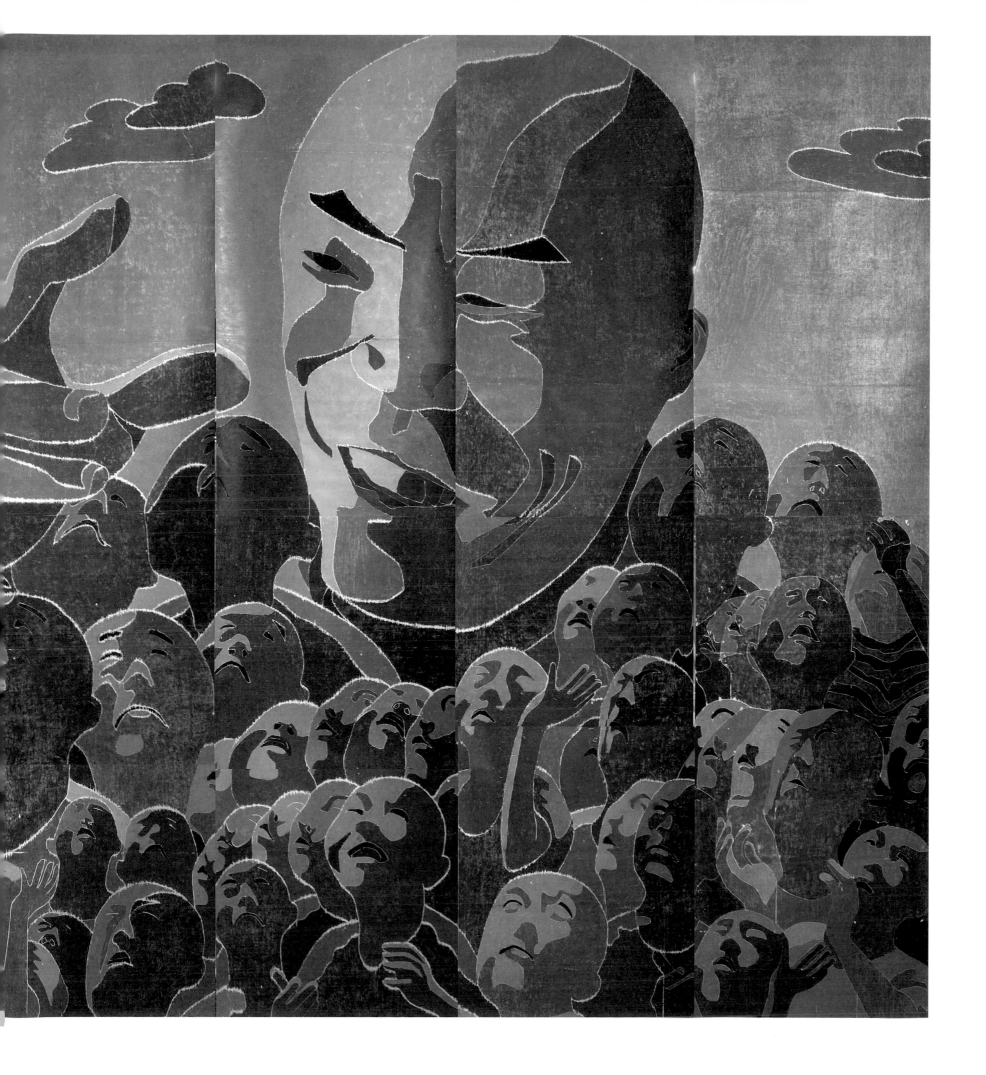

FANG LIJUN
1996.NO.17, 1996
woodblock prints and ink on 3 paper and fabric scrolls with wooden dowels,
261.6 x 365.7cm (103 x 144in)

FANG LIJUN
UNTITLED (SWIMMERS), 2006
inkwash on paper mounted on canvas,
132 x 213cm (52 x 84in)

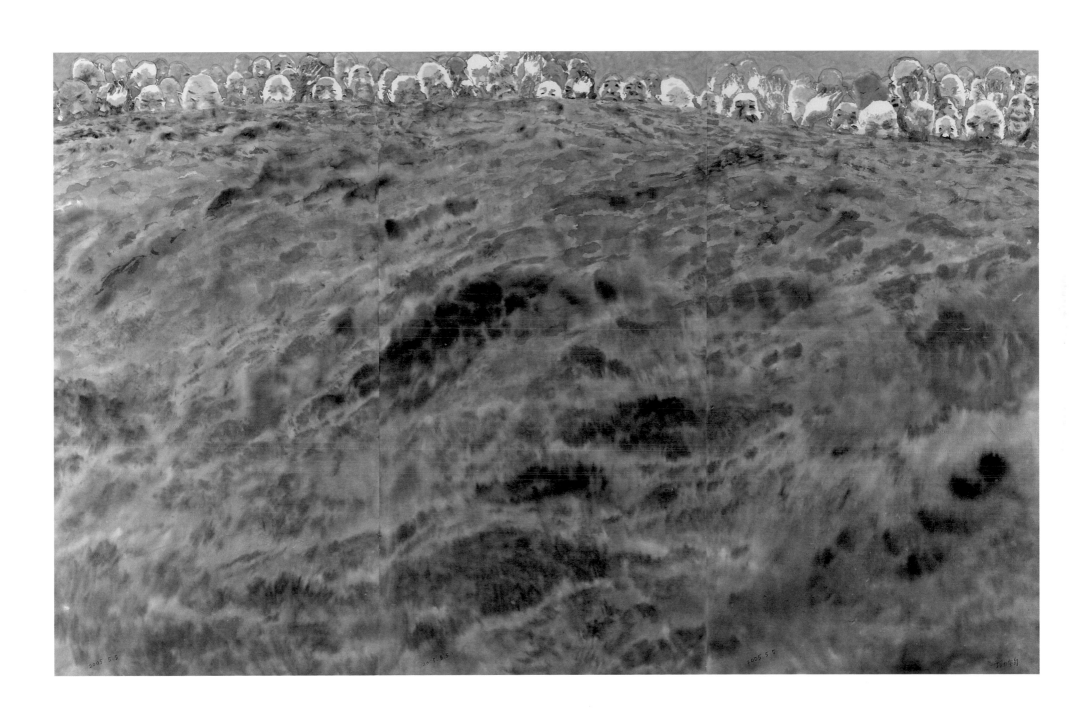

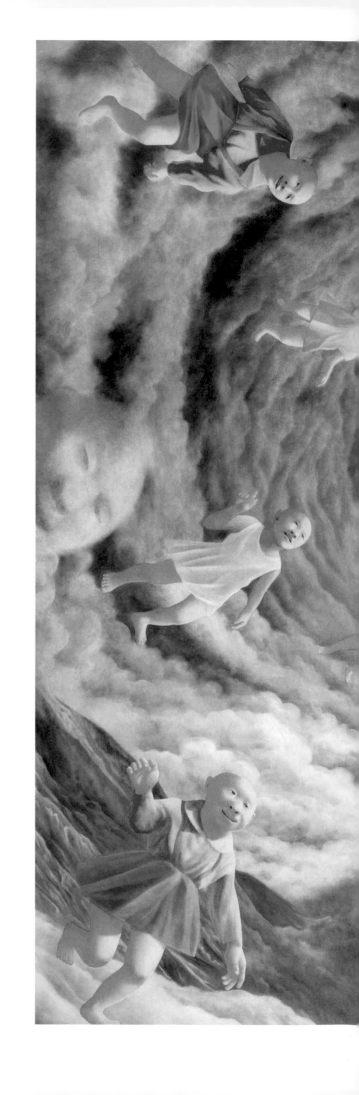

FANG LIJUN
30TH MARY, 2006
oil on canvas,
400 x 525cm (157 1/2 x 206 3/4 in)

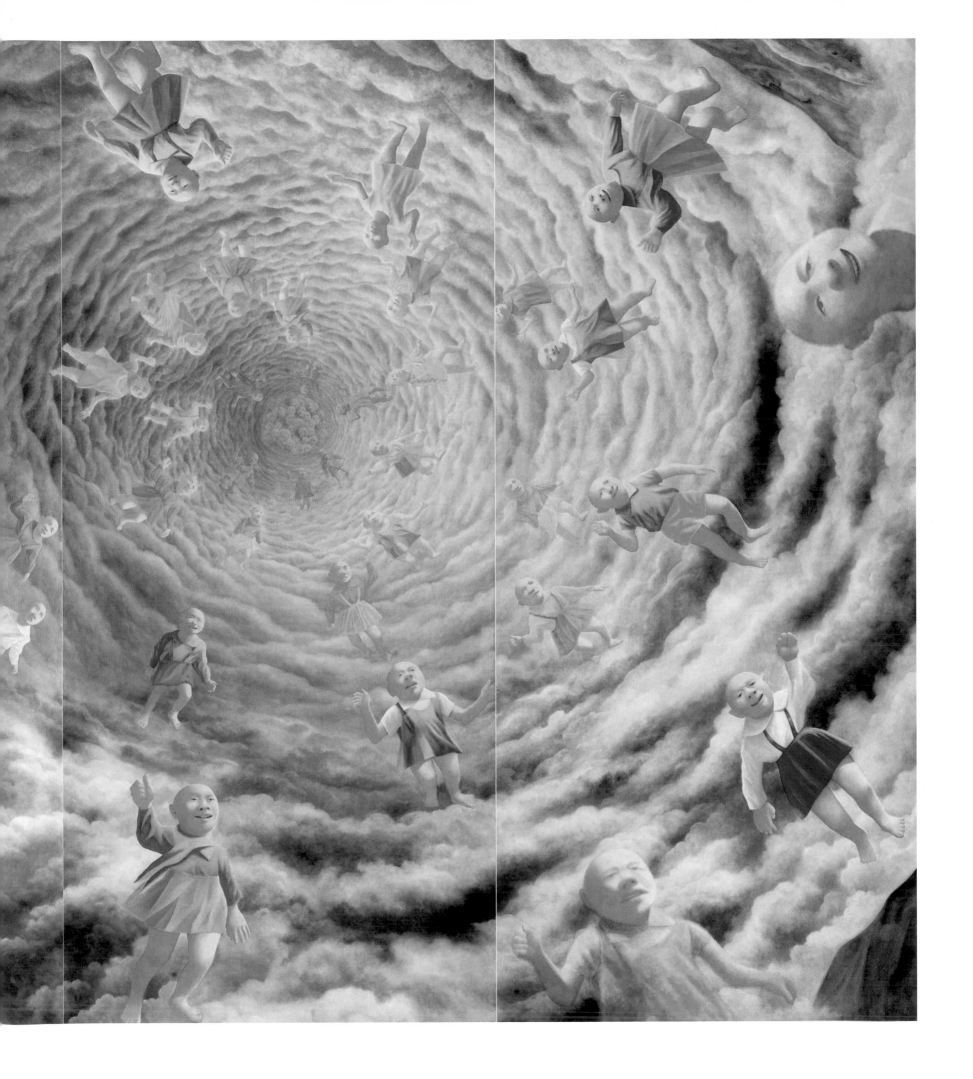

MIAO XIAOCHUN
THE LAST JUDGEMENT IN CYBERSPACE — THE SIDE VIEW, 2006
c-print,
320 x 120cm (126 x 47 1/4 in)

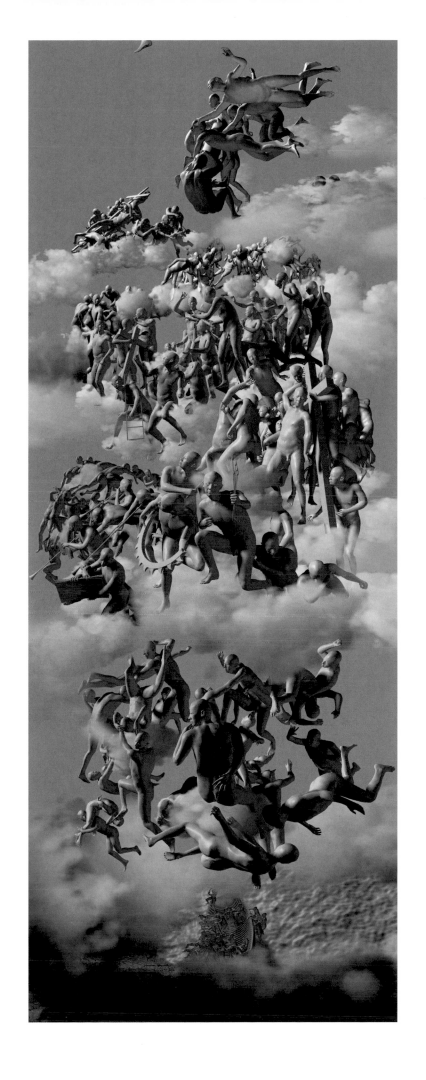

MIAO XIAOCHUN
THE LAST JUDGEMENT IN CYBERSPACE — THE FRONT VIEW, 2006
c-print,
279 x 240cm (110 x 94 1/2 in)

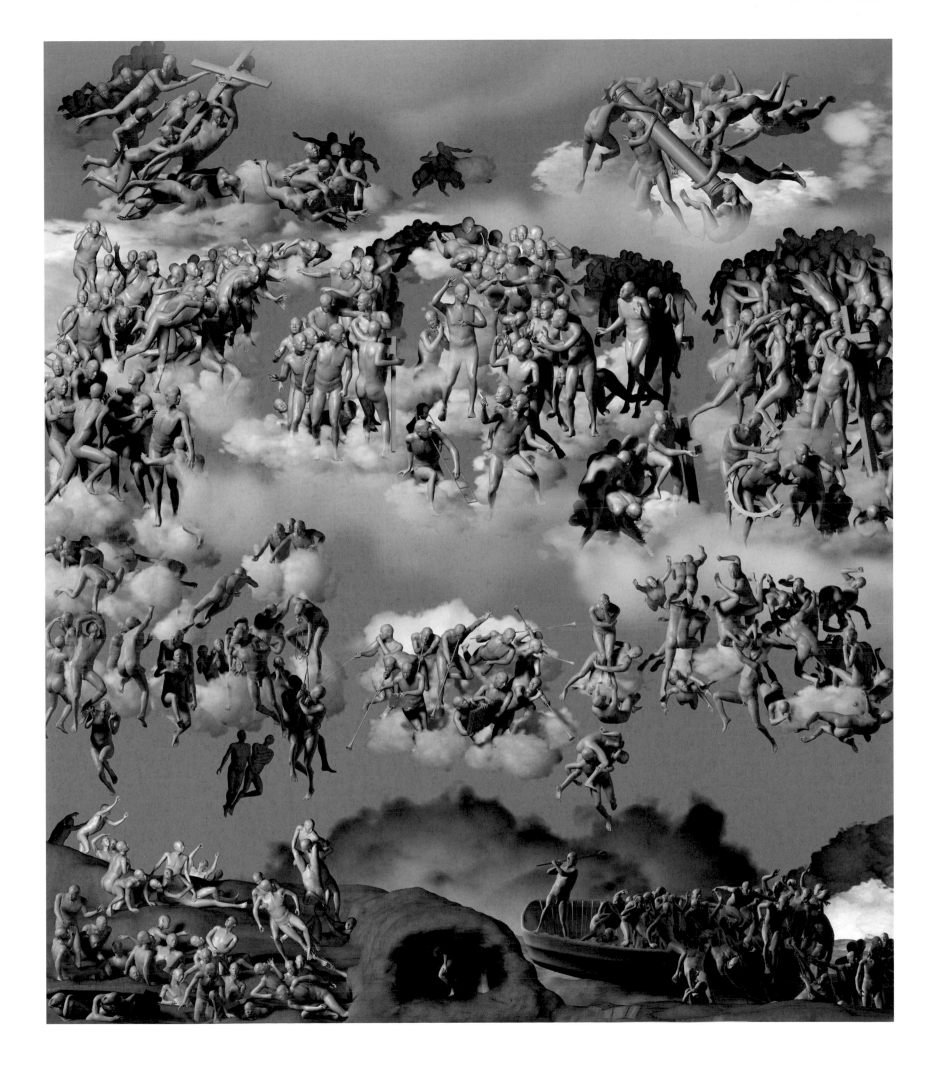

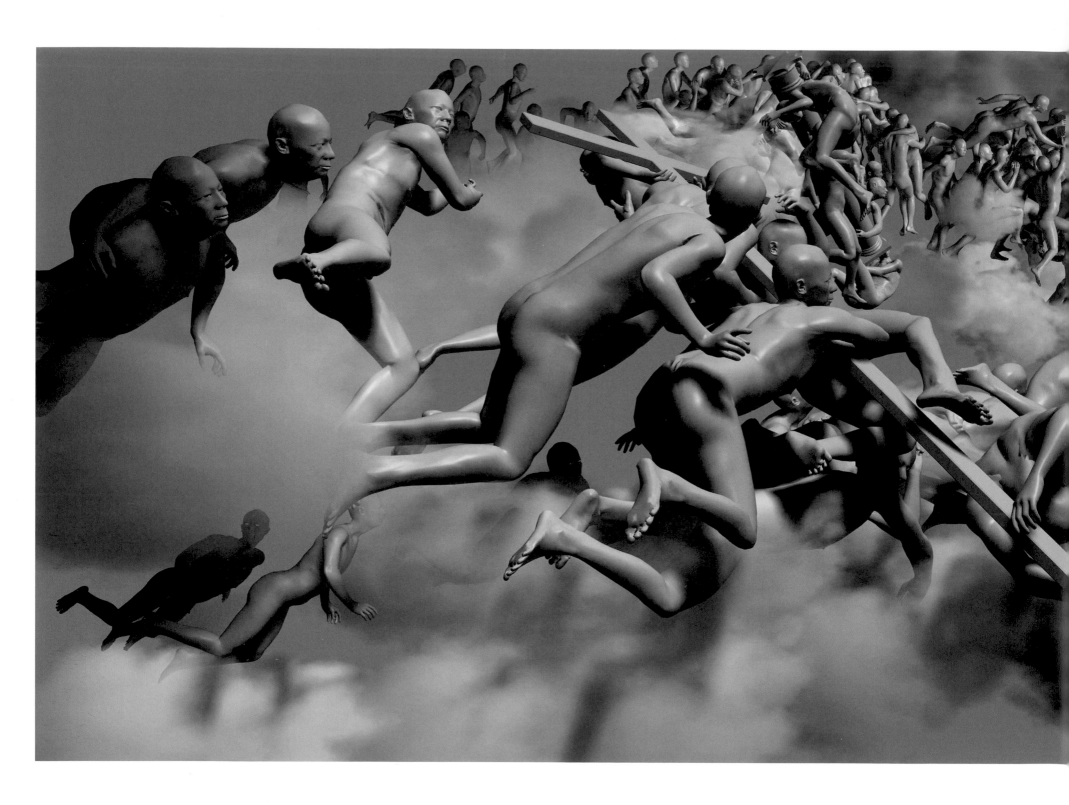

MIAO XIAOCHUN
THE LAST JUDGEMENT IN CYBERSPACE – THE VERTICAL VIEW, 2006
c-print,
120 x 354cm (47¼ x 139½ in)

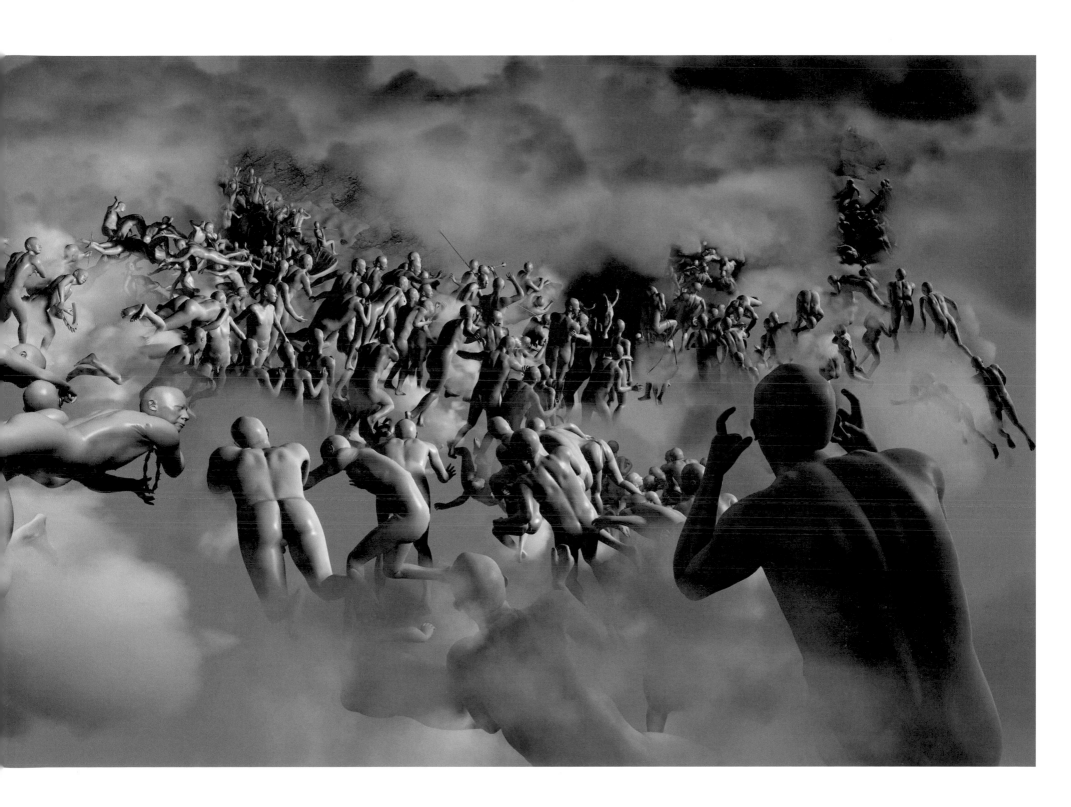

MIAO XIAOCHUN
THE LAST JUDGEMENT IN CYBERSPACE — THE BELOW VIEW, 2006
c-print,
289 x 360cm (114 x 142in)

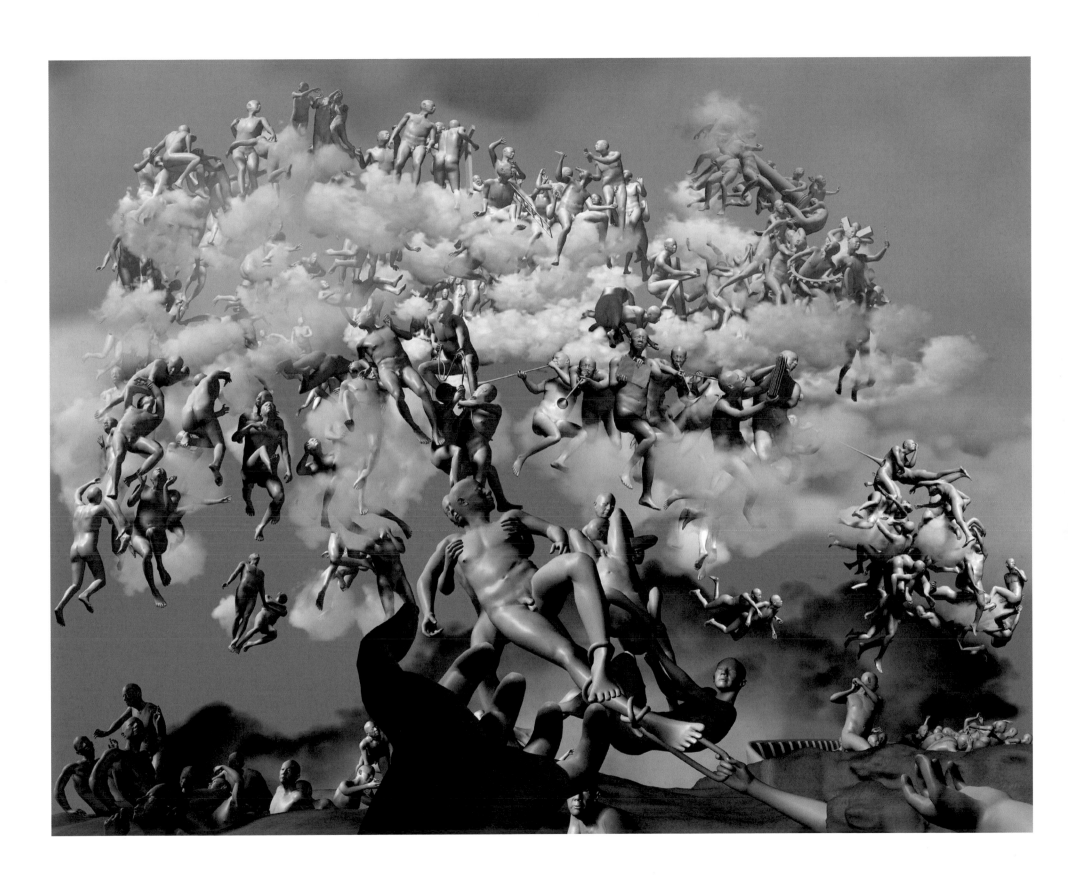

MIAO XIAOCHUN
THE LAST JUDGEMENT IN CYBERSPACE — THE REAR VIEW, 2006
c-print,
288 x 240cm (113 1/2 x 94 1/2 in)

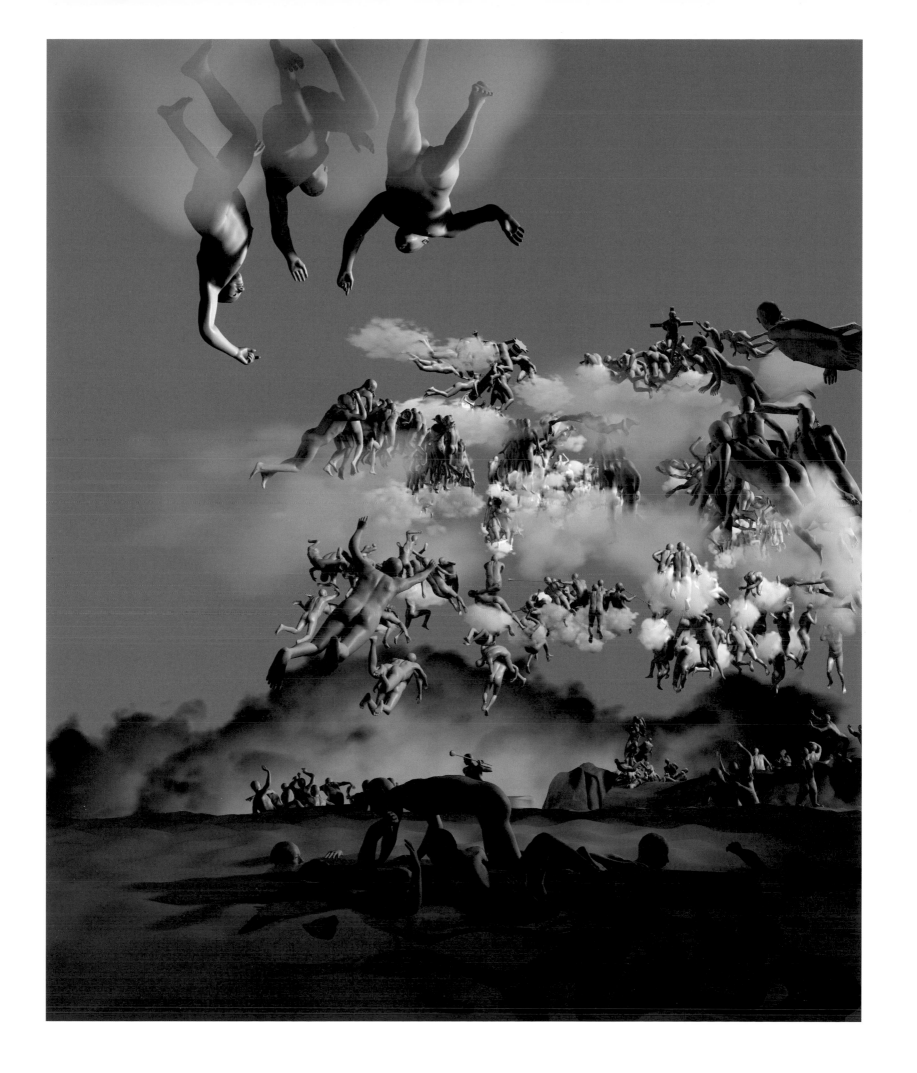

GLOSSARY

CHINESE NAMES

Ai Weiwei	艾未未	b. 1957		Wang Shilong	王世龙	b. 1930
Bai Yiluo	白宜洛	b. 1968		Wang Xizhi	王羲之	321–379
Cang Xin	苍鑫	b. 1967		Wang Yuanqi	王原祁	1642–1715
Cai Guo-Qiang	蔡国强	b. 1957		Wen Naiqiang	翁乃强	b. 1936
Chen Duxiu	陈独秀	1879–1942		Wu Chengen	吴承恩	ca. 1500–1582
Cui Jian	崔健	b. 1961		Wu Shanzhuan	吴山专	b. 1960
Deng Xiaoping	邓小平	1904–1997		Xiang Jing	向京	b. 1968
Fang Lijun	方力钧	b. 1963		Xiao Zhuang	晓庄	b. 1933
Feng Zhengjie	俸正杰	b. 1968		Xu Bing	徐冰	b. 1955
Gu Wenda	谷文达	b. 1955		Xu Zhen	徐震	b. 1977
Huang Rui	黄锐	b. 1952		Yang Fudong	杨福东	b. 1971
Jiang Jieshi	蒋介石	1887–1975		Yang Zhenzhong	杨振中	b. 1968
Jiang Shaowu	蒋少武	b. 1930		Yin Zhaohui	尹朝晖	b. 1977
Li Qing	李青	b. 1981		Yue Minjun	岳敏君	b. 1962
Li Shan	李山	b. 1944		Yu Youhan	余友涵	b. 1943
Li Songsong	李松松	b. 1973		Zeng Fanzhi	曾梵志	b. 1964
Li Yan	李演	b. 1977		Zhan Wang	展望	b. 1962
Liu Chunhua	刘春华	b. 1944		Zhang Dali	张大力	b. 1963
Liu Dahong	刘大鸿	b. 1962		Zhang Haiying	张海鹰	b. 1972
Liu Jiakun	刘家琨	b. 1956		Zhang Hongtu	张宏图	b. 1943
Liu Ye	刘野	b. 1964		Zhang Huan	张洹	b. 1965
Liu Wei	刘韡	b. 1972		Zhang Peng	张鹏	b. 1981
Ma Desheng	马德升	b. 1952		Zhang Xiaogang	张晓刚	b. 1958
Mao Zedong	毛泽东	1893–1976		Zhang Xiaotao	张小涛	b. 1970
Miao Xiaochun	缪晓春	b. 1964		Zhang Yuan	张远	b. 1966
Mu Chen	慕辰	b. 1970		Zheng Guogu	郑国谷	b. 1970
Peng Yu	彭禹	b. 1974		Zhuang Hui	庄辉	b. 1963
Qiu Jie	邱节	b. 1961				
Qiu Zhijie	邱志杰	b. 1969				
Shao Yinong	邵逸农	b. 1961				
Shen Shaomin	沈少民	b. 1956				
Shi Jinsong	史金淞	b. 1969				
Shi Xinning	石心宁	b. 1969				
Sui Jianguo	隋建国	b. 1956				
Sun Yuan	孙原	b. 1972				
Wang Guangyi	王广义	b. 1957				
Wang Jinsong	王劲松	b. 1963				
Wang Keping	王克平	b. 1949				

CHINESE TERMS

biaozhun xiang	标准像	standard portrait
bupo buli	不破不立	there is no construction without destruction
cuobie zi	错别字	miswritten word
dahai hangxing kao duoshou	大海航行靠舵手	sailing on the sea relies on the Helmsman
danao tiangong	大闹天宫	making troubles in heaven
dayuejin	大跃进	the Great Leap Forward
dazi bao	大字报	big-character poster
diyi sudu	第一速度	the first speed
geming	革命	revolution
gonggong hua	公共化	public
hong haiyang	红海洋	red sea
hongse kongbu	红色恐怖	red terror
hong wulei	红五类	Five Red Categories
jiti	集体	collective
Maore	毛热	Mao-craze
min gong	民工	immigrant workers
quanguo shangxia yipian hong	全国上下一片红	the whole country being awash with red
san zhongyu	三忠于	Three Loyalties
shinian dongluan	十年动乱	ten-year turbulence
sige weida	四个伟大	Four Greats
simi hua	私密化	private
sijiu	四旧	four olds
wenzi gongzuozhe	文字工作者	character worker, generally known as writers or editors
wuchan jieji wenhua dageming	无产阶级文化大革命	The Great Proletarian Cultural Revolution
xin wenhua yundong	新文化运动	the New Culture Movement
yangban xi	样板戏	model opera
yanzhi hua	胭脂化	rouged
zaofan youli	造反有理	to rebel is justified
zhengjian zhao	证件照	identity photo
zhengzhi bopu yishu	政治波普艺术	political pop art
zhongguo pai	中国牌	Chinese card
zilai hong	自来红	born red
zi xiang	字象	character figure

LIU WEI
PURPLE AIR III NO.11, 2006
oil on canvas,
190 x 300cm (74 3/4 x 118in)

First published in the United States of America in 2008 by Rizzoli International Publications, Inc.

300 Park Avenue South. New York, NY 10010

www.rizzoliusa.com

First published in Great Britain in 2008 by Jonathan Cape, Random House,

20 Vauxhall Bridge Road, London SW1V 2SA in association with the Saatchi Gallery

The Random House Group Limited Reg. No. 954009

Published in association with the Saatchi Gallery

Corporate Partner: Phillips de Pury and Company

PHILLIPS
de PURY & COMPANY

Founding Patron: Dinesen

Dinesen

ISBN: 978-0-8478-3206-4
Library of Congress Control Number: 2008922983

2008 2009 2010 2011 / 10 9 8 7 6 5 4 3 2 1

Edited by Mark Holborn

Design Holborn

Coordinated by Philippa Adams and Annabel Fallon of the Saatchi Gallery

Production Controller: Simon Rhodes

Printed in Germany by Appl Druck, Wemding

Case: Detail from *Chairman Mao reviewing Red Guards in Tiananmen Square*, 1966, by Weng Naiqiang